Baltimore's Historic

OAKENSHAWE

—— *Baltimore's Historic* ——

OAKENSHAWE

FROM COLONIAL LAND GRANT
to STREETCAR SUBURB

D.J. WILSON

THE
History
PRESS

Published by The History Press
Charleston, SC
www.historypress.com

Copyright © 2019 by D.J. Wilson
All rights reserved

First published 2019

Manufactured in the United States

ISBN 9781467136235

Library of Congress Control Number: 2018960974

Contents

CONTENTS

PREFACE

T his book was written as a record of the author's research concerning the early history of Oakenshawe, a historic neighborhood in Baltimore, Maryland. The book concentrates on historic aspects of the land that Oakenshawe now stands upon. As reflected in its title, the book covers a time period from the original 1688 land grants to building the neighborhood between 1916 and 1926. Oakenshawe and the surrounding neighborhoods were referred to as "streetcar suburbs," providing new, affordable housing to the growing population of Baltimore Town. The new neighborhoods were accessible by streetcar as their routes expanded north of the city due to the 1888 acquisition of land formerly in Baltimore County called "The Annex."

Much of the book is devoted to two families that were significant in Oakenshawe history, the Wilson and Mueller families. The Wilson family, important Baltimore merchants, established a summer residence where Oakenshawe now stands in 1802 and maintained the property as several summer residences until well into the twentieth century. The neighborhood name is derived from a mansion house and estate, Okenshaw, which once stood where Homewood Terrace now stands.

The Mueller family was prominent in building Baltimore in the late nineteenth and early twentieth centuries. They were mostly concerned with building in east Baltimore, where they established the Brewers Hill neighborhood, but were involved with building throughout Baltimore. The family perfected the "land rent" system in Baltimore; owned real estate

firms, building supply companies and construction companies; and operated several home and loan associations. Oakenshawe was the brainchild of one of the Mueller brothers, Phillip C. Mueller, who conceived the idea and purchased the Okenshaw estate in 1914. Henry R. Wilson, who occupied the estate, died in 1908, and his children sold the property to Mueller in 1914 for $57,000. An architect was engaged to design the homes in Oakenshawe, a first for the Muellers, who generally allowed the building companies to design homes as they were built.

The Oakenshawe development was expanded by two additional Mueller Construction Company purchases in 1919 and the annexation of part of the old Waverly Village neighborhood west of the Greenmount Avenue commercial district in the mid-1900s. Today, the Historic District of Oakenshawe spans East University Parkway and Calvert Street below Southway and west of Greenmount Avenue. The author leaves to a future writer the more recent history of the community.

ACKNOWLEDGEMENTS

Many resources were consulted in the preparation of this manuscript. The impetus for its existence is the first Oakenshawe House and Garden Tour in 2003, which piqued the interest of the author concerning the owners of the original Oakenshawe estate and the builders and architects of houses in the historic neighborhood. A longtime resident, Matthew Mosca, stated in the tour introduction that "the name Oakenshawe derives from Henry Wilson's estate, once located in this area," and further described interesting details of the houses and their construction.[1]

A primary document used for the preparation of this manuscript was the application for the inclusion of Oakenshawe in the National Register of Historic Places, prepared by Dean R. Wagner and submitted in July 2002. Historic Trust designation was granted on December 18, 2003.[2]

Numerous authors over the years have compiled short pieces regarding all or part of the land that Oakenshawe now sits upon, and these have been referenced where appropriate.

The Wilson family occupied the land where Oakenshawe now stands as summer residences for over one hundred years prior to its development as a Baltimore neighborhood. Of special note to this period of time is *The Life Story of Franklin Wilson, as Told by Himself in His Journals*, published in 1897, shortly after the death of Franklin, a grandson of William Wilson. Several members of the Wilson family were active supporters of the Maryland Historical Society (MdHS), some serving as officers or trustees. Due to

this affiliation, there is a substantial collection of Wilson family history in the MdHS collections; some elements of those collections are used here with permission.

Numerous online resources are available from Baltimore City and Maryland state government offices, including land records, title transfers, wills and last testaments. The Baltimore City Directories and Baltimore "Blue Book"[3] are available for most of the nineteenth century, and these were invaluable in tracing the lineage of the Wilson family and their numerous business associations as well as documents pertaining to the builders and architects involved in construction of the Oakenshawe development. The Baltimore City Archives, in particular, was a valuable source of period maps. My thanks to Saul Gibusiwa and Dr. Edward Papenfuse for their invaluable assistance in retrieving and interpreting relevant references. Land transactions are denoted by the initial of the land office clerk followed by book (Liber) and page (folio) numbers—for instance, WG Liber 239 folio 87, a format used for citing land transactions throughout this book. The Maryland State Archives land records for Baltimore City and Baltimore County were very helpful in this research, located at www.mdlandrec.net.

Many adjacent neighborhoods have had histories published, and these were both interesting to read and informed the author. Among those with special affiliations to Oakenshawe were Alexander and Williams's *A Brief History of Charles Village*, Hayward and Belfoure's *The Baltimore Rowhouse*, Blum's *Baltimore County*, Ambrose's *Remington*, Bowditch and Draddy's *Druid Hill Park*, Giroux's *Guilford*, McGrain's *Charles Street*, Hayward and Shivers's *The Architecture of Baltimore* and Kelly's *Peabody Heights to Charles Village*.

Also of special note are the writings of William B. Marye and Thomas J. Scharf. Marye liberally contributed much of his considerable knowledge of Baltimore and its surroundings to scholarly pieces that appeared in the *Maryland Historical Magazine* in the late 1950s and early 1960s. Scharf published two volumes of the history of Baltimore City and County in 1874 and 1881, essential reading for anyone interested in the history of Baltimore and a valuable resource for this author.

Special thanks to George Radcliffe of Cambridge, Maryland, who has preserved a great deal of history pertaining to the Wilson family. Giving me total access to his collections of writings and photographs of Wilson family documents helped immensely in sorting through confusing bits of information and provided many of the photographs and anecdotes presented in this book.

ACKNOWLEDGEMENTS

The author is indebted to his Oakenshawe neighbors who read and reviewed the manuscript while in preparation, and the many suggestions they made helped to improve the organization and content of the book. Special thanks to the Oakenshawe Improvement Association, which spearheaded the publication of the manuscript and made valuable contributions to its final form and content, alas too late for the Oakenshawe centennial of 1916. Specific thanks go to John Farley, Joy Myers, Ann Beckemeyer, Katherine Fritz, Anthony Nathe, Matthew Mosca, Peter Halstad and Miye Schakne for their contributions.

The author's editors at The History Press supported this publication, and it would not have been published without their encouragement, conversations and wise suggestions; thanks to Hannah Cassilly, J. Banks Smither and Mike Litchfield.

—Dennis J. Wilson
Baltimore, Maryland

INTRODUCTION

The neighborhood name Oakenshawe is derived from the estate of Henry R. Wilson, a small portion of his parents' large summer estates. The estate was variously spelled Okenshaw, Oakenshaw, Okenshawe or Oakenshawe in maps and directories of the time. For this book, "Okenshaw" is used when referencing the old summer estate, and "Oakenshawe" is used when referring to the current neighborhood. When Henry's father, James Wilson, established a large summer estate in the area, it was common to name estates and the houses that stood upon them. Henry R. Wilson occupied Okenshaw for over sixty years, from his youth until his death in 1908. His surviving children, Henry M. Wilson and Elizabeth Wilson Heyward, sold the old place in 1914 for development for $57,000. The summer house, described as an "artistic mansion" among "many stately old trees," was demolished in 1916 to make way for development.[4]

Okenshaw was part of the much larger estates established by James Wilson and his brother, Thomas, senior partners in their father's mercantile and shipping house, William Wilson & Sons. The old firm was started in the 1770s and grew to become one of the largest and oldest mercantile firms in the city, maintaining one of the largest shipping fleets on the Eastern Seaboard. It was said that "their ships whitened every commercial port in the known globe, and poured into the lap of Baltimore the products of every country."[5] The firm eventually controlled the tea trade from China and Japan. At a time when few businesses lasted more than a single generation, William Wilson & Sons established and maintained a

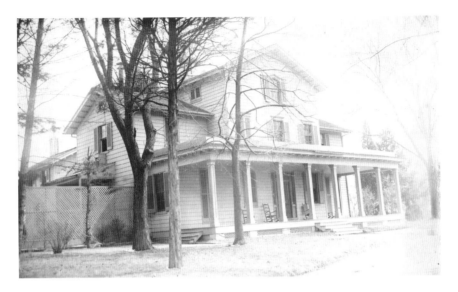

Okenshaw, summer home of Henry R. Wilson, Merryman's Lane. *Maryland Historical Society PP3.80.*

business in Baltimore that spanned the globe for over one hundred years, encompassing four generations of the Wilson family, a testament to their remarkable business acumen.

The Wilson family consisted of the founder of the family in Baltimore, William Wilson; his wife, Jane Stansbury, a fourth-generation colonist; and their four children: James, Thomas, Hannah and William Jr.

James married Mary Shields, and they had ten children: David, Anne, Jane, Eliza, Mary, William C., Thomas, Henry and Melville. A son, James, died when eleven years old. Thomas married Mary Cruse, and they had six children: James, Thomas, Emma, William T., Franklin and Mary. Hannah Wilson married Peter Levering, and they had fourteen children: Mary, William W., Leonidas (died as infant), Thomas, Lydia, Rebecca, Leonidas, Frederick, Oliver, James, Louisa, Eugene, Hanna and Maryland. William Jr. married twice, first to Ann Carson, with whom he had two daughters, Ann and Jane, then to Mary Knox, with whom he had nine children: Isabella, William K., Fayette, Samuel, James T., Mary E., Martha, Hannah and Lewis.

The James Wilson family, longtime owners of the land where Oakenshawe stands, began accumulating property in the area when it was forested and largely unoccupied in 1802. Over the next several years, they acquired more than 350 acres, eventually comprising four contiguous estates: Huntington (also known as Huntingdon), Roseland,

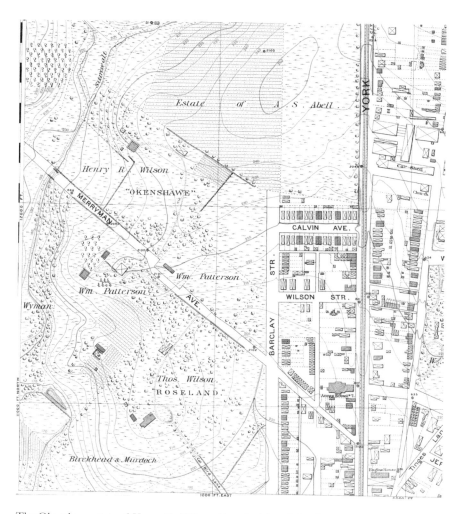

The Okenshaw estate of Henry R. Wilson. *From the* Atlas of the City of Baltimore, Maryland, *Sheet 3.N1E, 1894.*

the Cottage (later known as Oakenshawe) and Oak Lawn. Their land stretched from Twenty-Seventh Street on the south to Thirty-Ninth Street on the north and from the Merryman and Wyman estates on the west (roughly where St. Paul Street is now) to a point east of Old York Road. The original estate spanned the Baltimore & York Turnpike Road, as it was then known, and the family encouraged development in the area from an early time. Much of the original estate was held by the family for over one hundred years, representing four generations, and was used as their summer residences. The estate comprised the easternmost section

of the original 1688 Merryman's Lott land grant and all of the original 1688 Huntington land grant.

Exactly when the Okenshaw estate was named and built is unknown, but it is clear in historic records that the Henry R. Wilson family used the estate as a summer residence before they made it their permanent home in 1860. The house may have been the first summer residence of James Wilson, existing on the property when he acquired land north of Merryman's Lane (now East University Parkway) in 1802. His grandson, William Bowly Wilson, notes that "James Wilson bought 'The Cottage' in 1802 and Huntingdon in 1823 paying nearly $1000 per acre for the latter." The properties were "on Merryman's Lane—'The Cottage' is on the North Side and Huntingdon proper on the South Side."[6] According to William Bowly Wilson's notes, it is likely that the house originally known as the Cottage was probably built in the late 1700s and was renamed Okenshaw sometime after 1823. Okenshaw is clearly visible on the Sidney Map of 1850. In their book on Charles Village, Alexander and Williams suggest that Roseland and Oakenshawe were born out of the division of Huntingdon after the death of James Wilson in 1851, but the notes of William Bowly Wilson record the Roseland estate separate from that of Huntingdon, with Huntingdon purchased in 1823 and Roseland in 1840 by James Wilson.

James Wilson joined his father's firm in 1802 and began acquiring property in the country north of the city the same year.[7] His city residence at 20 North Holliday Street was a three-story brick house that stood at the corner of Holliday Street and Orange Alley extending to North Street (now Guilford Avenue), where a handsome two-story brick stable was located. The buildings were razed in 1867 to make way for city hall; the house stood where the north end of city hall now stands. The residence was sold to the city by James's sons Thomas J. and Henry R. Wilson at the same price for which the family had offered it several years earlier, $40,600.[8]

By 1819, James Wilson had acquired over 130 acres along the York Turnpike Road three miles north of the city line (Boundary Avenue, now known as North Avenue). He and his brother Thomas continued to acquire property in the area until their holdings reached over 350 acres roughly situated within the modern landmarks of Twenty-Seventh Street, St. Paul Street, Thirty-Ninth Street and Old York Road. The estate took in all or part of the following old land grants: Huntington Resurveyed, Merryman's Lott, David's Fancy, Hard Lot Resurveyed, Grant's Addition, Gorsuch's Folly, Wild Cherry Bottom, Morgan's Delight and the western portion of Sheredine's Discovery, as well as smaller adjoining properties.

Handwritten ancestry
note by Thomas Wilson.
George Radcliffe collection.

Modern-day Oakenshawe sits in the northwest portion of the old Wilson estates.

The summer house that James Wilson built in 1823, later known as Roseland, was constructed on the Huntington estate south of Merryman's Lane. The original Huntington house, built in the late 1700s, was occupied by James's brother Thomas and became a part of his adjacent estate, Oak Lawn. Huntington house stood where Guilford Avenue now stands, near Twenty-Ninth Street. It was reached from Catbird Lane off Vineyard Lane; remnants of both lanes still exist in the Abell neighborhood. Thomas Wilson maintained a city residence at 18 Lexington Street, between Charles and St. Paul Streets. In a handwritten note Thomas Wilson stated that his son, "William Thomas Wilson was born 6 August 1820 at 3 o'clock P.M. at Oak Lawn."[9] On an 1857 map, the estates Oak Lawn, Huntington and Roseland are shown contiguously.

The Roseland property included the westernmost portion of the old Huntington estate and Camperdown. The latter was an estate of 5 acres more or less east of Charles Street Avenue and south of Merryman's Lane that James's father, William Wilson, acquired from Francis Brunelot in 1813 for $2,050[10] and used as a summer estate. Camperdown, left to William's daughter Hannah Wilson Levering upon his death in 1824, was sold to Frederick Harrison, Hannah's son-in-law, for $2,000 in 1834.[11] In 1837,

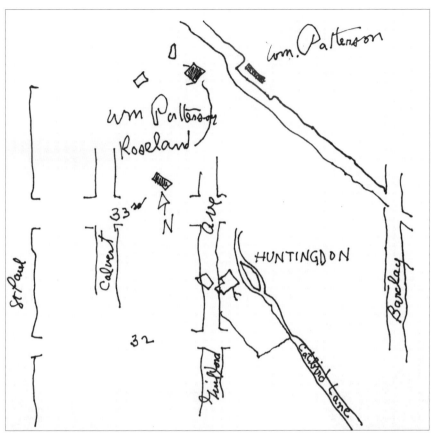

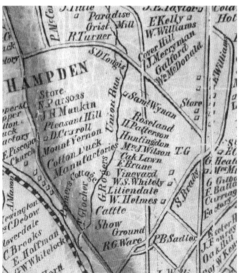

Above: Hand-drawn map by Alice Patterson Harris, ca. 1900, of the Roseland estate, her childhood summer home. *Maryland Historical Society*.

Left: Map showing the contiguous estates Roseland, Huntingdon and Oak Lawn. *Robert Taylor Map of the City and County of Baltimore, 1857*.

after the death of his first wife, Harrison married Anne, the daughter of James and Mary Wilson. In 1840, Harrison exchanged his property adjacent to the James Wilson house for a 110-acre lot on the York Turnpike Road. In 1855, the Harrisons built a summer house named Villa Anneslie on the York Road property. The Wilson property named Roseland included the James Wilson house and the old Harrison property, about 9 acres in all. Roseland was then acquired by another daughter of James Wilson, Mary, and her husband, Henry Patterson. They shared Roseland with her parents. Henry was the brother of Elizabeth Patterson Bonaparte, the first wife of Jérôme Bonaparte, king of Westphalia and Napoleon's youngest brother.

Mary and Henry Patterson began to occupy Roseland as a summer residence before 1842, while Mary's parents, James and Mary Wilson, still occupied the summer place. Henry and Mary Wilson Patterson's first child, James Wilson Patterson, was born at Roseland in 1842.[12] According to a Patterson granddaughter, Alice Patterson Harris, both her parents, Henry and Mary Wilson Patterson, and her grandparents James and Mary Shields Wilson occupied the summer house at Roseland, consistent with the time

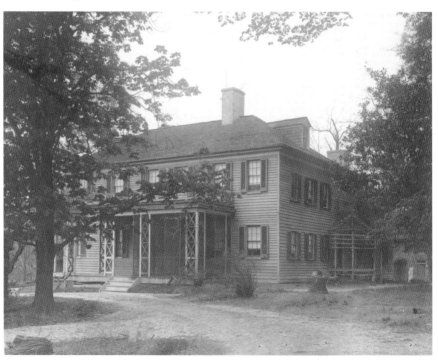

Roseland, summer home of James and Mary Wilson built in 1823, end view. *Maryland Historical Society.*

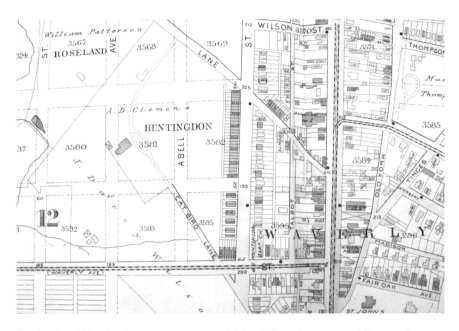

Roseland and Huntingdon, summer estates of Mary Wilson Patterson and Thomas J. Wilson. *Bromley Map of Baltimore City, 1906.*

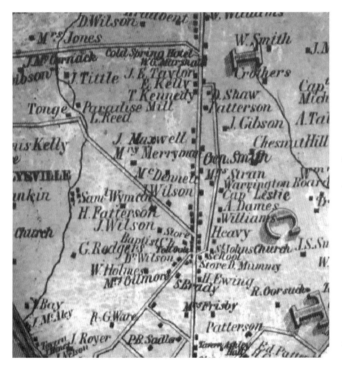

Baltimore County map showing the summer estates of James Wilson and Henry Patterson. James Wilson occupied the original site of Okenshaw on an estate called The Cottage, and his daughter, Mary, and her husband, Henry Patterson, occupied the Wilson-built Roseland estate. *Sidney Map of Baltimore County, 1850.*

and dates on record. Photographs of Henry and Mary Patterson and their daughter, Alice, taken in the mid- to late 1800s were once part of the Maryland Historical Society Collection[13] but are reported missing.

Portions of the James Wilson estate were sold for development over the century the family owned it. In 1840, according to the Waverly Village website,[14] six structures were located in the area of the Wilson estates along the York Turnpike Road: a shoe shop owned by Jacob Aull, a corn husk depot, a blacksmith shop and three small stone houses.

The Henry Wilson family became the sole occupants of Okenshaw, including the house, barns and gardens—about ten acres in size—in the 1840s. It became the family's permanent residence in 1860. Today, the Okenshaw estate of Henry R. Wilson would lie within the boundaries established by Greenway, Southway, University Place and University Parkway. The house stood approximately where Homewood Terrace is now, close to Oakenshaw Place.

The Wilson families were devout Baptists. William Wilson, the founder of the family in Baltimore, donated land and helped fund construction of the First Baptist Church at Sharpe and Lombard Streets. His son James

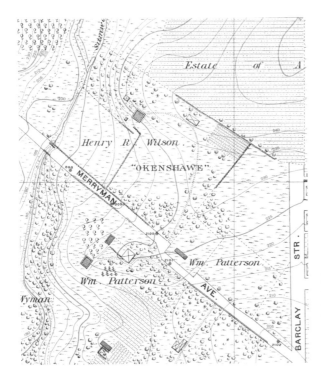

Map showing Okenshawe, the summer estate of Henry R. Wilson. *From the* Atlas of the City of Baltimore Maryland, *Sheet 3.N1E, 1894.*

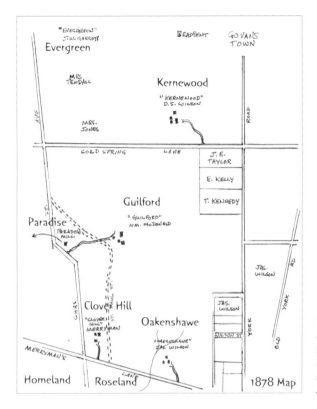

Hand-drawn map of Oakenshawe and surrounding estates around 1878. Homeland should read Homewood. *Author's collection.*

Wilson built a chapel called the Huntington Chapel at Thirty-First and Barclay Streets in 1846, donating the land and petitioning the legislature to form a corporation for its preservation after his death. Chapel services were nondenominational, according to the founder's wishes. These events testify to the family's use of land donation and development to strengthen community ties.

James Wilson acquired part of the Roseland estate from Frederick Harrison in 1840, about the same time that Harrison acquired land from James Wilson to build his Villa Anneslie estate on the York Turnpike Road. The Harrisons moved to Villa Anneslie from their summer estate of the same name in Green Spring Valley in 1855.

Prior to his death in 1851, James Wilson acquired additional properties in the area for each of his nine living children. His children were expected to purchase these properties from their father's estate and had input into the parcels they selected. A significant bequest of $40,000 was given each child upon their father's death, and a well-endowed trust estate was established for his widow. The expectation of purchasing these properties was not an

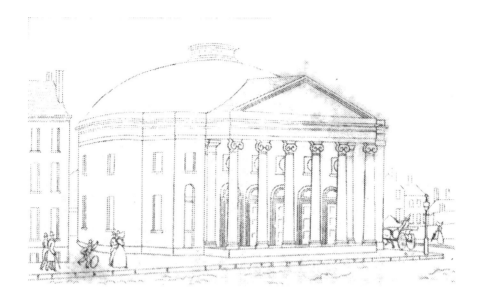

First Baptist Church at Sharpe and Lombard Streets. *Above: In* Picture of Baltimore. *Hazlehurst and Latrobe, 1832; Below: U.S. Library of Congress.*

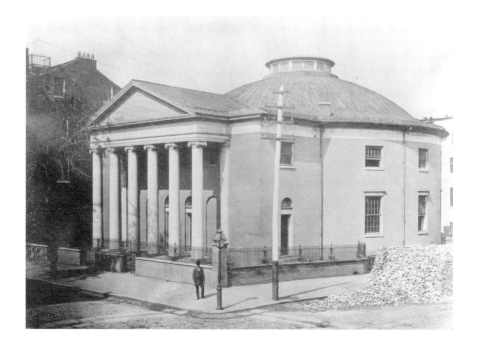

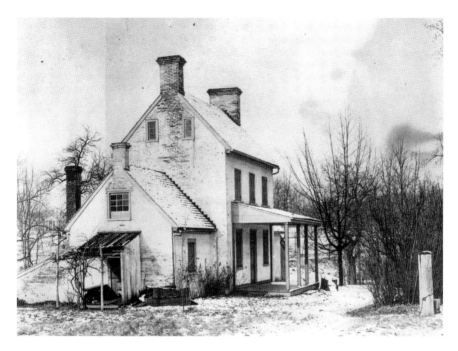

Gardener's cottage at Roseland estate. *Maryland Historical Society*.

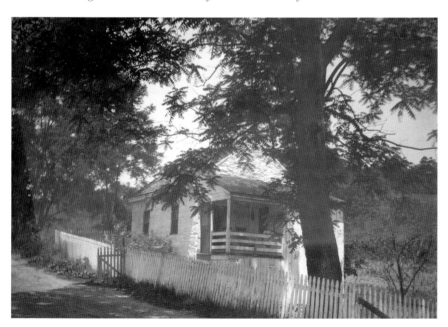

Patterson rental cottage on Merryman's Lane. *Maryland Historical Society*.

onerous one due to the inheritance, and it allowed the family to remain close in proximity during later years. At his death, James Wilson owned over 1,000 acres in the county. David, the eldest son, owned considerable property by the 1840s, eventually extending to both sides of Cold Spring Lane between Charles Street and York Road, where he built an impressive estate and gardens called Kernewood. Daughter Jane married Robert Brown, and they acquired part of the old Govane/Howard estate, Drumquastle, through her father. They built Stoneleigh on a 100-acre estate there in 1852. Daughter Anne married Frederick Harrison, and they acquired 110 acres through her father, a part of the old Drumquastle estate adjacent to Stoneleigh on the York Turnpike Road, where they built Villa Anneslie in 1855. The house still exists and is now a national historic property. Daughter Eliza remained unmarried and acquired property in trust. Daughter Mary married Henry Patterson and acquired the Roseland property, later adding the acreage between Okenshaw and Barclay Street as well as a portion of the family's old Huntingdon estate. Son William C. and his younger brother Melville acquired Gaston, a 392-acre property on Lake Avenue west of Charles Street purchased by their father in 1846, which they renamed Springvale. The property sat on all or portions of today's neighborhoods of Wyndhurst, the Orchards and Roland Park/Poplar Hill. Melville died in 1856 at the age of twenty-nine. William C., who remained unmarried, occupied the property as a summer estate and working cattle and horse farm with extensive orchards until his death in 1878. Thomas J., another son of James Wilson, acquired the old Huntingdon property, and his brother Henry R. acquired Okenshaw.

The fate of the summer properties of the Wilson family can be deduced from the neighborhoods they spawned: Oakenshawe, Stoneleigh, Anneslie, Kernewood, Wyndhurst, Poplar Hill and the Orchards are all situated on land once occupied by summer homes and estates of the children of James Wilson. Several of these neighborhoods acquired the names of their predecessors. Likewise, Roseland, Huntingdon and Oak Lawn were merged into an early neighborhood development started in 1869 and known as Peabody Heights, now the neighborhoods of Charles Village, Abell and Harwood. Land along the York Turnpike Road, once part of the Wilson estates, was developed early in the nineteenth century, helping to establish a community. Truly, the Wilson family made their mark on the area and acted as its wise custodians for nearly a century.

Prior to 1860, the Henry R. Wilson family maintained a city house at 86 or 78 Monument Street, depending on the old or new number system, in

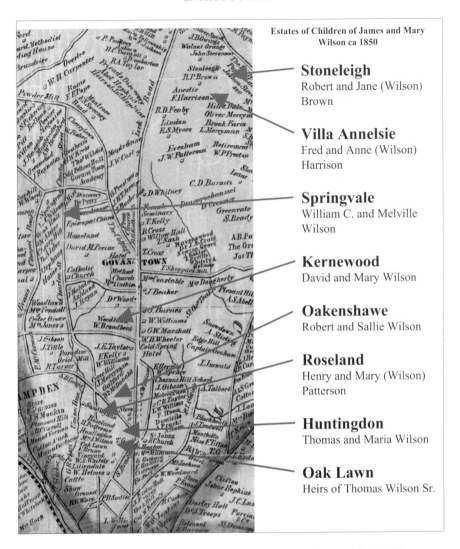

Estates of Children of James and Mary Wilson ca 1850

Stoneleigh
Robert and Jane (Wilson) Brown

Villa Annelsie
Fred and Anne (Wilson) Harrison

Springvale
William C. and Melville Wilson

Kernewood
David and Mary Wilson

Oakenshawe
Robert and Sallie Wilson

Roseland
Henry and Mary (Wilson) Patterson

Huntingdon
Thomas and Maria Wilson

Oak Lawn
Heirs of Thomas Wilson Sr.

Estates of the children of James and Mary Wilson. Note that Robert and Sallie Wilson should read Henry R. and Sallie Wilson. *Author's notes on the Robert Taylor Map of Baltimore City and County, 1857.*

addition to their summer residence at Okenshaw. Henry probably acquired the Monument Street house prior to his 1847 marriage.

A photograph of Huntingdon labeled "The Cottage aka Roseland" in the Maryland Historical Society collection is also labeled "James Wilson House." Alice Patterson Harris called it the "home of grandfather and grandmother Wilson."[15] Since the Cottage was north of Merryman's Lane and Roseland

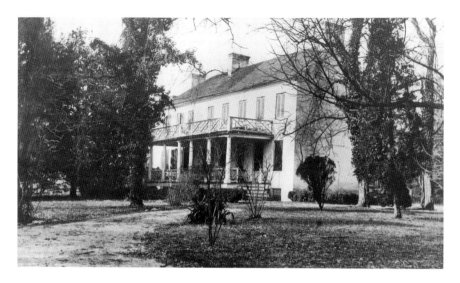

Huntington House at Oak Lawn, summer home of Thomas Wilson. *Maryland Historical Society.*

south of Merryman's Lane, it is not likely that they shared the same name, as the MdHS photograph label implies.

After the death of James Wilson in 1851, his city house, country seat and numerous other properties were placed in trust for his wife, and upon her death in 1869, they fell to his children.[16] The name of the Huntington estate was later changed to Huntingdon, and the property became a small village of the same name in the 1840s. It was renamed Waverly Village in 1863.[17]

By 1866, occupancy of the area expanded with the addition of a firehouse, town hall and post office. Jacob Aull's sons acquired land in the area that they sold as building lots, including land acquired from the Wilson estates. When horse-drawn, double-decker buses on iron tracks came to the area in the 1870s, additional expansion occurred. An 1877 map of Waverly clearly shows the development of Wilson estate land sold and divided into building lots not only along the York Turnpike Road but along Barclay Street, indicating the Wilson family's participation in development of the area. According to a Drexel post,[18] only forty-two homes existed in Waverly in 1884, and most were frame construction.

Expansion continued through the 1890s, when electric streetcars replaced the horse-drawn buses. Between 1880 and 1890, the population of the area quadrupled, and new streets were laid out. In Waverly, 265 houses were built between 1885 and 1904. The Peabody Heights development was

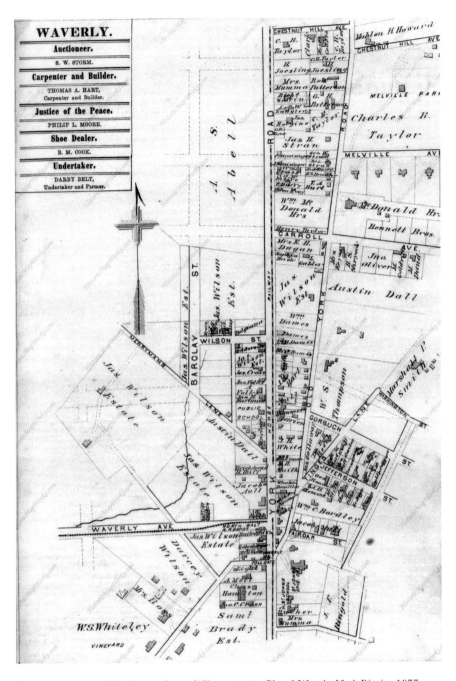

Developing areas of the former James Wilson estates. *Plat of Waverly, Ninth District, 1877.*

incorporated in 1869 and fostered building west of York Road and south of Waverly Avenue, now Thirtieth Street. A significant housing boom between 1905 and 1924 added 1,052 houses to Waverly; most were brick, reflecting the increasing affluence of the area.[19]

James Wilson's Roseland house stood where Guilford Avenue now stands, between Thirty-Third Street and East University Parkway, although those streets did not exist at the time. The house faced south, according to the personal account of William Marye, who saw the house still standing about the time that Thirty-Third Street was laid out—construction of the street began around 1911, it was paved in 1914, and the median was planted with trees in 1916.[20] Marye recorded:

> *To the best of my recollection, the Wilson mansion stood at the intersection of Thirty-third Street and Guilford Avenue, facing south. I recall that when Thirty-third Street was laid out from Charles Street towards the York Road, the Wilson house was left standing on a high artificial bank on the north side of the new thoroughfare. Roseland stood on top of a low hill which fell precipitously into the hollow of Sumwalt Run. As I remember the house, it was…a short distance below University Parkway on the east side of Calvert Street.*

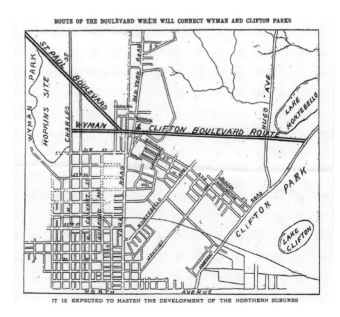

Proposed route of Wyman and Clifton Boulevard (Thirty-Third Street).
From the Baltimore Sun, *1906.*

Marye stated that the area the house once occupied looks nothing like it used to due to the grading and filling in of earth for construction in the area, completely removing the hill it once stood on.[21]

An article appeared in the *Baltimore Sun* on November 1, 1906, titled "Route of the Boulevard Which Will Connect Wyman and Clifton Parks" that states the following (St. Paul Boulevard in the *Sun* article was then known as Merryman's Lane and is now known as East University Parkway):

> *It is expected to hasten the development of the northern suburbs.*
>
> *The above map shows the route of the boulevard which will connect Wyman and Clifton Parks. An ordinance for opening this thoroughfare is before the City Council Committee on Highways.*
>
> *The boulevard will be the first to be constructed in accordance with the Olmstead plan for parking Baltimore.*
>
> *According to the map of the Topographical Survey, the route is what would be Thirty-third street if it were opened. The boulevard, which will be 120 feet wide, will start from the site of the Johns Hopkins University at Charles street. The St. Paul boulevard will join it west of the York road. It will pass south of Lake Montebello and will connect with the beautiful driveway around that reservoir.*

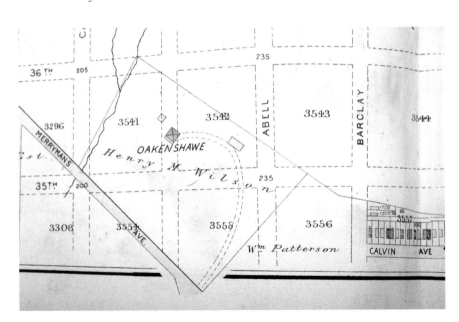

Oakenshawe, summer estate of Henry R. Wilson. *Bromley Map of Baltimore City, 1896.*

Although this section of the Annex is not fully developed, the city will be compelled to purchase or condemn a number of dwellings which are standing on the proposed thoroughfare.

Immediately upon the passage of the ordinance by the Council, the Commissioners for Opening Streets, under whose supervision the right of way will be secured, will begin their work. It is hoped that work on the improvement will be begun in the spring. The cost will be taken from the $1,000,000 park loan.

A stream, originally known as Edward's Run (later called Sumwalt's Run), flowed in a southwestward arc from Thirty-Ninth Street and Old York Road to Calvert Street just west of the old house on the Okenshaw estate. The stream then flowed south to join a tributary flowing from Brentwood Avenue between Thirty-First and Thirty-Second Streets, turning west to feed Wyman's Dell and eventually the Jones Falls. The stream was covered over in the 1920s and now runs under Calvert Street and the Marylander Apartment building, serving the Baltimore City sewer system.[22]

LAND GRANTS, SPECULATION AND SETTLEMENT

T he land on which Oakenshawe now stands was part of two 1688 land grants. The 135-acre Huntington grant was made on June 29, 1688, to Tobias Starnborough (also spelled "Stansbury"), and the 210-acre Merryman's Lott grant was made on June 24, 1688, to Charles Merryman and Nicholas Haile.[23] It is said that the Huntington grant once belonged to Lady Huntington in its entirety, hence the name.[24]

Stansbury sold the Huntington grant to Richard Thompson in 1695.[25] After Thompson died in 1697, a portion of the land was sold by Hugh Thompson, possibly a relative, and was eventually acquired by Harry Dorsey Gough (1745–1808) of the wealthy Carroll-Ridgely-Carnan-Onion family.[26] Gough was a wealthy land investor, mostly in city properties, who maintained a large country estate called Perry Hall.[27] His middle name, Dorsey, from his mother's family, was colloquially pronounced "Dossy."

In 1757, Huntington was resurveyed for John and Achsah Ridgely Carnan and consisted of 475 acres,[28] including 89 acres known as Wilkinson's Lott, gifted to Achsah Ridgely in 1735 by her father, Colonel Charles Ridgely of Hampton. John and Achsah Carnan were the parents of Prudence Carnan and Governor Charles Ridgely Carnan, also known as Charles Carnan Ridgely. A lien on the Huntington property was held by Christopher Carnan and Cecil Carnan Gist, John's brother and sister, at the time of his death in 1762.

A complicated interfamily ownership of the Huntington land grant during most of the eighteenth century involved Christopher Carnan; Cecil Carnan

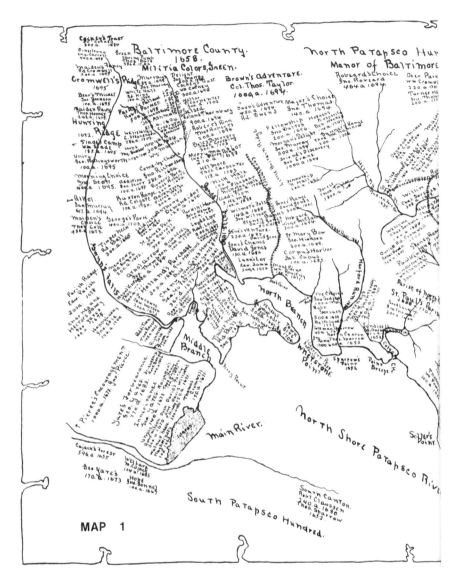

Old land grant map showing the location of Merryman's Lott. *Map of Baltimore County, 1700.*

Gist; their brother and sister-in-law John and Achsah Ridgely Carnan; and the daughter of John and Achsah, Prudence Carnan, wife of Harry Dorsey Gough. In 1789 Achsah Carnan died and the Huntington grant passed to her daughters and their husbands, Prudence and Harry Gough

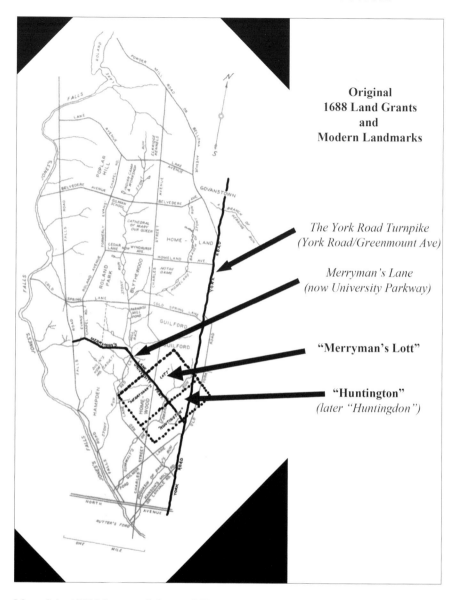

Map of the 1688 Merryman's Lott and Huntington land grants on a modern grid of the Stony Run valley. *After Marye, 1959, amended by the author.*

and Elizabeth and Thomas Bond Onion. Thomas Bond Onion sold his portion of the Huntington property to Harry Dorsey Gough in 1790,[29] and Gough acquired additional acreage from Lavalin Barry in 1792.[30] Harry and Prudence Gough had a daughter, Sophia, who helped manage the property

Thomas Bond Onion and his wife, Elizabeth Carnan. *Enoch Pratt Free Library.*

with her husband, James MacCubbin (also known as James MacCubbin Carroll). The Gough and Carroll families held the property speculatively and began selling lots after the 1790 purchase.

William Marye mentions an advertisement placed by Gough in the *Federal Gazette* on May 3, 1799, to sell lots in Huntington adjacent to Liliendale (the estate of Hugh Thompson) and Oxford (the estate of James Edwards).[31] The home of Hugh Thompson sat on Holmes Avenue, now Twenty-Eighth Street, within the boundaries of St. Paul Street, Barnum Street and Gilmor's Lane. Barnum Street is now known as Twenty-Seventh Street, and Gilmor's Lane was later known as Vineyard Lane. After the death of Harry Gough in 1808, his daughter and son-in-law continued to sell lots from Huntington. James Wilson acquired part of the acreage from Job Merryman in 1802, the same year Merryman purchased lots from the Gough family.[32]

Harry Dorsey Gough (1745–1808) was born in Annapolis. His father, Thomas Gough, was a wealthy English merchant who immigrated to the Maryland Colony in 1733. Thomas Gough's first wife, Ann Brooksby, died before he immigrated, and they had a son, John William Gough, who stayed in England. Thomas married into the affluent Dorsey family in 1743, taking the hand of Sophia Dorsey of Hockley. Harry was the only child of Thomas and Sophia. By 1746, Thomas was in debt to several creditors and was forced to sell the family's household items, livestock and crops to pay his accounts,

but he held no land in his own name. Sophia inherited the Dorsey family plantation Hockley in the Hole upon the death of her brother Edward.[33] The planation and a family fortune were passed to Harry upon the death of his mother in 1762, his father having died two years earlier. Harry also inherited £70,000 from his half-brother in England upon his death in 1767. John Gough had a son, also named Harry Dorsey Gough (1766–1807), who came to America after his father's death, and a grandson of the same name, Harry Dorsey Gough (1793–1870).

The eldest Harry Dorsey Gough married Prudence Carnan in 1771, and they had a daughter named Sophia. Harry was a merchant planter and established a plantation in north Baltimore County on the Great Gunpowder River called Perry Hall. At one point, it comprised over 4,300 acres, including The Adventure, the old estate of Corbin Lee, which Gough purchased in 1774. He finished the manor house that Lee started and expanded it to include sixteen rooms. Gough was an Anglican who converted to Methodism in 1775, became president of the Maryland Society for Promoting Agriculture in 1786, served in the Maryland House of Delegates (1787–1792) and was most occupied by land development, particularly in Baltimore Town. He primarily focused on the development of Charles, St. Paul, Light and Baltimore Streets, where he owned several lots. He also managed over forty lots in Baltimore Town through his wife for his father-in-law, John Carnan. Between 1768 and 1807, he brokered over 150 land transactions. His funeral was attended by more than two thousand mourners and was officiated by Bishop Francis Asbury. His estate was eventually passed to his grandson Harry Dorsey Gough Carroll (1793–1866) upon the death of his wife, daughter and son-in-law.[34]

Merryman's Lott was granted to Charles Merryman and Nicholas Haile, both from Lancaster County, Virginia. Merryman and his wife, Mary Haile, who was the sister of Nicholas, took the northern 120 acres, and Haile took the southern 120 acres. The Merryman property became the family farm of Charles's son, John Merryman, and was called Clover Hill.[35] This portion of the land grant, with some additions and subtractions, stayed in family hands until housing development reached the region in the late nineteenth century. Clover Hill was bordered on the east by Wilson's Okenshaw estate.

Haile named his portion of the grant Liliendale and made his home there, expanding the estate to the west over the years. Liliendale was sold to Nicholas's son, Neale Haile, and Joesph Ensor in 1771, and 130 acres were acquired from the estate by Charles Carroll of Carrollton as a gift to his son, Charles Jr., on the occasion of his marriage in 1800. Merryman's Lane—now East University Parkway, extending from the York Turnpike

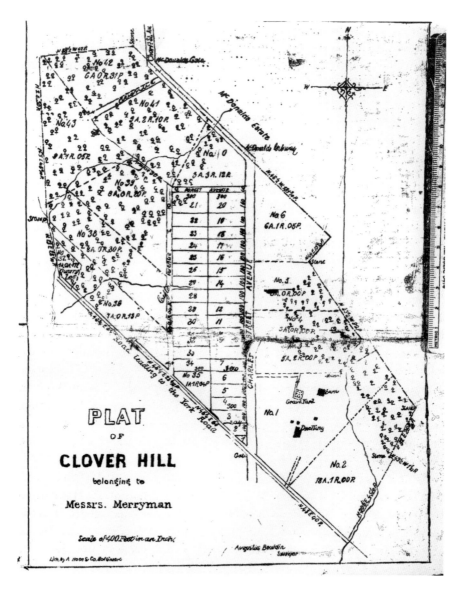

Plat of John Merryman's farm estate Clover Hill, 1867. *Baltimore County Land Records JHL 47 352.*

Road to the Falls Turnpike Road—was built around 1800 so the Carrolls could access the property. The younger Carroll renamed the property Homewood after spending $40,000 to construct a home there of his own design, much to the frustration of his father.[36] Charles Jr.'s marriage

produced five children, including one son, Charles Carroll III, but did not last, resulting in the couple's separation in 1816. Charles Jr., an alcoholic, died in 1825, leaving Homewood to his twenty-four-year-old son. Upon the death of his grandfather in 1832, Charles Carroll III moved to his ancestral home, the 70,000-acre estate at Doughoregan (also known as Daughregan Manor), and auctioned the Homewood property.

Homewood was acquired in 1839 by Samuel Wyman of Boston, who came to Baltimore as a young man. He established the wholesale dry goods house of Cobb, Wyman & Co., later known as Wyman, Tiffany & Co., and retired from business in 1838. Two Wyman sons, William and Samuel, inherited the Homewood property upon the death of their father in 1865.[37] William lived on the property all his life, spending summers at his house in New Hampshire. He built Homewood Villa on the Homewood estate in 1853, the same year he married Amanda Sanderson of Massachusetts. They had a daughter, Helen. William's brother Samuel, a childless widower, engaged in business in Baltimore for a short time but spent most of his life in New York, where he retired. Along with Francis Jenks, their cousin William Keyser helped William in his effort to preserve the Homewood estate by donating it to the Johns Hopkins University, then located in cramped quarters at Howard Street between Monument and Centre Streets in the Mount Vernon–Belvidere area of downtown Baltimore. William Wyman wished to preserve the estate as a city park or college campus, but Samuel emphatically refused, changing his will to disinherit William and instead directing his estate, including half of the Homewood property, to a sister, Elizabeth (Mrs. Herman Aldrich), of New York City.[38]

Samuel Wyman died in 1889, and his brother William, working in concert with Keyser and Jenks, secretly acquired land adjacent to Homewood between 1898 and 1901. They accumulated 179 acres and offered it to the university, which accepted in 1902, setting aside 30 acres for a city park. William donated his 60 acres of the Homewood estate to the university along with gifts worth $250,000 prior to his death, contingent on retaining use of the estate by him and his daughter for life. The university, through lengthy negotiations, acquired Samuel Wyman's half of Homewood from the trustees of his estate, making the campus 200 acres. The university accepted the donations in a timely fashion—William Wyman died in 1903, and in 1904, both William Keyser and Elizabeth Wyman Aldrich died and the great Baltimore fire destroyed much of downtown Baltimore.

James Wilson acquired a 3.75-acre plot, now part of Oakenshawe, from the original Merryman's Lott land grant in 1802.[39]

A Century of Stability

The Wilson Family Summer Estates and Neighboring Summer Estates

The land on which Oakenshawe now stands was acquired by James Wilson between 1802 and 1814 in several land purchases. He and his brother, Thomas, eventually created several large estates encompassing about 350 contiguous acres about three miles north of the city along the York Turnpike Road. James married Mary Shields in 1800, and Thomas married Mary Cruse in 1815.

James and Thomas Wilson became partners in their father's mercantile and shipping house in Baltimore, William Wilson & Sons, in 1802. James lived at 20 Holliday Street in Baltimore Town. The firm had offices at 105 West Baltimore Street, between Calvert Street and North Street (now known as Guilford Avenue). James Wilson had a busy year in 1802—in addition to joining his father's firm, he either purchased or built the Holliday Street home, celebrated the birth of his first son and began serving his first term as a member of the Baltimore City Council. He would serve on the council again from 1809 to 1820. Also in 1802, he began to acquire property in the country. Between 1802 and 1814, he acquired five properties totaling 26.5 contiguous acres from the Huntington Resurveyed and Merryman's Lott land grants about three miles north of the town line. These properties represent the nucleus of the future Wilson estates, which would sit on both

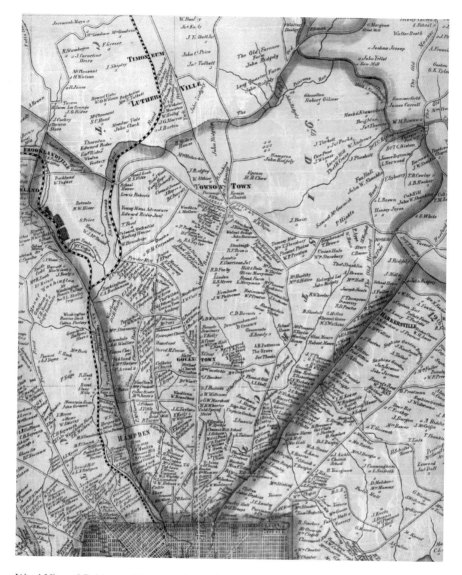

Ward Nine of Baltimore County included the Wilson summer estates Roseland, Huntington and Oak Lawn. *Robert Taylor Map of Baltimore City and County, 1857.*

sides of Merryman's Lane reaching from Twenty-Seventh Street to Thirty-Ninth Street between St. Paul Street and Old York Road.

Portions of the James Wilson estate were derived from land sold to Job Merryman by Prudence Gough and James Carroll.[40] In addition to Job Merryman, Wilson acquired properties from James Edwards and Abraham

41

Van Bibber, Ebenezer Smith Thomas, John Whiteley and Philamon Merryman, executor of the Nicholas Merryman estate.

James Edwards and Abraham Van Bibber acquired the land they sold to James Wilson in 1802 from John Hacket and his wife, Jane, through Samuel Moale and Daniel Grant. Hacket had been in business with Grant's late father, Alexander Grant, at Hacket & Grant, Merchants of Baltimore. The firm seems to have borrowed money from the younger Grant and his partner Moale through a deed of trust dated May 28, 1800.[41] The sale was executed upon John Hacket's death according to provisions in the deed. Referring to Jane Hacket's "Right of Dower," the land was used to pay the company debt to Moale and Grant. On February 24, 1801, the same day they acquired the land,[42] Moale and Grant sold the tract to Edwards and Van Bibber for $2,500.[43] These parcels included tracts of Huntington numbered ninety-five through ninety-eight, amounting to 15 acres more or less, with a section of the parcel on Merryman's Lott that contained the residence of John and Jane Hacket on one half-acre. This purchase included the furnished house, farming utensils and three slaves. The house, later acquired by Wilson, may be the original house on the Cottage estate, what later became the Okenshaw estate of Henry R. Wilson. Another 10.25-acre portion of the property was sold by Edwards and Van Bibber to James Wilson on September 3, 1802, for $3,000.[44] It should be noted that the Wilson family was ardently opposed to slavery, and the patriarch of the family, William Wilson, helped to form the Anti-Slavery Society of Baltimore.[45]

Abraham Van Bibber was a Baltimore merchant and shipping agent with his brother, Isaac, in the firm Isaac and Abraham Van Bibber & Co., as well as a land speculator and ship owner. Abraham spent the Revolution as the Maryland and Virginia purchasing agent in St. Eustatius, Dutch West Indies. He and the Virginia agent at Martinique, Richard Harrison, warehoused American products shipped to the islands during the war, later trading them to the Dutch. The Dutch were neutral during the war and could trade without restriction, much to the chagrin of the British. This allowed American goods—mostly flour, grain and tobacco—widespread distribution in the islands at a time when trade restrictions were in effect and gave Americans access to arms and gunpowder through their Dutch trades.[46] According to one source,

The Van Bibbers were a fine old Maryland family of Hollandish descent, who settled in Maryland before the Revolution. They were ardent patriots and adherents of the Continental Congress. Mr. Abram [sic] Van Bibber

fitted out the privateer the Baltimore Hero, *which about the time of the first salute ever fired in honor of the American flag at St. Eustatius in the West Indies by the Dutch, on November 16, 1776, captured a British brigantine, and was made the subject of much correspondence between the Governments of London and the Hague.*[47]

Abraham Van Bibber's country estate, Paradise, adjoined the northwest corner of the Wilson estates and sat north of Merryman's Clover Hill farm. A seasonal mill on the property was called Van Bibber's Mill or Paradise Mill and was powered by Stony Run when it swelled with water.[48] He married Mary Young, and when widowed, she married Luther Martin Cresap in 1812. Abraham Van Bibber is buried at Westminster Burial Grounds in Baltimore.

James Edwards was one of the original subscribers, along with Abraham Van Bibber and ten others, of the Bank of Maryland in 1790.[49] He inherited Oxford, the family estate along the York Turnpike Road near North Street about two miles north of the city line, and also owned Mount Pleasant at Elm and Chestnut Avenues between Second and Third Avenues.[50] (Third Avenue is now Thirty-Sixth Street; Second Avenue no longer exists but was near Third Avenue. Mount Pleasant is said to have been only three and a half or four acres in size.) He married twice. His first wife, Ruth Stansbury, was the daughter of William and Elizabeth Ensor Stansbury; they had no issue. His second wife was Ruth's sister, Elizabeth (1760–1846), the widow of James Brown. James and Elizabeth Brown had a daughter named Elizabeth, who became Richard Frisby's second wife at Oxford in 1811. Richard Frisby lived at the Frisby estate, across the road from Oxford. The Frisbys were a wealthy family; Richard was the son of James Frisby, who was born at Violet Farm in Kent County, Maryland, and relocated to Baltimore County. James Frisby died at Oxford owning nearly two thousand acres, mostly in Kent County. The Frisby-Edwards estates bordered the Wilson estates.

Richard and Elizabeth Brown Frisby's son James Edwards Frisby (1813–1838) was born at Oxford, home of his grandmother Elizabeth Edwards. James Edwards Frisby graduated from Yale in 1832.[51] He married Eleanor Merryman in 1834, and she also died in 1838. They had one daughter, named Elizabeth.

Elizabeth Brown Frisby inherited large estates from her mother, stepfather James Edwards and her husband. She passed these estates to her surviving son, John J. Frisby, upon her death in 1864.

Oxford was adjacent to Cold Stream, the fifty-six-acre country estate Edward Patterson Jr. inherited from his father. Cold Stream sat between the York Turnpike Road and the Harford Turnpike Road adjacent to the Vineyard estate of William Gilmor. Cold Stream stretched west of the York Turnpike Road. The Oxford estate gave way to a small town of the same name in the latter half of the nineteenth century, contemporary with its neighbor Huntingdon (later renamed Waverly Village). The town of Oxford was located "on either side of the York Turnpike Road one or two miles north of the city and contiguous with the estate of Edward Patterson, Jr."[52] The village of Friendship was just to the north of Oxford and adjoined Peabody Heights on the west but was older than Peabody Heights. Friendship was "partly located on the former Frisby estate" and was described as "a pretty, flourishing place." It was a region of "steadily increasing elevation from the harbor with dozens of brooks fed by the abundant springs and flowed down from the elevations topped with tasteful and imposing suburban mansions."[53]

A few weeks after James Wilson purchased land from Van Bibber and Edwards, he purchased the adjacent 3.75-acre parcel from Job Merryman for £227 5s on November 3, 1802.[54] Job Merryman had purchased a portion of this tract from Prudence Gough and James Carroll; he inherited another part from other members of the Merryman family who had held it from the time the original land grant was made to Charles Merryman in 1688.

On December 16, 1809, James Wilson purchased seven acres from Ebenezer Smith Thomas for $1,585[55] "laying on the road to Van Bibber's Mill" (i.e., on Merryman's Lane). Van Bibber's Mill was also known as Paradise Mill, named after the estate of Abraham Van Bibber, Paradise, on Stony Run at Cold Spring Lane.[56]

Ebenezer Smith Thomas was the nephew of Isaiah Thomas, the New England printer who founded the American Antiquarian Society in 1812, and the father of Frederick William Thomas, the novelist who became Edgar Allan Poe's close friend and frequent correspondent.[57] Ebenezer Smith Thomas was born in Cambridge, Massachusetts, in 1795; for two decades, he pursued a career as a bookseller in Charleston, South Carolina, and edited the *City Gazette* there. In 1805, Thomas was in the process of moving into a house he had purchased in Providence, Rhode Island, to pursue his investment in a new cotton mill when he met Ann Von Erden Fonerden of Baltimore, whom he married. In 1809, after a short residence in Rhode Island, the family settled in Baltimore County, where Thomas had already purchased a farm. He became a farmer and land speculator for a year. In 1810, while retaining the Baltimore County farm, the family returned to

Charleston, where Thomas published the *City Gazette* and "drew up plans for the Planters and Mechanics Bank with capitol of 1,000,000 of dollars." The family returned to Baltimore in 1816,[58] and Thomas served as a candidate for the state legislature in 1817, 1818 and 1820. In 1822, he enlarged his farm to 150 acres[59] and was granted a patent on the estate.[60] Ebenezer Smith Thomas and his wife had eight children. His investments began to decline in 1817, but he continued a heavy travel schedule in Europe and the States.

The Fonerden summer residence sat between Van Bibber's Mill, Merryman's Clover Hill farm and the James Wilson estate, the Cottage. It became the nucleus of the Ebenezer Smith Thomas estate, Thomasville. According to Dwight R. Thomas:

To at least four of his children Thomas imparted his own penchant for literature; two sons and two daughters were listed by Oscar Fay Adams in his Dictionary of American Authors, *5th ed. (Boston: Houghton, Mifflin, 1905). Frances Ann Thomas was especially close to her brother Frederick, whom she encouraged to write his first novel* Clinton Bradshaw *(1835). Thomas described the death of Frances Ann and her two children in a shipwreck on their way home from India as "the most awful affliction of my life." Sketches of Lewis Foulk Thomas (1808–1868), a poet and playwright, may be found in William T. Coggeshall's* Poets of the West, *p. 243, and in Coyle's* Ohio Authors. *Mary Von Erden Thomas (1814–1897) published a novel* Winning the Battle *(1882). Martha McCannon Thomas (1818–1890) was a frequent contributor to magazines and the editor of several Cincinnati periodicals; she published a novel* Life's Lesson *(1854). Brief notices of Mary and Martha Thomas may be found in Adams'* Dictionary of American Authors *and in Coyle's* Ohio Authors. *In his September 3, 1841, letter to Poe, Frederick William Thomas also mentioned his sisters Susan and Isabella (Belle), and his brother Calvin. Coggeshall, p. 186, identified Calvin W. Thomas as "a well-known banker."[61]*

Thomas transformed his Baltimore County estate into a beautiful agricultural showplace, investing in excess of $20,000 in land and improvements. He is often compared to Thomas Jefferson with respect to his travels in Europe, where he learned new farming techniques and collected seeds and plant specimens that were eventually introduced to his Baltimore County property. He acquired considerable debt, estimated

at over $100,000 but probably much less, and on his return from London in 1820 found his estate, then valued at "seventy or eighty thousand dollars,"[62] in the hands of the local sheriff for a $6,000 debt. He was able to avoid confiscation of his estate but found his speculative investments crippling, and in 1827, he sold what he referred to as the "remainder of my property," probably referring only to his farmland, then valued at $27,000, for $10,000 to satisfy a $7,500 debt and left his house and personal property to be disposed of by the court. The following year he moved his family to Cincinnati, where he pursued new publishing opportunities. Thomas's Baltimore County land was purchased by "General" William McDonald, who renamed the estate Guilford.[63] An earlier sale of Thomas land to James Wilson was likely made to give liquidity to Thomas by a neighbor in a time of need. The land that Wilson purchased from Thomas in 1809 was eventually sold by Wilson to McDonald. The court sale of Thomas's property was a loss. He wrote, "The large house, out of which I had removed, which cost me upwards of eight thousand dollars, independent of the lot, was sold for fifteen hundred and fifty dollars, and everything else in proportion!"[64]

On July 3, 1811, James Wilson acquired two and a half acres south of and adjacent to his country place from John Whiteley for $600 "on the York Turnpike Road" and "the road leading from Joseph Merrymans to the city of Baltimore."[65] An additional acre was purchased in a separate transaction on the same day for one penny.[66] The tracts were entirely within the old Huntington land grant. Whiteley obtained part of the land from the estate of the late Jesse Brown and part from James Edwards and Abraham Van Bibber in 1802.

The Hard Lot Resurveyed tract, consisting of 110.25 acres, was acquired by James Wilson on July 3, 1819, from the estate of Nicholas Merryman of Benjamin through the executor of the estate, Philamon Merryman, for $2,140. The tract lay "on the west side of the York Turnpike Road and in part bounding with the same."[67] It was adjacent to land Wilson already owned in the area.

The most significant Wilson land purchase in the Oakenshawe area was made by James and his brother, Thomas, as tenants in common. The 216.5-acre purchase was made on February 4, 1826, from the president and directors of the Union Bank of Maryland for $6,923. The purchase included parcels consisting of the land grants Sheredine's Discovery, Gorsuch's Folly, Grant's Addition, Prospect, Merryman's Lott and Huntington on both sides of the York Turnpike Road. Portions of this property would become the

town of Huntingdon around 1840. In 1863, a post office was applied for by the residents and prompted Huntingdon to be renamed Waverly Village; the post office was granted and built in 1866.[68]

The Wilson estates of the Cottage (later known as Okenshaw), Oak Lawn, Huntingdon and Roseland reached the size of about 350 acres by the late 1820s. They were added to and subtracted from in minor terms but remained largely intact throughout the nineteenth and early twentieth centuries, when the area became attractive to housing developers.

A firehouse and town hall were built in Waverly Village along with the post office between 1863 and 1866. By 1866, lots were laid out on land acquired by the wealthy Hoen family, followed by streets and houses. By 1877, a portion of the Wilson estate, today part of Oakenshawe but then included in Waverly Village, was sold as lots by the Wilson family. This area was bounded by Merryman's Lane, now East University Parkway; the York Turnpike Road (also known as York Road), which is now Greenmount Avenue; Barclay Street; and Wilson Avenue, later known as Henderson Street and now known as Venable Avenue. The corner lot at Merryman's Lane and York Road was sold to F. Sinclair; north of his lot was a public school. Lots to the north were owned by John H. Hartman, A. Volks, John Volks and James Cross. Two lots owned by James Wilson went unsold. On the corner of York Road and Wilson Avenue was a lot owned by J. Henderson. The block between Brentwood Avenue and Barclay Street was divided into five lots but remained unsold and was still owned by the Wilson family in 1877. The north side of Wilson Street was divided into four lots owned by, from west to east, Myers (first name unknown), J.H. Martin, Charles Clark and Reiley (first name unknown), and two lots on Brentwood Avenue were owned by Balgiana (first name unknown). The remaining land between Wilson Street and Southway on both sides of York Road continued to be part of what is referred to as the "James Wilson estate"—this may refer to the original trust estate of James Wilson, who had been dead for twenty-six years, or to his grandson James D'Arcy Wilson, son of Thomas J. Wilson. It may also refer to John D'Arcy Wilson, grandson of James's brother, Thomas Wilson. Calvin Avenue was not yet built; it would appear on maps in 1887 with houses on its south side, and houses are shown on the north side of Calvin Avenue in an 1888 map. Land north of Southway and west of York Road was owned by A.S. Abell, who acquired the property around 1872. The land east of York Road above Carroll Avenue (now Thirty-Fifth Street) extending to well east of the Old York Road, a remnant of the old Guilford estate, still belonged to the heirs of William McDonald.

By 1869, large tracts of land had been acquired for the development of a community of row houses named Peabody Heights. This and the surrounding area were developed into a diverse set of housing groups that would later become Charles Village, Abell and Harwood, roughly bordered by Thirty-Third Street, Greenmount Avenue, Twentieth and Twenty-Fifth Streets, Howard Street and the Johns Hopkins University undergraduate campus. Construction of houses in these neighborhoods, south of Oakenshawe, started before the turn of the century.[69] Construction in the Waverly area, east of Oakenshawe with Greenmount Avenue as a common border, began before 1880, but construction occurred in a less organized fashion than in Peabody Heights or the later developments of Guilford and Oakenshawe. The Guilford development, north and west of Oakenshawe, was laid out in 1911, but building did not commence in earnest until the 1920s. A 1917 map shows fewer than twelve houses completed. Guilford shares a common border with Oakenshawe at the alley behind the Guilford houses on Southway.

Development in the area was slow but quickened in the decade between 1880 and 1890. A second spurt of growth occurred in 1910 and a third after World War I. By the time Philip C. Mueller acquired land for the Oakenshawe development in 1914, there was significant development in Waverly Village to the east and Peabody Heights to the south. The Guilford development, to the north and west of Oakenshawe, began grading for road construction, water, sewer and utility installations, paving and planting by the spring of 1912. Construction of Chancery Square was begun in 1912, and construction at Bretton Place and York Courts started in 1914, all on York Road north of Oakenshawe.

Development of Oakenshawe began as the concept of Philip C. Mueller. The target area for his development, the Okenshaw estate of Henry R. Wilson along Merryman's Lane, was not subject to Baltimore City zoning regulations, since the commission did not exist until 1923. Development in the area was guided by ideals and objectives of the Roland Park Company, which acquired the Guilford property to the north of Oakenshawe in 1911. The Roland Park Company maintained a design advisory board whose members included architects and designers active in the development of Roland Park and the newly acquired Guilford District. Their street design was at odds with that of the Topographical Survey Committee, precursor of the Baltimore City Zoning Commission, which had planned a grid street design for the area, shown in numerous maps of the late nineteenth century as dotted lines covering the area that

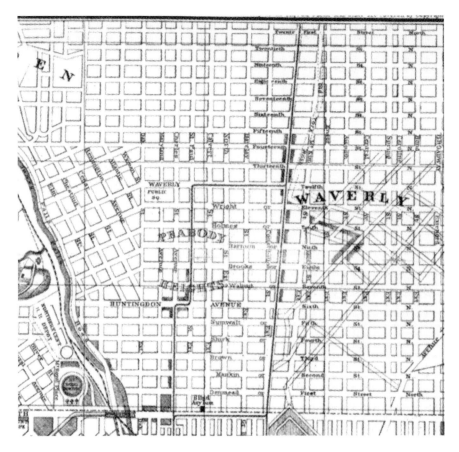

Peabody Heights development. *Plan of Peabody Heights, 1890.*

is today Oakenshawe and Guilford. The Roland Park board aggressively asserted its influence not only within Guilford but also for construction bordering the Guilford District as much as it possibly could. It is likely that the architects Philip C. Mueller hired for his new development, the Washington, D.C., firm Flournoy and Flournoy, Architects, followed the Roland Park board guidelines because the firm was later admitted to the exclusive group of architects allowed to design houses within the Guilford District.

According to Tom Hobbs, president of the Guilford Association, the Roland Park Company as "planners were less than innovative in the social dimensions of development, advocating the deliberate exclusion of economic and racial diversity." While the Guilford District "was to

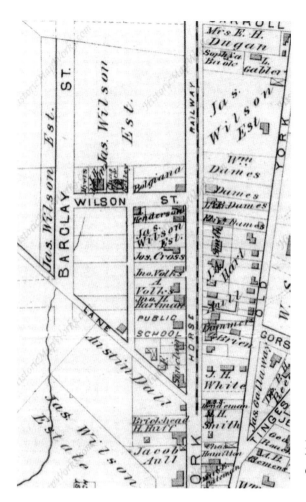

Development along the York Turnpike Road (now Greenmount Avenue). *Plat of Waverly, Ninth District, 1877.*

be developed with housing of various sizes…a community of the highest architectural style and quality [was envisioned,] and the company had the right to reject plans 'for aesthetic and other reasons' to maintain harmony with its surroundings."[70] Hobbs noted, "The city already had on paper a plan to continue the grid street pattern north through the [Guilford] estate property. Such a plan would have disregarded the topography and devastated the lush green forested areas. The Directors [of the Roland Park Company] rejected such a plan and were determined that there should be a green garden suburb reflecting the value of the countryside." Additionally, "There were other conditions unique to the Guilford site that required careful consideration [by its designers, Frederick Law] Olmsted [Jr.] and [Edward] Bouton. The Episcopal Diocese had purchased a site

at the southwest edge of Guilford [adjacent to the Henry R. Wilson estate, Okenshaw] on which it planned to build a large, twin-towered cathedral, requiring Olmsted to plan options for both the cathedral site and the important southern entrance to Guilford."[71] He continued:

> *The Roland Park Company marketed the Roland Park–Guilford connection and the desirability of the area as Baltimore's prestigious location. The prospects of Guilford were made even greater by the move of the Johns Hopkins University to the Homewood campus, the decision of the Maryland Episcopal Diocese to purchase the southern tip of Guilford with the intention of building a huge twin-tower cathedral, and the access to downtown that was direct by extended trolley lines. These houses were intended to influence the architecture in that particular section but most of the lots were sold to be developed by the buyer and their selected architect. While the Roland Park Company prided itself on planning Guilford for residents with a range of incomes accommodating cottages to mansions, as James Waesche observes in* Crowning the Gravelly Hill, *"its intent in Guilford was clear—plenty of room for Baltimore's biggest spenders."[72]*

The developers of the Guilford District plans specified that "a series of very elegant 'group homes' be built on the outer fringes of the new development." This was accomplished on land owned by the Roland Park Company but was harder to control on land the company did not own. These border developments included Mueller's Oakenshawe development. Oakenshawe fit the bill for the Roland Park Company due to its design as an upscale townhouse community in sympathy with its more exclusive northern neighbor. The Mueller plan for Oakenshawe included angled streets and preservation, when possible, of the stately old trees. Hobbs wrote:

> *The Roland Park Company placed much initial attention on the eastern, northern and southern edges of the Guilford site and took responsibility for the housing that was constructed there because they could not control the development of the areas to the east, north and south of the Guilford tract. As was characteristic of many Olmsted community plans, streets on the outer edges of the tract were designed with the house lots facing inward, toward a green or a cul-de-sac, thus ensuring the privacy of the new development and insulating the inner, more expensive house lots from the "lesser neighborhoods" outside of the development. Along York Road,*

the company had taken yet a further step of designing and constructing the housing shortly after the opening of Guilford. On the north edge, the Norwood cottages would be Palmer designed and company built in a similar action. Many prime inner lots were sold in 1913 and 1914 with active construction following but development was slowed by the outbreak of World War I.[73]

The first houses built by the Roland Park Company for the Guilford District were the Edward Palmer–designed homes on Chancery Square in 1912–1913, six paired Tudor Revival houses that were fashionable and attractive at the junction of St. Martins, Fenchurch and Chancery Roads. These were English-style residences that offered affordable luxury. Bretton Place followed in 1914 with a group of seventeen homes in three structures on a type of cul-de-sac to ensure the privacy of the new development and insulate the inner, more expensive house lots from the lesser neighborhoods outside of the development.[74] Like Chancery Square, the Bretton Place houses were designed by Palmer at the direction of Edward Bouton to be elegant but affordable. The seven-room homes at Bretton Place sold for $6,900 and the ten-room homes sold for $9,875 in 1914. York Court, also constructed in 1914, was located north of Bretton Place in three groups with four houses in each group. Designed by Palmer to face York Road (Greenmount Avenue) in a rectangular green space placed back from the road among trees and greenery, these houses also served as a buffer to the inner, more expensive lots of Guilford. To the north, Palmer designed the Norwood cottages to be built by the Roland Park Company, and to the south, Oakenshawe was designed by Flournoy and Flournoy and built by the Mueller Construction Company for the same purpose, to insulate the garden-like inner lots of Guilford from the lesser neighborhoods around it.

At Oakenshawe, Mueller hired the architect Parke P. Flournoy (at the newly established Baltimore office of Flournoy and Flournoy, Architects) to design row houses befitting his upscale planned community. Flournoy relied heavily on the popular daylight design used by Edward L. Palmer several years earlier for houses in Roland Park. As the Oakenshawe development expanded beyond its original plan, other architects and builders in the community adhered closely to a common design, and the general character of the existing houses, with regard to building materials and styles, gave the Oakenshawe community a cohesive character. The neighborhood houses built between 1916 and 1926 were largely of the Colonial Revival, Neoclassical Revival and Dutch Colonial Revival styles.

The Roland Park Company included covenants in all the Guilford home deeds. In Oakenshawe, most deeds did not include covenants, but a deed dated June 13, 1923,[75] between the Mueller Construction Company and D. Ferdinand Onnen Jr. and Gertrude Spetzler Onnen outlined certain covenants for the house at 3413 University Place. These included:

1- that no shop store factory saloon or business house of any kind no hospital asylum or institution of kindred nature no charitable institution shall be erected or maintained on said premises hereby conveyed but the said premises shall be occupied and used for residence purposes only and not otherwise 2- No stable shall be erected or kept on said premises 3- That no cess pool or receptacle of any kind for the storage of liquid waste no privy vault nor any form of privy shall be constructed nor kept on the land hereby conveyed that no swine or live fowl shall be kept on the said premises and no nuisance of any kind shall be maintained or allowed thereon nor any use thereof made or permitted which shall be noxious or dangerous to be had 4- That no building shall be erected or constructed nearer than twenty two feet to the building on University Place upon which said lot fronts 5- That

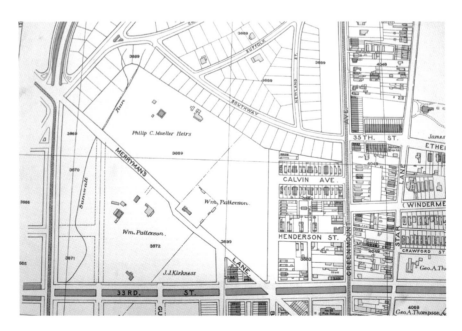

The old Okenshaw estate, now property of Philip C. Mueller Heirs. *J.W. Shirley Topographical Map of Baltimore, 1915.*

porches must be set back at least thirteen feet from the front building line 6- That no front porch shall be enclosed with glass or otherwise without the consent of The Mueller Construction Company its successor or assignee 7- That any garage erected upon said lot must be set back at least two feet from the twelve foot lane in the rear of said lot and at least eighteen inches from the party line It must not be more than fifteen feet above finish grade in height and confer in design and material to the house erected upon said lot 8- That no fence either wire or wood to be constructed on the front or rear of said lot 9- That as to all corner lots no building porch or obstruction of any kind shall be erected along the said line thereof nearer the building line than the improvements porches or other obstructions existing upon such lots at the time of the sale by the said The Mueller Construction Company.[76]

Philip C. Mueller died shortly after his company acquired the Henry R. Wilson estate, and construction of the development was delayed until other members of the Mueller family, also in the construction business, could reorganize to complete the planned community. A 1915 map of the area lists ownership of the old Okenshaw estate as property of the "Philip C. Mueller Heirs."

3
BIOGRAPHIES OF
THE WILSON FAMILY

WILLIAM AND JANE STANSBURY WILSON

William Wilson (1749–1824) was born in Limerick, Ireland. His parents were Scottish and lived in London before they settled in Limerick, where they stayed the remainder of their lives. They had six sons and two daughters; only William left Ireland. As a young man of twenty in 1770, he came to Baltimore, where he met and married Jane Stansbury in 1772. He purchased a three-and-a-half-story brick building at 105 Baltimore Street (also known as Market Street) from Robert Shields in February 1774, a time when brick buildings were rare in the city. The first floor of the building became the counting house of a new business venture, Wilson & Maris, Merchants, that he started with Matthias Maris and John Brown, recently arrived from Philadelphia. He was one of the first to carry on a general mercantile trade in Baltimore, beginning in 1771.[77] The upper floors of the house would be the Wilsons' dwelling place, where they raised their four children and lived for the remainder of their lives.

Wilson & Maris was a mercantile house and became very successful after the Revolution. John Brown, the silent partner of William Wilson and Matthias Maris, was born in Belfast, Ireland, in 1745 and arrived around 1770 in Philadelphia, where he met and married Sarah Levering, the cousin of Matthias Maris. The Browns moved to Baltimore around 1774, at the same time as Matthias Maris. John Brown started a successful tanning

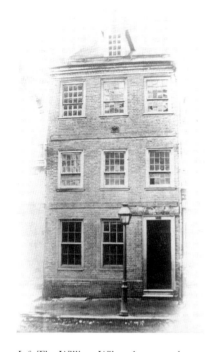

WILLIAM WILSON,

FOUNDER OF THE HOUSE OF

WILLIAM WILSON & SONS,

1780—1880.

Left: The William Wilson house and counting house of William Wilson & Sons on Baltimore Street. *Maryland Historical Society*.

Right: Sketch of William Wilson. *From* History of American Shipping, *1883*.

business in Baltimore and "amassed quite a fortune in the tannery business and was also engaged with William Wilson and Mathias [*sic*] Maris in the shipping business."[78] Upon his death on November 1, 1794, he left his wife with ten children from the age of newborn to twenty-two. His heirs sold their interest in the tannery and the shipping firm to William Wilson, who continued to operate the profitable tannery.

Matthias Maris was the son of Matthias Maris Sr. and his wife, Magdalena Levering. The family lived in Roxbury, Pennsylvania, and had three children before the untimely death of Matthias Sr. on the day Matthias Jr. was born, May 19, 1747. The younger Maris lived with his mother until her death in 1772. He moved to Baltimore with his cousin Sarah and her husband, John Brown, in 1774. In Baltimore, he formed a mercantile firm with William Wilson. According to the Levering family history, Matthias Maris was "a man of considerable natural talents, he became a skillful land surveyor. He was also a teacher of the Roxbury school....He was a successful merchant, and soon acquired an ample fortune. He purchased a farm of 200 acres of land

in Franklin County, Pa near Chambersburg, to which he moved and made his residence. Here he devoted himself to agriculture and the improvement of his mind."[79] At the age of forty-nine, Maris married Margaret McDowell (1765–1853) of St. Thomas in Franklin County, Pennsylvania, where they lived until his death on October 9, 1811.[80] He is buried at Spring Grove Cemetery in Franklin County.[81] They had no children. Maris disposed of much of his Baltimore property when he moved to Pennsylvania, but he retained some of his business holdings there when he retired from the firm. His principal heir was his great-nephew and namesake, the son of his older brother Captain William Maris. After Matthias died, his widow sold much of their remaining interests in Baltimore to William Wilson over a period of several years. The brother of Margaret Maris, John McDowell, LLD, served as provost of the University of Pennsylvania and later as president of St. John's College in Annapolis. In 1802, the sons of William Wilson (James, Thomas and William Jr.) joined the mercantile and shipping firm, and the firm name was changed to William Wilson & Sons.

According to John Thomas Scharf:

> *Wm. Wilson was highly esteemed as a citizen. While upright in all his dealings, he was foremost in material aid to all worthy benevolent enterprises. He was an active member of the Baptist Church, and contributed largely to the erection of the First Baptist church, on the corner of Sharpe and Lombard Streets. Mr. Wilson exhibited his patriotism for his adopted country by liberal-handed contributions to the army in 1812–14. In the latter year, when no funds could be obtained to meet the obligations of the government, Mr. Wilson tendered James Beatty, the navy agent, a loan of fifty thousand dollars, and at the time of its repayment refused interest, remarking that "the money was just lying idle, and it was just as well the government have the use of it." William Wilson was a member of the Legislature for one term, having been nominated on the morning of election day, on account of his popularity, to replace a candidate withdrawn.*[82]

William Wilson was a founder of the Bank of Baltimore in 1795 and served as its second president for seventeen years; he was also one of the founders of the Equitable Society. He helped form the Antislavery Society in Baltimore, the fourth such chapter in America and sixth in the world,[83] and served on the Committee of Health in 1795, during the yellow fever epidemic. He served as a director of the Baltimore Insurance Company in 1796. Wilson was elected to the Baltimore City Council from the Fourth

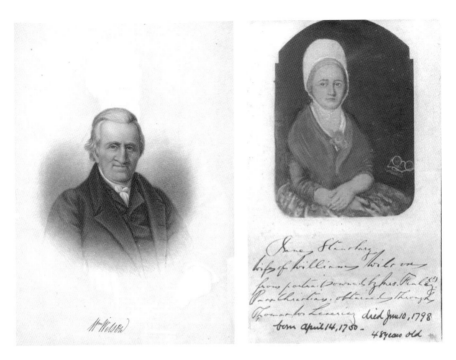

Left: William Wilson. *Right*: Jane Stansbury Wilson. *George Radcliffe collection.*

Ward for the 1797–1798 term, and in 1798, he was elected as a delegate to the Maryland General Assembly. The distinguished Washington, D.C., philanthropist William Wilson Corcoran, who established the Corcoran Art Gallery, was his namesake and a grandson of William's sister, Elizabeth, who married Thomas Corcoran Sr. and lived in Ireland. Corcoran's father, Thomas Jr., was sent to Baltimore as a young man and served in Wilson's counting house before settling in Georgetown.

Jane Stansbury Wilson belonged to an old Baltimore County family. Her great-grandfather Tobias Stansbury founded the family in America, arriving from Germany when he was a teenager.[84] Tobias was the original grantee of the 135-acre Huntington land grant in 1688. Coincidentally, the same land would be acquired by his great-great-grandson James Wilson in 1802. Today, Oakenshawe stands on a part of this land grant.

William Wilson, who owned over thirty lots in Baltimore Town at the time of his death in 1824, purchased two lots in the county about the same time his sons were accumulating property there. He purchased Hector's Hopyard, a sixteen-and-a-half-acre tract, from Levering and Nelms, Merchants, a commercial firm in Baltimore owned by Peter Levering and Noah Nelms, in

> **NOTICE.**
>
> THE partnership heretofore existing under the firm of WM. WILSON & SONS, has been dissolved by the death of Wm. Wilson. All persons having claims against the said concern are desired to present them for settlement, and those indebted, are earnestly requested to liquidate their accounts without delay, as it is particularly desirable to bring the dependencies of the late concern to an early close.
>
> JAMES WILSON,
> THOMAS WILSON,
> Surviving Partners.
>
> JAMES & THOMAS WILSON have admitted DAVID S. WILSON into partnership, and they will continue to conduct their business under the firm of WILLIAM WILSON and SONS. june 25 eo4t

Notice of reorganization of William Wilson & Sons after the death of William Wilson. *George Radcliffe collection.*

1804[85] and in 1813 purchased two and a half acres of Merryman's Lott along Merryman's Lane from Francis B. Brunelot for $2,050.[86] He maintained a small summer house, Camperdown, on Merryman's Lane near Charles Street Avenue, which he left to his daughter upon his death. The family company, William Wilson & Sons, was reorganized after his death.

JAMES AND MARY SHIELDS WILSON

James (1775–1851) was the oldest child of William and Jane Stansbury Wilson. He married Mary Shields (1779–1869) in 1800 and joined the family firm in 1802, becoming a senior partner upon his father's death in 1824. The family lived at 20 Holliday Street and began accumulating property in the country in 1802, keeping a summer estate there called The Cottage. They had ten children, including a son, James Jr., who died at eleven. Their nine remaining children survived them, except for Melville, who survived his father but preceded his mother in death by thirteen years.

James served as a director of the Bank of Baltimore and as acting president of the bank during the extended illness of its president, William Lorman.

Right: James Wilson. *Below*: Notice of reorganization of William Wilson & Sons after the death of James Wilson. *George Radcliffe collection*.

ja 14 4tawom

NOTICE.

ing
iu
ns

THE PARTNERSHIP which existed under the firm of **WILLIAM WILSON & SONS** was dissolved by the decease of James Wilson.

The business will be conducted hereafter under the same firm by the undersigned surviving partners.

DAVID S. WILSON,
THOMAS J. WILSON,
HENRY R. WILSON.

June 2d, 1851. d4t* je 2

CO-PARTNERSHIP.

He refused the presidency when it was offered to him upon Lorman's death in 1841, citing his advanced age.[87] His son David was also offered William Wilson's old post of president of the Bank of Baltimore but refused due to his heavy travel schedule. James and his brother Thomas increased the size, scope and reputation of the old family firm, William Wilson & Sons, until their deaths in 1851 and 1845, respectively; the firm was reorganized after the death of James in 1851. Three of James's sons continued the firm: David S., Thomas J. and Henry R. The three liquidated the old firm's shipping assets in 1862 due to disruption in shipping lanes caused by the Civil War as well as new competition with steamships and the opening of the Suez Canal, but they retained the firm's name and kept the Baltimore Street office. Henry left the firm in 1866 to follow other business pursuits. The

Baltimore Street building became the office of both William Wilson & Sons and Wilson, Colston & Company. The latter firm was formed in 1867 by two of David's sons, James G. and William B. Wilson. In 1871, the building was sold and demolished; William Wilson & Sons moved to 8 South Street in 1872 and remained there until after David's death in 1882. Thomas J. Wilson retained the firm's name, moving the office back to Baltimore Street in 1887 and maintaining an office there until 1889. William Wilson & Sons was no longer listed in the Baltimore City Directories after that. Thomas died in 1894. At the time of its demise, the Baltimore Street building had housed the counting house of a Wilson business for one hundred years.

An 1819 painted chair and two pier tables once belonging to James and Mary Wilson are on display at the Maryland Historical Society. The yellow chair and tables were built for the double parlor of Wilson's Holliday Street home. The furniture is attributed to John (1777–1851) and Hugh Finley (1781–1830), famous English-born makers of painted furniture who settled in Baltimore around 1803; their work is greatly desired by collectors and academics. The Finley shop was one block away from James Wilson's house on Holliday Street. A center table dated 1825 by the same makers, also owned by James and Mary Wilson, is on display at the Brooklyn Museum of Art in New York. The Baltimore Museum of Art has on display an elaborately painted center hall table attributed to Hugh Finley that is said to have stood in the entrance hall of the Holliday Street house of James Wilson. The table at the Baltimore Museum of Art is the centerpiece in a display room that also contains the elaborate Woodlawn Vase of Preakness fame.

David Shields Wilson (1802–1882), the eldest son of James and Mary Wilson, studied law in the office of Judge Robert Perviance in Baltimore and passed the bar before abandoning the profession in favor of the family shipping house. He married Mary Hollins Bowly (1811–1849), and they had four children. He first lived on Lexington Street, one door away from his uncle, Thomas Wilson, and then moved to 47 Charles Street North. He was a senior partner in his grandfather's firm until his death. He began accumulating land along the old Cold Spring Lane, near his father's estate, in 1847 with a purchase of forty-seven and a half acres from William A. Talbott[88] and added to the estate the following year with the purchase of fourteen and a half acres from Abraham Van Bibber[89] and a small piece of land from James Bryan and William Broadbent.[90] In 1862, he acquired the Crocker estate of Emmanuel and Harriet Crocker on Cold Spring Lane east of Charles Street Avenue.[91] He gradually amassed a large acreage on

Above: James Wilson center table on display at the Baltimore Museum of Art, attributed to Hugh Finley. *Left*: James Wilson center table at the Baltimore Museum of Art; note the Woodlawn Vase of Preakness fame in the background. *Opposite, top*: James Wilson pier table at the Maryland Historical Society; the painted decoration is attributed to Hugh Finley. *Opposite, bottom*: James Wilson pier table and chair at the Maryland Historical Society. *Author's collection*.

both sides of Cold Spring Lane stretching between Charles Street and York Road, including all of the Loyola College property later acquired by the Garretts. He built an estate and extensive gardens there called Kernewood. The grand house sat high on a hill, and the property was fed by two springs. The estate was known for its extensive manicured gardens, partly preserved in the walled garden of the late Virginia Perviance Bonsal White, wife of Miles White Jr. After the death of David Wilson, the estate gradually diminished in size, and the residue now exists as a neighborhood named after the old estate.[92]

Later in life, David S. Wilson lived with his son William Bowly Wilson (1839–1906) at 225 North Charles Street. William B. Wilson also kept a country estate in Catonsville called Glen Alpine. His previous Baltimore addresses include 69 Courtland Street in 1872, 279 North Charles Street in 1874 and later 330 North Charles Street. William B. married Jane Marshall, and they had four children. Another son of David's, James Guilian Wilson (1831–1904), inherited his father's Kernewood estate. He married Josephine Chapman, and they had a son, Marshall Guilian Wilson, who lived in Maryland and France. The daughter of David S. Wilson, Mary Bowly Wilson (1835–1906), remained unmarried and held property in trust. She lived at 1125 North Charles Street and may have lived with her brother William for a time. An obituary of David Shields Wilson appears in the appendix.

James Guilian Wilson and William Bowly Wilson founded the successful financial and investment firm Wilson, Colston & Company in the original counting house of William Wilson & Sons at 216 East Baltimore Street in 1867 and maintained offices in New York, Paris and London in addition to Baltimore.

James Guilian Wilson and Josephine "Julia" Chapman Wilson lived at 505 Park Avenue. James was president of the Baltimore & York Turnpike Company in 1883 and served as the lieutenant governor of the Society of Colonial Wars in addition to his other business interests. He was a director of the Baltimore Fire Insurance Company and is listed as president of the York Road Rail Works from 1879 to 1883. He was also a partner in the old family firm William Wilson & Sons. He was part owner of the bark *Covington*, the last of the great whaling vessels registered in Warren, Rhode Island, when it sailed from Honolulu in 1864 to the Bering Strait, where it was captured and burned by the Confederate pirate ship *Shenandoah*, captained by James Iredell Waddell, a month after the Civil War ended in 1865 (unknown at the time to the captain). The value of the ship and its contents were estimated

Left: David Shields Wilson. *Right*: Mary Hollins Bowly, wife of David S. Wilson. *George Radcliffe collection.*

David and Mary Wilson's estate Kernewood, front view. *George Radcliffe collection.*

A view of Kernewood, summer residence of David S. Wilson. *George Radcliffe collection.*

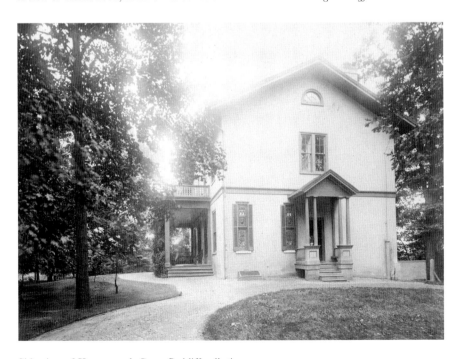

Side view of Kernewood. *George Radcliffe collection.*

Carriage and horse used by David S. Wilson at Kernewood. *George Radcliffe collection.*

at over $120,000 at the time.[93] It was the custom of William Wilson & Sons to retire shipping vessels to their Warren whaling fleet when their useful shipping life was over. This custom continued until the shipping fleet was sold in 1862; the company retained its whaling fleet for several more years.

James raised registered Jersey cattle—the American Registry of Jersey Cattle was started in 1868, and James's uncle William C. Wilson was a founding organizer of the registry. In June 1890, James G. Wilson registered two Jersey calves, Mushee and Norette, both of the same sire, Idas, and different dams, Zorah of Kernewood and Zoresta.[94]

The family tragically expired within a single year between 1904 and 1905 with the successive deaths of James, Julia and Marshall. Marshall lived in France but maintained a residence in Baltimore; he died on the first day aboard ship after leaving France shortly after his mother's death. He was the subject of a lawsuit that established Maryland law: his will, written in French, was translated by two individuals, and the translations were not identical. The Maryland courts set precedent in interpreting the translations.

William B. Wilson was treasurer of the Sons of the Revolution and a delegate to the Maryland General Assembly along with his cousins James W.

"EMPRESS OF THE SEAS," 2197 TONS, BUILT AT EAST BOSTON, IN 1853
From a drawing by Charles E. Bateman

William Wilson & Sons clipper ship *Empress of the Seas*, built in 1853, capacity 2,197 tons, purchased for $125,000. *Drawing by Charles E. Bateman, from* Marine Research Society Publication 13, *Salem, Massachusetts, 1927.*

Patterson and James Appleton Wilson. He was a member of the University Club, the Catonsville Country Club, the Bachelors Cotillion and the Junior Cotillion. He served as treasurer of the Maryland Historical Society. William married Jane Marshall, and they had two sons and three daughters. He sold his interest in Wilson, Colston & Company after the death of his brother James in 1904, and in 1908, the firm was known as Colston, Boyce & Company. It failed sometime before 1918.[95] There is an oil portrait on canvas of William Bowly Wilson in the Baltimore Museum of Art by Oliver Tarbell Eddy (1799–1868) under the heading "Business and Industry/Banker Portrait."

The oldest daughter of James and Mary Wilson, Anne R. Wilson (1804–1889), married Frederick Harrison in 1837. Harrison was a civil engineer from Connecticut who trained at West Point. He moved to Baltimore to work on civil projects for the government and later for the Baltimore & Ohio Railroad. His ill health was also a factor, Baltimore having a better climate than New England. His first wife was Anne's cousin Lydia Levering, who died

Left: William Bowly Wilson (*left*) with First Sergeant Edward Cohen, Maryland National Guard, 53rd Regiment, Company G, 175th Infantry, 1860. *Right*: Lennox Birckhead (*left*) with Samuel George (*center*) and Frederick Colston (*right*), Maryland National Guard, 53rd Regiment, Company G, 175th Infantry, 1860. *Maryland Historical Society*.

childless in 1834. Frederick and Anne lived at 104 East Monument Street and summered at an estate called Villa Anneslie in Green Spring Valley until they built a new place, also named Villa Anneslie, on the York Turnpike Road. Much of their time was spent in Florida and Nassau due to Harrison's poor health. They spent the Civil War years in Ireland and Europe. Their only child, a daughter named Anne, married Lennox Birckhead and lived at 1023 North Charles Street as well as Villa Anneslie, where they farmed and raised horses. The Birckhead family was well established in Baltimore— Dr. Solomon Birckhead, an ancestor of Lennox, purchased a country estate named Mount Royal from Charles Carroll of Carrollton in 1789 as a retreat from his house at Calvert and Fayette Streets. Solomon Birckhead was born and raised on the family estate on Maryland's Eastern Shore where the town of Cambridge now stands.

Jane S. Wilson (1805–1864), the second daughter of James and Mary Wilson, married Robert Patterson Brown, son of the renowned Baltimore surgeon Dr. George Brown. The families were neighbors on Holliday Street, the Wilsons at #20 and the Browns at #29. Robert and Jane Wilson Brown had a country home known as Stoneleigh built after the death of her father

Right: Frederick Harrison. *From* History of Baltimore City and County from the Earliest Period to the Present Day, *1881.*

Below: Villa Anneslie, home of Frederick Harrison and his wife, Anne Wilson. *From* History of Baltimore City and County from the Earliest Period to the Present Day, *1881.*

"ANNESLIE."

RESIDENCE OF F. HARRISON,

YORK ROAD, BALTIMORE CO., MD.

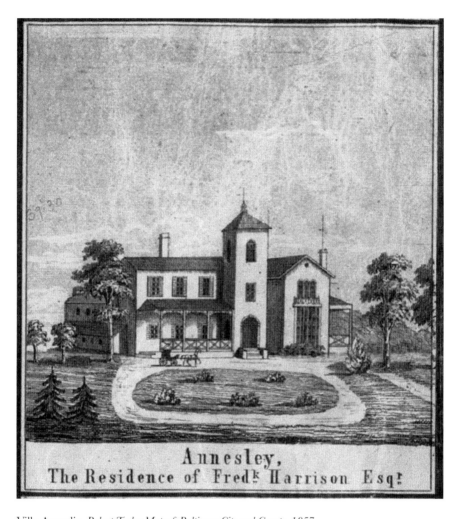

Villa Anneslie. *Robert Taylor Map of Baltimore City and County, 1857.*

on land he acquired for them. The house was designed in the Italianate style by John Rudolph Niernsee (1814–1885) and James Crawford Neilson (1816–1900), popular and well-respected architects of Baltimore. The house, styled as an Italianate villa, consisted of twenty-two rooms with thirteen-foot ceilings on the first floor and eleven-foot ceilings on the second. It was built of brick and had a tin roof imported from Europe. The cost of the house in 1852 was $15,738.94, and the outbuildings added $1,643 to the total cost of the property.[96] Jane's sister Anne built Villa Anneslie next to Stoneleigh using the same architects. Robert and Jane Wilson Brown had two sons, Robert

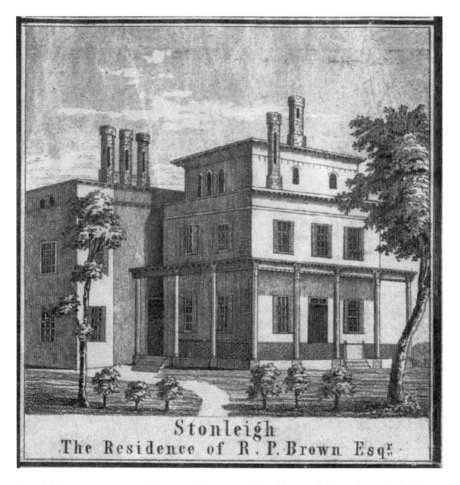

Stoneleigh, summer home of Robert P. Brown and his wife, Jane Wilson. *Robert Taylor Map of Baltimore City and County 1857.*

Jr. and George, and three daughters. Two daughters married, and the third, Mary Leigh Brown, remained unmarried and summered at Stoneleigh all her life. George Brown inherited Stoneleigh.

According to some sources, Robert and Jane Brown acquired 240 acres directly from the Govane Howard estate, Drumquastle. Govane Howard was a descendant of the original 1755 land grant holder, William Govane.[97] According to the source, the Browns later sold the southern 120 acres of the estate to Jane's sister Anne and her husband, Frederick Harrison. However, land records and Wilson family notes indicate that a Harrison property on Merryman's Lane was exchanged for the property

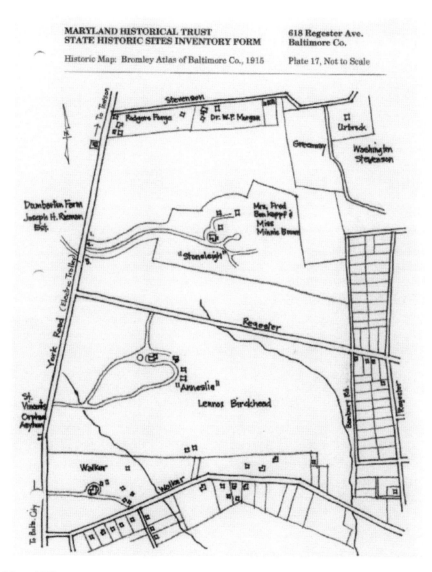

Map of Villa Anneslie and Stoneleigh, the Harrison and Brown summer estates on York Road. *After Bromely Atlas of Baltimore County 1915, plate 17, and Maryland Historical Trust.*

on the York Turnpike Road owned by James Wilson, Anne's father. James Wilson purchased 110½ acres of the Govane Howard estate on the York Turnpike Road in 1850 for $13,000.[98]

Another daughter of James and Mary Wilson, Eliza McKim Wilson, never married and inherited a trust estate as well as her mother's personal

property. Her sister, Mary Louisa Wilson (1810–1884), married Henry Patterson (1800–1858) in 1841. He was the son of William Patterson and brother of Elizabeth "Betsy" Patterson, the wife of King Jérôme Bonaparte of Westphalia. They had seven children; four lived to adulthood, including James Wilson Patterson (1842–1908), who married Margaret Sherwood (1847–1921) in 1881. James was born in Baltimore at Roseland and graduated from Princeton in 1863.[99] He was one of the most well-traveled students in the class, having crossed the Atlantic Ocean twenty-eight times before his twenty-first birthday. When in Baltimore, the James W. Patterson family lived at 14 Mount Vernon Place (later at 1012 Belvidere Terrace), but much of his time was spent in Europe.[100] He was an accomplished historian and gained membership to the prestigious Royal Geographical Society in London at a young age. He was a member and served on the Membership Committee of the Society of Colonial Wars in Baltimore. James and Margaret had a daughter named Marjorie (1886–1948) who became a well-known actress and writer. She was the first American woman to play a leading part in the Shakespeare Memorial Performance at Stratford-upon-Avon[101] and had a successful acting career in New York and London. She also wrote the novels *Fortunata* (1911), *Dust in the Road* (1913) and *A Woman's Man* (1919), as well as several plays and poems.[102] She inherited personal items and household goods from her aunt, Madame Bonaparte. Marjorie was the subject of several flattering newspaper and magazine articles.[103]

Another child of Henry and Mary L. Patterson, William (1844–1935), married Emma M. Claggett (1852–1933) in 1875, and they had a son and two daughters. The family lived at 2116 St. Paul Street. William Patterson assumed control of much of his mother's property upon her death in 1884, including her summer estates on Merryman's Lane. William Patterson sold land from the old Wilson estates, adjacent to the old Okenshaw estate, to the Mueller Construction Company in 1919. Another son, Arthur "Melville" Patterson (1850–1879), died at the age of twenty-nine. He married Alice Gerry (1850–1921) from Portland, Maine; she was the granddaughter of Elbridge Gerry, a signer of the Declaration of Independence and vice president under James Madison. Melville and Alice had a daughter, Anna St. Clair (1875–1950). After Melville's death, Alice married a Baltimore attorney, David Stewart. They divorced in 1912. Anna married an Italian count in 1899.[104] An unflattering—and inaccurate—wedding comment in the Richmond *Evening News* stated:

Marjorie Patterson. *From the* Scrap Book, *1908.*

MARJORIE PATTERSON

Marjorie Patterson, author of "Fortunata," has an interesting ancestry. There are a number of famous personages of Colonial days from whom she claims descent, but more in the present are her grandfather, John Neal, of Portland, Maine, well known as the publisher of "The Yankee," the friend of Longfellow and Emerson, and her great-aunt, Betty Patterson, the sister-in-law whom Napoleon Bonaparte refused to acknowledge. Miss Patterson is barely twenty now. Her relationship to some members of the Italian aristocracy gained her the entrée into Roman society, and even while dancing, driving on the Pincio, and sightseeing, she had begun the writing of her novel of Italian life. She is now in Europe travelling with her mother.

Marjorie Patterson. *From* Bookman, *1912.*

The marriage of Miss Anna St Clair Patterson, of Baltimore, and Count Cesare da Conturbia, of Milan, Italy, took place in the former city yesterday. The usual splendid accompaniments of a great wedding, where an American girl of wealth gives her hand in marriage for a title to some worthless foreigner, made a fine descriptive article for the newspapers. After a few thrashings from their "distinguished" husband these American girls generally get a divorce and come home to the paternal roof, somewhat improved in wisdom if not in wealth.[105]

The couple apparently lived a long, happy life together at the family estates in Milan and traveled frequently in Europe and America. The Conturbia

Anna St. Clair Patterson, Countess da Conturbia, Milan. *Author's collection; etching by Joanna Barnum after Sleicher, 1900.*

family, originating in di Arona, was one of the oldest and noblest families in Europe, prominent since the twelfth century. Cesare was the son of Carlo-Fortunato da Conturbia and Barbara Salazar. He was the oldest of eight children and heir to the family title and estates. The Conturbia family is differently stated by various sources as either not wealthy or well-to-do. The couple is said to have settled "in Milan on the rich estates of the count."[106] The family maintained at least two residences, a city house at 2 Via Lorenzo Mascharoni in Milan and a country place, Villa Malcacciata de Carmano, about nine miles north of the city. At best, the *Evening News* account was an inaccurate generalization of the marriage concerning the family finances. The count and countess had a son named Fortunato da Conturbia.

After she divorced her second husband, Alice Gerry Patterson Stewart married Francis Baylies Griswold, a cousin of her second husband. She met with a bad end after an apparently erratic life. According to documents uncovered by a trial to settle her estate after her death, her former husband, David Stewart, testified that she was a habitual drug user, which led to their divorce. The suit was brought by her daughter, the countess, who received a $500 bequest, while the remainder of the estate was left to Mary M. Drischman, formerly of Baltimore, now the wife of an Atlantic City butcher. David Stewart said that his wife lost her mind about six years after they married and recovered after she spent three months at Portsmouth, New Hampshire, without access to drugs. On her return to Baltimore, she resumed using narcotics and nearly overdosed on three occasions. Mary Drischman was accused by several witnesses of keeping Alice Griswold a prisoner for four years in an obsolete cottage in Northfield, New Jersey, where she died. Mrs. Drischman stripped her of jewelry and money and induced her to sign a will disinheriting her daughter. The estate consisted of three mortgages amounting to $75,000 on Atlantic City properties, an electric automobile and some furniture. When the previous manager of the estate, John H. Cross of Baltimore, turned over the estate to Mrs. Drischman, he said it was worth at least $500,000. One witness testified that Mrs. Griswold came to her a year before her death, said that the Drischmans had hidden her clothes and begged the witness to take her home for lunch. The witness testified that the former society leader was clothed in an old shirt and a man's coat.[107] According to a *Town and Country* article:

> *Mrs. Alice Gerry Griswold left a personal estate of $80,000, according to her will dated November 4, 1920, which was probated recently in Atlantic City, N.J. No mention was made of any real estate of which Mrs. Griswold*

inherited a considerable portion in Baltimore from her first husband, Mr. Melville Patterson, of that city, including a handsome residence on North Charles Street, and various business properties. She also inherited about $250,000, a few years ago from her sister, the widow of Pangiris Bey, a Greek diplomat of enormous wealth, with whom she resided in Paris for the greater part of the interval between her separation from her second husband, Mr. David Stewart, of Baltimore, and her third marriage to Mr. Francis Griswold, of New York. From Madame Pangiris she further received a magnificent collection of jewels and rare old laces, none of which does her will mention. Of the property specified only $500 is bequeathed to Mrs. Griswold's daughter, the Countess da Conturbia, of Italy, formerly Miss Anna St. Clair Patterson, with an additional $500 to each of the Countess' children.[108]

Alice's sister, Elizabeth "Bessie" Gerry, married the Greek diplomat Constantine Pangeris (or Pangiris) Bey, secretary of the Turkish delegation in Rome, where they lived. Pangeris belonged to one of the famous families who served the sultan after the fall of Constantinople, and he was a loyal subject. The family had enormous wealth and controlled vast banking concerns in the Ottoman Empire.[109] Constantine Pangeris was referred to by the honorific Bey. There was said to be nothing Turkish about him—"he was pure Greek,"[110] small in stature but perfectly formed with an athletic build. He spoke five languages and had a vast knowledge of the world. His great ambition was to come to Washington as minister, but the sultan found his views to be too democratic to give him the post. He retained his position as head of the delegation in Rome until his death. Constantine and Bessie Pangeris had no children. Mrs. Pangeris survived her husband and died of paralysis in Switzerland while recovering from an illness in 1912; she is buried at Campo Cestio in Rome. In addition to her sister, she named her niece and great-nephew, the countess and her son Fortunato da Conturbia, as heirs in her will. The will stipulated that the countess, daughter of Melville Patterson, was to receive $20,000 in annual ground rents, and "a like sum" was left to Fortunato da Conturbia, to be forfeited if he was found gambling in cards, stocks, races or any other sport or game. Some say that Marjorie Patterson's novel *Fortunata* was loosely based on the lives of her aunt and cousin, although Marjorie's life itself may have been the inspiration.

The last of the Patterson children to live to adulthood was Alice (1855–1944), who married a well-known and respected Maryland lawyer and

politician, William Hall Harris (1852–1938), in 1876. He was postmaster of Baltimore under Theodore Roosevelt, president of the Maryland Historical Society and a partner in the Baltimore law firm he started with H. Oliver Thompson and W. Hall Harris Jr. They lived at 511 Park Avenue in Baltimore and summered at the family estates Ivy Hall and Eutaw near Herring Run. They had a daughter and three sons.

James and Mary Wilson's son William Charles Wilson (1810–1878) never married. He and another son, Melville Wilson (1827–1856), inherited the 392-acre Gaston estate, which was renamed Springvale; it was located where Wyndhurst, Poplar Hill and the Orchards now stand. William C. Wilson was an avid agriculturalist and well-known pomologist and introduced many innovative farming practices to Maryland. His house stood on a hill between what is now Melrose Avenue and Castlewood Road opposite the entrance to Bryn Mawr. For a time before her death, his mother deeded her house on Gay Street to William. He lived at his mother's Gay Street house from at least 1856 to 1868. William is listed at 41 Franklin Street in 1869 and at his brother Thomas's house at 91 Park Avenue (later renumbered 81 Park Avenue) in 1872. Melville died in 1856, shortly after his father. William retained the Springvale estate until his own death in 1878 and lived near his mother until her death in 1869.

Thomas J. Wilson (1815–1894) lived at 43 Lexington Street in 1849 and 91 Park Avenue before 1856. He married Maria Bosley D'Arcy (1820–1882), and they had two children, Amelia Wilson Whetmore and James D'Arcy Wilson. James, who was also known as J. Darcey Wilson, lived at 2213 Charles Street and would later acquire part of the old Wilson estates on Merryman's Lane, which he eventually sold for development. Maria D'Arcy was one of six daughters born to John N. D'Arcy and Amelia Didier; they were considered the most charming women and most faultless beauties of Baltimore.[111] Maria's younger sister Henrietta married Thomas's nephew Dr. William Thomas Wilson. Maria, much traveled, died at Ryde on the Isle of Wight in England. Thomas, a senior partner at the old family firm, became its last surviving partner in 1882 with the death of his brother, David, and moved the office of the company back to a building on Baltimore Street in 1887.

The remaining son of James and Mary Wilson was Henry Robert Wilson (1819–1908), who married Sallie Lloyd Skinner (1822–1894), the daughter of Andrew Skinner of Fairview and Elizabeth Harrison Skinner of Appleby, in 1847. They had four children; the oldest, James, died as an infant, and a daughter, Mary, died at twelve. The surviving children were Henry Melville

Thomas James Wilson, son of James and Mary Wilson, in an undated photograph. *Maryland Historical Society.*

Wilson (1849–1916) and Elizabeth Skinner Wilson (1852–1948). Henry R. lived at 83 West Monument Street by the old number system, which later became 76–78 Monument Street. The family lived there until 1860, when they made Okenshaw their permanent residence. He was a senior partner of William Wilson & Sons in 1848, when the firm's ship *Andalusia* rescued all of the passengers of the sinking ship *Wakona* in the North Atlantic on a return trip from Bremen to Baltimore.[112] He remained a senior partner in the old family firm until 1866, when he left the company in favor of other business pursuits.

In 1860, Henry R. Wilson was founder and president of the Crescent Coal Oil Company of Baltimore City; his cousin Enoch Levering was treasurer. The company had a plant in south Baltimore bordered by Howard, Stockholm, West and Eutaw Streets, with offices at 62 Gay Street. The company was sold in 1870. Henry was asked by the mayor

to become treasurer of the troubled People's Gas and Light Company of Baltimore, a position he accepted. The company was started during the Civil War to offer citizens a choice in gas suppliers and provide greater access to city gas service, poorly provided by the existing monopoly. He held the position until the company merged with its competitors to form the Consolidated Gas Company of Baltimore, a forerunner to Baltimore Gas & Electric.

In *Wood's Directory of Baltimore City* editions from 1864 to 1870, the following listings appear for Henry R. Wilson and note his changing careers:

1864
Wilson Henry R. (Wm. Wilson & Sons,) president of Crescent Coal Oil Co. dw [dwelling] *Baltimore Co.*

1865
Wilson Henry R. (Wm. Wilson & Sons,) pres'd of Crescent Coal Oil Co, treasurer People's Gas Co., dw Baltimore county

1867
Wilson Henry R. pres'd Crescent Coal Oil Co treas'r Peoples Gas Co pres't Baltimore Wrought Iron Pipe and Tube Co. dw Baltimore Co

1870
SECURITY LIFE INSURANCE AND ANNUITY CO, OF N.Y., Henry R. Wilson, gen'l agt. 7 Maryland Bldg. Postoffice av [avenue]

Security Life Insurance and Annuity Company advertisement, Henry R. Wilson, Agent. *From* Baltimore Underwriters, *1876.*

Above: Crescent Coal Oil Company manufacturing plant at Stockholm and Eutaw Streets in south Baltimore. *E. Sachse and Company, Bird's Eye View of the City of Baltimore, 1869.*

Right: Crescent Coal Oil Company advertisement. The company was founded by Henry R. Wilson of Okenshaw, who served as president. *From Matchett's Directory of Baltimore City, 1860.*

CRESCENT COAL OIL COMPANY,

BALTIMORE,

Manufacturers of

REFINED BURNING OIL,

BENZINE,

LUBRICATING OILS,

GAS OIL,

Axle Grease, &c.

Office, No. 62 S. Gay St.,

Manufactory, Cor. S. Howard and West Streets, BALTIMORE.

HENRY R. WILSON, Pres't.

In 1864, Henry formed, with four others, the Baltimore Petroleum Company, an oil exploration firm that "failed to realize its potential."[113] The company drilled four successful wells and nineteen that were not successful and folded in 1881 having accumulated no debt. After 1870, Henry Wilson was listed with the Security Life Insurance and Annuity Company of New York as its mid-Atlantic agent.[114] He died in 1908, and his children sold the old Okenshaw estate to the Philip C. Mueller Building Company for development in 1914 for $57,000. Interestingly, the property, at the time of its sale, belonged to the estate of Henry's wife in trust for their children. Henry had use of the property for the duration of his natural life, after which it went to his wife or children, whoever survived him (see the last will and testament of Mary Wilson, appendix four).

Little is known of Henry's son, Harry Melville Wilson, and details of his life are easily confused with another Henry M. Wilson in Baltimore at the time, Dr. Henry Merryman Wilson, who was not related. Henry and Sally's daughter, Elizabeth, married Wilson Presstman Heyward (1852–1916) of New Castle, Delaware, in 1882. He was an investment broker who took his own life after a market reversal. They had three children, including Elizabeth Elsie Heyward, who married Archibald Marion Lesense Du Pont, great-great-grandson of the founder of E.I. du Pont De Nemours & Company. The family lived between Baltimore and New Castle, maintaining houses in both cities as well as spending summers at her family's summer house, Okenshaw, and his boyhood home, Winterthur.

THOMAS AND MARY CRUSE WILSON

Thomas (1777–1845) was the brother of James Wilson and the second son of William Wilson. He lived at 69 Harrison Street in 1814 and married Mary Cruse (1793–1824) the following year; they had six children. The family's summer estate was Oak Lawn at Huntington, adjacent to his brother's summer estates. Before 1816, the family moved to New Church Street (now Lexington Street), near St. Paul's Lane and east of Charles Street in Baltimore. Thomas was a senior partner with his brother at the old family firm and purchased properties with James in the county along the York Turnpike Road. James was the more aggressive land investor. Mary died at the age of thirty shortly after the birth of their last child in 1824, the same year Thomas's father died. A cousin, Priscilla Stansbury, helped

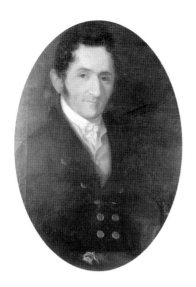 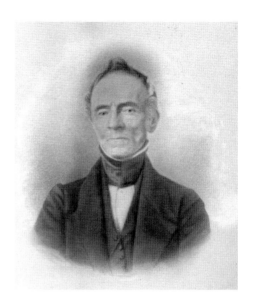

Left: Thomas Wilson Sr. as a young man. *George Radcliffe collection.*

Right: Thomas Wilson Sr. *Maryland Historical Society.*

raise the children. Priscilla resided for many years with her aunt and uncle at the Baltimore Street house and apparently continued living there after their deaths. In his memoirs, the Reverend Franklin Wilson, son of Thomas and Mary, states that his mother's death "left him as an infant of 13 months to the care of a cousin, Miss Priscilla Stansbury, and faithfully did she discharge the trust….[His] infant years were partly spent at his grandfather's Baltimore Street house in Miss Stansbury's care. His boyhood was spent in the Lexington street house during the winter, and the summers at 'Oak Lawn,' a beautiful country place at Huntington, now Waverly."[115] Oak Lawn sat adjacent to James's places Huntington, Roseland and Okenshaw. Thomas died in 1845 after a lingering illness; the day of his funeral, the ships in Baltimore Harbor flew their flags at half-mast in his honor.

The oldest son of Thomas and Mary, James Hamilton Wilson (1816–1853), married Margaret McKim Marriott (1823–1890), and they had three children. They owned the old Howard mansion on Mount Vernon Square, where the Methodist church now stands. James died suddenly at the age of thirty-seven after a riding accident at his father-in-law's estate, Marriott Plantation, in Howard County—the old estate is now known as the town of Marriottsville. According to his brother's memoirs, he was "suddenly stricken

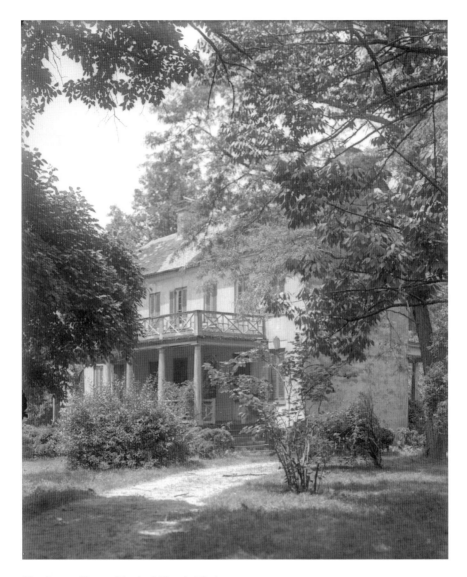

Huntington House. *Maryland Historical Society.*

down, and after days of unconsciousness passed to another world."[116] In a draft of his father's will, he was left $20,000 in addition to one-third of the proceeds from the sale of his father's property.[117] In 1860, James Hamilton Wilson's widow married Francis Brown Hayes (1819–1884). The family relocated to a house they purchased in Lexington. Together they had a son the following year. Hayes was a graduate of the Berwick Academy in Maine,

The Old Howard mansion on Mount Vernon Square, home of James H. Wilson and his wife, Margaret McKim Marriott. *U.S. Library of Congress.*

where he was born, and attended Harvard and Harvard Law School before becoming an executive of several railroads, including the Boston & Maine and the Atlantic & Pacific. He became president of the Massachusetts Horticulture Society—a rhododendron was named for him—and pursued an avid interest in agriculture at the Hayes estate. Among Francis's bequests was $10,000 to Berwick Academy and, reportedly, the statue of the Minuteman at Lexington, Massachusetts, where Hayes also had a home.[118]

Hayes was among Lexington's most prosperous residents in the late nineteenth century; he was a railroad official, lawyer, state senator and U.S. congressman. He and Margaret purchased a house (no longer standing) at 45 Hancock Street in November 1861 and used it as a summer home. Over time, they acquired additional small farms encompassing nearly four hundred acres. The estate extended across Granny Hill from Hancock and Adams to Grant and Woburn Streets. In 1883–1884, Hayes built a thirty-two-room Victorian fieldstone mansion called the Hayes Castle or Oakmount on what is now Castle Road. It was first occupied on Christmas Day 1884 and stood as a monument to the affluence the new professional class brought to Lexington. The property boasted a small natural pond near the top of the hill and several varieties of rare and imported plants, including orchids, camellias and rhododendrons, cultivated by Hayes. Hayes won several awards for his rhododendrons; to this day, they are maintained on Castle Road. The

Hayes couple enjoyed children—they once invited every Lexington child to a Christmas party, and the estate hosted annual Halloween parties for them. Hayes died while seeking the Republican nomination for the U.S. Senate in 1884 having never lived in the Hayes Castle. It was finished and briefly occupied by his son, Francis B. Hayes Jr., but by 1900, most of the Hayes property had been sold as house lots.[119] It was torn down in 1941.

In an interesting aside, three portraits by Rembrandt Peale now in the collection of the Maryland Historical Society—of John McKim Jr.; his wife, Margaret Telfair McKim; and her sister Annie Telfair Timothy—were donated to the society by William Power Wilson.[120] He was the son of James Hamilton Wilson, stepson of Francis B. Hayes and grandson of Thomas Wilson. Both John McKim Jr. and his eldest son, David Telfair McKim, lived next to the James Wilson family on Holliday Street in Baltimore. The portraits were painted around 1812. At the time of the Civil War, they hung at Belvidere, the home of John McKim Jr.'s son John S. McKim and the former home of John Eager Howard. John S. McKim's wife was a staunch Confederate, and his sister Anne (Mrs. S.J.K. Handy) was a staunch Unionist. In order to keep the paintings in the hands of the North, Anne McKim Handy removed them and sent them to her niece, Margaret Marriott Wilson Hayes, who kept the paintings in Boston. Before her death, Margaret Hayes gave the paintings to her son, William P. Wilson, in an effort to heal old family wounds. William P. Wilson later donated the paintings to the society through his cousin J. Appleton Wilson, then secretary of the society. In a letter to William P. Wilson written by the son of John S. McKim, Reverend Dr. Randolph Harrison McKim, all previous bad blood was cleansed by the return of the paintings to Baltimore. Reverend McKim was to inherit the paintings but agreed with William P. Wilson that they belonged in a public repository in Baltimore City.[121]

Thomas and Mary's eldest daughter, Emma Jane Wilson (1818–1861), married Thomas Upshur Teackle (1800–1863), a cousin of the shipping tycoon Littleton Dennis Teackle (1777–1850). Littleton Teackle built the Teackle mansion in Somerset County, Maryland, which now houses the Somerset County Historical Society. They had a daughter, Mary Wilson Teackle (1841–1891), who married James Upshur Dennis (1823–1900); he became a Maryland state senator. Emma was left $50,000 in her father's will, placed in trust for her with her husband as trustee. An additional $5,000 was left to her daughter, Mary.[122] Emma died suddenly when she "dropped dead on reaching her home, after having made some purchases for the approaching Christmas."[123]

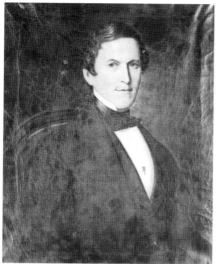 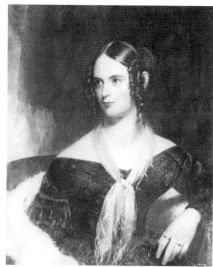

Left: Thomas Upshur Teakle. *Right*: Emma Jane Wilson, daughter of Thomas Wilson. *George Radcliffe collection.*

William Thomas Wilson (1819–1852), the second son of Thomas and Mary, was a prominent Baltimore physician and surgeon who graduated from Brown University in Rhode Island and trained as a surgeon at the University of Maryland. He married Henrietta D'Arcy (1822–1858), and they had three children, including John D'Arcy Wilson, also known as J. Darcey Wilson (1848–1900). Henrietta, a daughter of John Netterville D'Arcy and Amelia Margaret Didier, was reported to be "the most faultlessly beautiful woman in Baltimore."[124] William T. Wilson lived on Charles Street in the city and summered at Oak Lawn in Baltimore County.[125] After the death of his father, J. Darcey Wilson is listed on maps as the owner of Oak Lawn, adjacent to Huntingdon, Roseland and Okenshaw. The J. Darcey Wilson family resided at the corner of Lanvale Street and Park Avenue in 1877 and later at 33 St. Paul Street. He attended the University of Maryland Law School in 1880 along with a neighbor, William H. Brune, and a cousin, Frederick von Kapff. When J. Darcey Wilson was an infant, he was a participant in a land lawsuit,[126] *Henrietta D'Arcy and Thomas James Wilson v. Mary Netterville, Thomas Wilson, and John D'Arcy Wilson*, a petition to sell a lot on Washington Place in Baltimore.[127] William Thomas Wilson was left one-third of the proceeds from the sale of his father's property, as specified in his will, executed in 1845. His son William Thomas Wilson Jr. lived at 303 St. Paul Street and became a well-known architect who

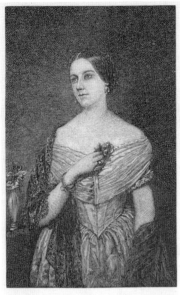

HENRIETTA D'ARCY WILSON. AMELIA DIDIER D'ARCY.

Left: Henrietta D'Arcy, "the most faultlessly beautiful woman in Baltimore," wife of Dr. William Thomas Wilson. *Right*: Amelia Didier D'Arcy, mother of Henrietta. *From* Harper's New Monthly Magazine, *1882*.

formed a firm in Baltimore with his cousin J. Appleton Wilson called J.A. & W.T Wilson, Architects.

Reverend Franklin Wilson (1822–1896), the third son of Thomas and Mary Wilson, married Virginia Appleton (1824–1902) of Maine. He attended Brown University in Rhode Island and Newton Theological Seminary (now Andover Newton) in Massachusetts. The family lived at 34 Pleasant Street until he built a large mansion called Oakley in 1855 on Kirby Lane near Franklin and Fulton Streets in west Baltimore; he lived there most of his life. He was a founding member of the West Baltimore Improvement Association. He was left one-third of the proceeds from the sale of his father's property as specified in his will, executed in 1845, and held considerable landholdings in Baltimore. He was ordained in 1846 and became a prominent Baptist minister and writer and editor. He served on the executive board of the Maryland Baptist Union Association and was a large donor to Baptist churches in the city and abroad; according to his journals, by 1862, he estimated his church largess at over $58,000. He is listed as president of the Claremount Land Company at 49 West Fayette Street in 1876; he was a founder of the

Left: Franklin Wilson as a child. *Right*: Franklin Wilson as a young man. *George Radcliffe collection.*

North Baltimore Land Company and was president of the Fire Proof Building Company from 1878 to 1888. He was active in development of the Peabody Heights neighborhood, where he inherited land from the former Wilson estates and served on the board of directors of the Peabody Heights Land Company. He was a community activist, being the first proponent and actively involved in building the Baltimore YMCA and the Female House of Refuge, serving as president of the latter. He fought for and contributed to accommodations for the poor and unfortunate in the city.

He and Virginia had three children, including the important Baltimore architect John Appleton Wilson, who started a firm at 58 North Charles Street with his cousin William Thomas Wilson Jr. Later in life, Franklin sold the Oakley estate to a developer and moved to 1012 St. Paul Street, where he and his wife lived out their lives. Franklin Wilson wrote the memoir often cited in this book, *The Life Story of Franklin Wilson, as Told by Himself in His Journals*, published posthumously in 1897.

Thomas and Mary's daughter Mary Cruse Wilson (1824–1856) married the Baltimore merchant J. McKim Marriott (1825–c. 1870). They had four

Left: Franklin Wilson shortly before his death in 1893. *Right*: Virginia "Bebe" Appleton Wilson, wife of Reverend Dr. Franklin Wilson. *George Radcliffe collection*.

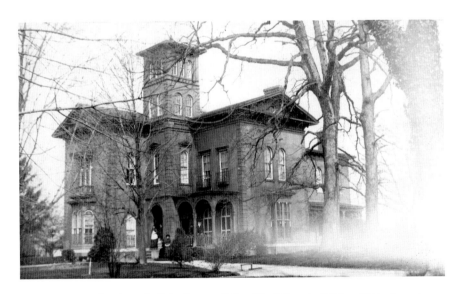

Oakley, the mansion house built by Reverend Franklin Wilson in 1855 on Kirby Lane in west Baltimore. *Maryland Historical Society*.

children. After her death in 1856, he married Cornelia Crittendon Coleman (1841–1873) and had two more children. Mary's son John McKim Marriott Jr. (1856–1876) suffered from bouts of depression; he committed suicide shortly after his marriage to Theresa Bracco (1859–1939) by jumping overboard into the ice-laden Chesapeake Bay while steaming from Baltimore to Virginia.

PETER AND HANNAH WILSON LEVERING

Hannah Wilson (1779–1854) was the only daughter of William Wilson and the sister of James, Thomas and William Jr. She married Peter Levering (1766–1843) in 1798; both were members of the First Baptist Church, which her father helped to build. Peter's father was Enoch Levering, who brought the family from Philadelphia to Baltimore in 1773 and established a large grocery business named Levering & Barge. Peter was born in Baltimore, where he became extensively engaged in shipping, forming the firm Levering & Nelms, which subsequently became Peter Levering & Sons. He also built a large sugar refinery in Baltimore. Peter and Hannah had fourteen children, including Mary Jane Levering (1799–1874), who married prominent Baltimore businessman Leonard Matthews and moved to New Orleans; William Wilson Levering, who married Eliza Corling and moved to Petersburg, Virginia; Leonidas, who died as an infant; prominent Baltimore merchant Thomas Wilson Levering; and Lydia Rebecca Levering, who married Frederick Harrison. Harrison later acquired a Levering summer home near the Roseland estate and, after the death of Lydia, married her cousin Anne R. Wilson. Other children included Rebecca; Leonidas, named after his brother who died; Frederick Augustus Levering, a partner in the mercantile firm Levering & Company; Oliver; Dr. James Jefferson Levering, who studied medicine at the University of Maryland and practiced in New Orleans before returning to Baltimore; Louisa; Eugene Levering, a prominent Baltimore businessman who was an active Baptist and leading merchant and importer in the city[128]—Eugene's twin sons, Eugene Jr. and Joshua Levering (1845–1921 and 1845–1935), were also influential businessmen of Baltimore; Hannah; and Maryland. Peter Levering inherited his father's honor and transmitted it to his sons and grandsons. Hannah was distinguished for her activity and usefulness in social and religious matters of the city.[129]

Eugene Levering, the youngest son of Peter and Hannah, was born in Baltimore on October 24, 1819. Like his parents, he was a member of the First Baptist Church, and he was later a member of the Seventh Baptist Church. He was an intimate friend of its pastor, Dr. Richard Fuller. He started business life with Hoffmans & Company, a dry goods, auction and commission house. Later, he was with George & Yates in the dry goods import business. In 1842, he formed a partnership with his brother Frederick A. Levering and conducted a general grocery business under the name Levering & Company on Hanover Street

Eugene Levering Sr. *From* Levering Family: History and Genealogy.

and later Commerce Street near Pratt Street. In 1855, the company was at 2 Commerce Street in a building the company constructed for itself. The company continued, taking a leading position in the trade, until Frederick's death in 1866, when the firm was dissolved. Eugene then took his sons, William, Joshua and Eugene Jr., into business and established the firm of E. Levering & Company, which grew very large. The firm subsequently engaged exclusively in the jobbing and importing of coffee. For many years, Eugene Levering was treasurer of the Maryland Baptist Union Association. He died on June 19, 1870.

The twin sons of Eugene Levering, Eugene Jr. and Joshua, were important Baltimore businessmen and politicians. Joshua Levering was president of the YMCA, board member of the House of Refuge and superintendent of the Sabbath school at the Eutaw Place Baptist Church. He was a staunch supporter of Prohibition and was that party's candidate for vice president of the United States in 1892, candidate for governor of Maryland in 1895 and candidate for president of the United States in 1896. Eugene Jr. presented Levering Hall to the Johns Hopkins University and donated $20,000 for construction of the hall for the downtown campus in 1889. When the campus moved to its Charles Street location, insurance money from the old hall, with additional funds from Eugene Levering Jr. and others, was used to construct Levering Hall at the new campus between 1928 and 1929. Eugene Jr. was president of the Bank of Commerce in Baltimore and a director of the Baltimore Board of Trade. Joshua was his business partner, and the two

Eugene Levering Jr. and his brother Joshua. *From* Levering Family: History and Genealogy.

lived near each other at 1308 and 1316 Eutaw Place. They maintained and grew their father's coffee business in Baltimore, E. Levering & Company, to become the largest in the state and one of the largest in the nation.[130]

WILLIAM WILSON JR., ANN CARSON WILSON AND MARY KNOX WILSON

William Wilson Jr. (1779–1832) was the brother of James, Thomas and Hannah Wilson. He lived at 14 Hanover Street in 1814. Less is known of William Jr. than his brothers. He joined the family firm at a young age but left to start a dry goods store, Wilson, Millikin & Company, with offices at 107 Baltimore Street, next door to his father and brothers' company at 105 Baltimore Street. Wilson, Millikin & Company later relocated to 169 Baltimore Street. According to codicils attached to his father's will, William Jr.'s firm did not do well, and the Bank of Baltimore took actions to repossess certain of his assets used to secure business loans. William Jr. also borrowed money from his father against his inheritance to support his family and business.

Greenmount Cemetery map with selected Wilson monuments marked. *Author's collection.*

He married twice, first to Ann Carson, with whom he had two daughters, Ann and Jane. Ann never married; Jane married a Mr. Sandford in Baltimore. His second wife was Mary Knox, daughter of the president of the Old Baltimore College (now University of Maryland, Baltimore). They had nine children: Isabella, William K., Fayette, Samuel, James T., Mary E., Martha, Hannah and Lewis. Several of their children appear in St. Louis, Missouri, for various periods of time; at least one lived there his entire adult life. Whether William Jr. ever lived there is not known—specific details of his life are not recorded with other family information. His daughters married into some of the wealthiest and most influential families in Baltimore.

Greenmount Cemetery and the Wilson Family

Many members of the Wilson family were buried at Greenmount Cemetery in Baltimore. The rural garden cemetery sits on sixty acres in the central city and was established in 1838 on the picturesque Robert Oliver estate. The remains of William Wilson Sr. were moved to the Peter Levering family crypt there. The James Wilson family plots are mostly located in section F, as are the family plots of his brother Thomas Wilson. A large monument marks the James Wilson plot, and an adjacent large obelisk marks the Henry and Mary Patterson family plots. The David S. Wilson plot is in this section on Oliver Walk and is marked with an imposing crypt. The Henry R. Wilson plots are enclosed by a small iron fence adjacent to the Patterson plots.

The Harrison and Birckhead plots are in section E, also marked with a large monument. James Hamilton Wilson and his wife are buried in the entrance area. Alice Patterson Harris and her family are buried in section I; her plot is next to the imposing monument of her aunt Elizabeth "Betsy" Patterson Bonaparte, sister-in-law of Napoleon Bonaparte.

4
BUILDING OAKENSHAWE

EARLY CONSTRUCTION

The Mueller Construction Company, and the earlier Philip C. Mueller Building Company, built terraced townhouses in Oakenshawe between 1916 and 1926. The terraced townhomes were initially designed by Flournoy and Flournoy, Architects. Other architects were involved in later construction. The original section of Oakenshawe was designed for sixty dwellings in terraced townhouse groups on Guilford Terrace, Oakenshawe Terrace and East University Parkway. Construction of three townhouse groups began in the fall of 1916 on the east side of Guilford Terrace. Each group consisted of six townhomes, Group A at 3433–3443, Group B at 3421–3431 and Group C at 3409–3419. In the spring of 1917, two more townhouse groups from the original plan were constructed on the west side of Guilford Terrace, Group D of four townhouses at 3408–3414 and Group E of five townhouses at 3416–3424.[131] Construction of the townhouse groups in the original plan was delayed due to difficulties obtaining building materials during World War I, when they were confiscated for the war effort. Construction resumed in 1919. The newly built Oakenshawe townhomes were described in the *Architectural Record*[132] and *Architectural Forum*[133] as "upscale residences built at an affordable price."

The 1918 Hamlin article for the *Architectural Record* contains the following paragraphs describing the Oakenshawe houses:

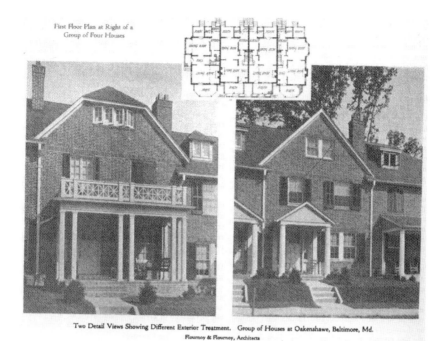

First Floor Plan at Right of a
Group of Four Houses

Two Detail Views Showing Different Exterior Treatment. Group of Houses at Oakenshawe, Baltimore, Md.
Flournoy & Flournoy, Architects

Mueller-built Oakenshawe houses from Group C on Guilford Terrace, designed by
Flournoy and Flournoy, Architects, constructed fall of 1916. *From the* Architectural
Forum, *1918*.

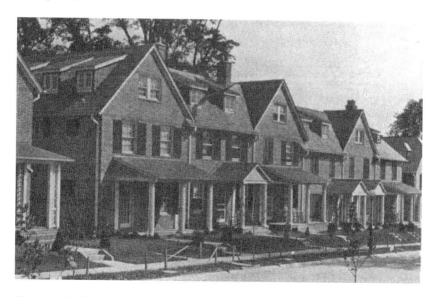

Mueller-built Oakenshawe houses from Groups B and C on Guilford Terrace, designed
by Flournoy and Flournoy, Architects, constructed fall of 1916. *From the* Architectural
Record, *1918*.

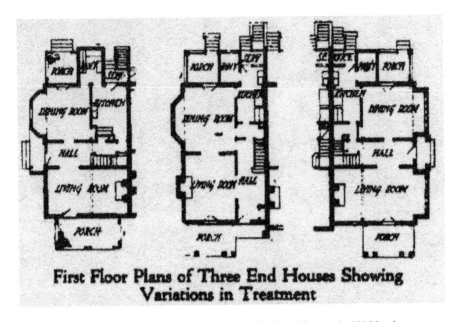

First Floor Plans of Three End Houses Showing Variations in Treatment

First-floor plan of a group of three houses built on Guilford Terrace in 1916 by the Mueller Construction Company, designed by Flournoy and Flournoy, Architects. *From the* Architectural Forum, *1918.*

This community forms the connecting link between the closely built-up section of Baltimore on the south and its suburb of Guilford which borders it on the north. Twenty-seven houses have been completed and sold. The construction of thirty-three more has been interrupted owing to the Government having seized the materials.

The completed houses occupy both sides of Guilford Terrace extending north from University Parkway toward Southway, Guilford. They are built in five groups: A, B and C containing six houses each, D containing four and E five. Widths 21 feet 6 inches and 22 feet. Depths of lots 100 feet to 105 feet. The walls are of dark red natural brick relieved by occasional stuccoed bay windows, white porches, white cornices, etc. Roofs of bluish grey slate, 8½ inches to the weather. The porches have floors of Welsh quarries with brick borders. The multiplicity of front porches is to be regretted from an artistic standpoint, but it was decided by both owners and architects that, in order to expedite sales, it would be advisable to defer to the popular taste. The interior standing finish is of yellow pine, generally painted white. Doors are of birch or fir with mahogany finish. The first floors of all houses and second floors of those in groups D and E are finished with quartered oak; others being of No. 1 pine flooring.

In designing the houses, the architects endeavored, as far as was consistent with economy, to obtain as much variety as possible, not only in the exterior appearance, but also in the interior arrangement of the rooms, there being few duplicate plans in any one group. As will be seen in the photographs, the porches vary greatly in form and are all separate, additional privacy being gained in some cases by the use of lattice.

The above paragraphs are taken from a memorandum by the architects, who further state that the cost of those houses built in 1916 (groups A, B and C) was only 15½ cents per cubic foot, and of the 1917 houses (groups D and E), 17½ cents. This low cost was effected, in spite of the very careful construction and finish of the houses, by the systematic use of stock sizes of lumber, doors, windows, etc. The memorandum concedes thus: The houses cost less to build and were sold more rapidly than those in a number of other speculative operations in the immediate neighborhood, in the construction of which the usual method was pursued of disposing with the services of the architect. This seems to controvert the commonly accepted opinion that an architect is an expensive luxury.

The owner and builder of Oakenshawe is the Philip C. Mueller Building Company of this city, to whose quick appreciation of the architect's suggestions and skill in carrying them out must in large part be attributed the somewhat artistic as well as the financial success of the work.

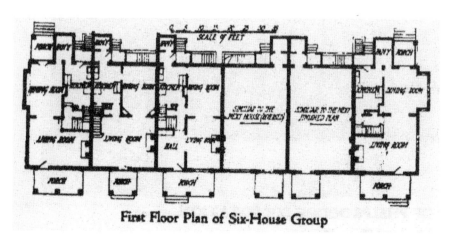

First Floor Plan of Six-House Group

First-floor plan of a group of six houses built on Guilford Terrace in 1916 by the Mueller Construction Company, designed by Flournoy and Flournoy, Architects. *From the* Architectural Forum, *1918.*

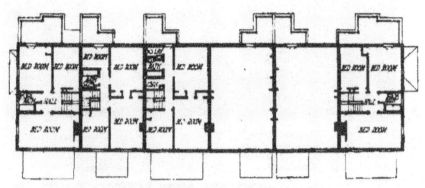

Second Floor Plan of Six-House Group

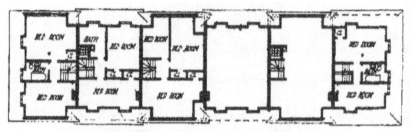

Third Floor Plan of Six-House Group

Top: Second-floor plan of a group of six houses built on Guilford Terrace in 1916 by the Mueller Construction Company, designed by Flournoy and Flournoy, Architects. *From the Architectural Forum, 1918.*

Bottom: Third-floor plan of a group of six houses built on Guilford Terrace in 1916 by the Mueller Construction Company, designed by Flournoy and Flournoy, Architects. *From the Architectural Forum, 1918.*

Construction by the Mueller companies resumed after war rationing ended in 1919 with a group of eight houses at 3401–3415 Oakenshaw Place, followed by two groups on East University Parkway, nine townhouses at 218–234 and a group of twenty-two townhouses at 312–354. John Leo Mueller (1858–1923), vice president of the Mueller Construction Company, purchased and lived at 314 East University Parkway, and his brother Maximillian V. Mueller purchased 312 East University Parkway for his home.

In 1922, the Mueller Company built a group of nine townhouses at 200–216 East University Parkway, and the following year, it built eight

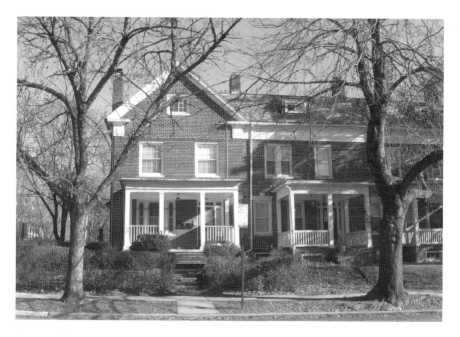

A group of houses on East University Parkway, including 212 and 214 (*both shown*), was built by the Mueller Construction Company in 1919, designed by Flournoy and Flournoy, Architects. *Author's collection.*

townhouses at 3400–3414 Oakenshaw Place. Louis A. Mueller, president and general manager of the Mueller Construction Company, first occupied 3408 Guilford Terrace (1918–1920) and then 226 East University Parkway (1920–1921) before purchasing 200 East University Parkway as his home.

A large group of fourteen homes designed by Flournoy and Flournoy, Architects, was built by the Mueller Company at 3412–3438 University Place in 1924, and six houses were built at 3501–3511 Calvert Street the same year. The last Flournoy and Flournoy–designed townhouses built by the Mueller Construction Company were at 3413–3521 Calvert Street, built in 1926, and the duplex at 3523 Calvert Street–201 Southway, built in 1926–1927. The duplex is only half in the Oakenshawe Historic District; the 201 Southway half is located in the Guilford Historic District.[134]

In a departure from its earlier homes in Oakenshawe, the Mueller Construction Company employed one of its own as an architect for some of its later construction in Oakenshawe. Matthew G. Mueller (1889–1975) designed the group of four homes at 228–234 Homewood Terrace, built in 1921, as well as the group of four homes at 3401–3407 University Place, built the same year. He also designed the large group of fourteen

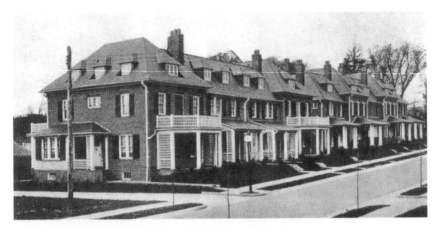

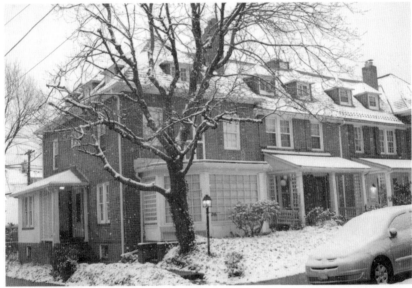

This page: Mueller-built houses from Group D on Guilford Terrace, designed by Flournoy and Flournoy, Architects, constructed spring of 1917 (*top*) and the same group of houses in 2016 (*bottom*). The end house is 3408 Guilford Terrace. *Top: From the* Architectural Forum, *1918. Bottom: Author's collection.*

Opposite, top: Mueller–built house designed by Flournoy and Flournoy, Architects, at 226 East University Parkway, constructed in 1919. *Author's collection.*

Opposite, bottom: Mueller-built house at 200 East University Parkway, designed by Flournoy and Flournoy, Architects, constructed in 1922. *Author's collection.*

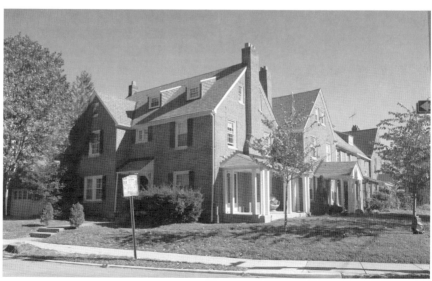

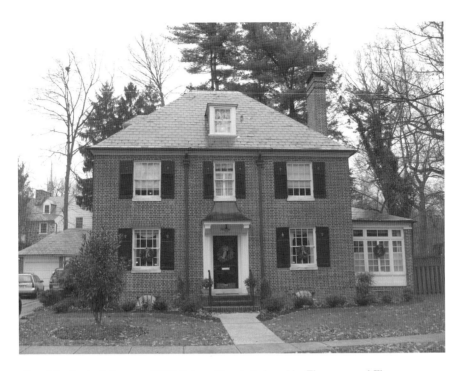

Above: Mueller-built house at 3516 Calvert Street, designed by Flournoy and Flournoy, Architects, constructed in 1924. *Opposite, top*: Mueller-built houses at 352 East University Parkway, designed by Flournoy and Flournoy, Architects, constructed in 1919. *Opposite, bottom*: Mueller-built houses at 3409 University Place, designed by Matthew G. Mueller, constructed in 1922. *Author's collection*.

homes built at 3409–3435 University Place in 1922 and fourteen homes at 200–226 Homewood Terrace built the following year. Matthew G. Mueller was not only an architect for the Mueller Construction Company but also its treasurer. He lived at 352 East University Parkway before he purchased and lived at 3409 University Place.

Most of the land comprising Oakenshawe today was acquired in three purchases by the Mueller companies—the 1914 purchase of the old Henry R. Wilson estate by the Phillip C. Mueller Construction Company and two 1919 purchases, one consisting of land lying between its 1914 purchase and Barclay Street from a Wilson heir, William Patterson, and a second purchase from the Realty Improvement Association of land at University Place and East University Parkway. Parcels from these purchases were divested by the Mueller companies to other builders. A tract of the original 1914 land purchase was sold to W.T. Childs for James Keelty. Keelty also developed tracts in Peabody Heights, south of University Parkway. Keelty

Keelty and Childs built this house group, designed in the Dutch Colonial Revival style by Frederick Beall, at 300–312 East University Parkway in 1917. *Author's collection.*

hired Frederick E. Beall to design his houses and W.T. Childs to build them. They built a group of six Dutch Colonial Revival houses at 300–312 East University Parkway in 1917 and a group of seven houses at 3400–3410½ University Place the same year.

The Oakenshawe houses on the south side of East University Parkway (303–331) were designed by Stanislaus Russell and constructed by the Guilford Building Company in 1917 on land acquired from Wilson heirs. Two years later, the same team built the apartment building at 301 East University Parkway.

The row house groups on Birkwood Place were built by George A. Cook on land he acquired from the Mueller Company in 1919. Designed by William B. Gerwig, three groups of row houses were constructed in 1923, consisting of two groups of eleven (300–320 and 301–321) and a group of four (323–329). Cook was best known for the many houses he built in Peabody Heights, now Charles Village; his architect for those buildings was Jacob F. Gerwig, probably related to William B. Gerwig.

The Gothic Revival apartment building at 300A East University Parkway, then known as Temple Court, was designed by John Freund Jr. and constructed by the Guilford Building Company. Land for this

Right: Group of houses at 303–331 East University Parkway, built by the Guilford Construction Company in 1917, designed by Stanislaus Russell. *From the National Register of Historic Places registration form for Oakenshawe.*

Below: A group of houses built on Birkwood Place by George A. Cook, designed by William B. Gerwig, constructed in 1923. *Author's collection.*

construction was acquired by the Lutheran Church from the 1914 Mueller purchase. It was still listed as church property as late as 1920, when it was acquired by the Guilford Building Company. Construction was completed in December 1920.

A Temple Court apartment was the subject of a lawsuit, which helps to date the building's construction. In the suit, William Y. Goldsborough leased a three-bedroom apartment on the third floor of the building prior to its completion. The rental agreement was made in August 1920 with the owners, the Guilford Building Company. Mr. Goldsborough leased the

Apartment building at 300A East University Parkway, built in 1920 by the Guilford Building Company, designed by John Freund Jr. *From the National Register of Historic Places registration form for Oakenshawe.*

apartment containing two baths, a kitchen, a dining room and a living room for $150 per month for a period of one year with a one-month deposit given in August to hold the apartment. At the time, the expected completion date was October 1920. When construction was not complete in October, Mr. Goldsborough extended the lease of his then-current apartment until the end of October but had to move out at that time. He moved into the Temple Court apartment on October 25, but construction was still not complete. Temporary boards were in the place of stairs and hallways, the electrical system was not operating, the heating system was inoperable and not fully installed, and one of the bathrooms in his apartment could not be used because it was not yet tiled and had no running water. The construction was completed on December 15, 1920. The suit was to determine the time that Mr. Goldsborough's year lease should commence—he claimed it should begin when the apartment was completed, and the builder claimed that it started on the day he moved in. A compromise was mediated by the courts.[135]

Construction details for the buildings in the east portion of Oakenshawe, formerly included in Waverly, are less well known than Mueller construction in Oakenshawe, partly because the houses east of Barclay Street are older in origin and probably replaced earlier construction. The twenty-seven detached or duplex houses on Calvin Avenue were constructed in two segments, the south side in 1887 and the north side in 1888. Calvin Avenue did not exist in 1877 but appears on maps in 1887. It is generally conceded that Calvin Avenue was the first racially integrated street in America.[136]

Venable Avenue is visible on 1877 maps. It was known previously as Wilson Street, then as Henderson Lane and Henderson Street. Fourteen structures remain on Venable Avenue; all reside in Oakenshawe except those fronting on Greenmount Avenue. The Oakenshawe Historic District

A Victorian-style house built on Calvin Avenue, builder and architect unknown. The first houses built on the south side of Calvin Avenue were constructed in 1887. *Author's collection.*

A pair of Victorian Gothic–style houses built on Calvin Avenue, builder and architect unknown. The first houses built on the north side of Calvin Avenue were constructed in 1888. *Author's collection.*

includes three duplexes (400–402, 404–406 and 408–410 Venable Avenue) and three detached houses (407, 409 and 411). The remaining structures on Venable Avenue within the Oakenshawe Historic District are eight garages in disrepair, now apparently used for storage. The group of three townhouses at 413–419 Venable Avenue and a garage are not included in the historic district, because they were built in the 1940s—historic designation is limited to construction prior to 1929. The house at 411 Venable Street is reported to be the oldest in the neighborhood,[137] constructed prior to 1890. The Italianate houses on Calvin Avenue were probably built prior to 1890, and many of the Victorian houses on Barclay Street and Venable Street may have preceded 1890. Victorian and Italianate designs were common in the last half of the nineteenth century, and several of these houses have common architectural details.

According to Dean R. Wagner, the structures on Brentwood Avenue north of Venable Avenue were constructed between 1919 and 1929, apparently replacing houses that stood on the lots prior to 1877. The three structures at 3402, 3404 and 3416 Brentwood Avenue are now used for

The house at 411 Venable Avenue, builder and architect unknown. It is reported to be the oldest house in the Oakenshawe Historic District, built in 1890. *Author's collection.*

A pair of Victorian Gothic houses on Barclay Street. *Author's collection.*

private, commercial purposes (probably car repair services) and are not dwelling units.

J.S. Nussear Jr. is thought to have designed a Victorian Gothic house at 3307 Barclay Street that was built in 1926.[138] The houses on this block (3401, 3403, 3409, 3411, 3413 and 3501–3503) appear similar and may have been designed by the same architect or builder; they were probably built in the same time period. The similarity of the group to houses at 407 and 409 Venable Avenue and several on Calvin Avenue (402–404, 410–413 and 418–421) leads one to speculate whether all of these houses shared a common builder or architect. The Venable Avenue and Calvin Avenue houses also appear to be of a similar vintage as the Barclay Street group.

Commercial properties in the Oakenshawe Historic District consist of a hair salon at 354 East University Parkway, an auto repair shop at 3304 Barclay Street and a car wash and service business at 3303 Barclay Street. The evolution of the neighborhood from its inception in 1916 to its conclusion in 1926 is shown in a series of area maps from 1917, 1919, 1922 and 1926.

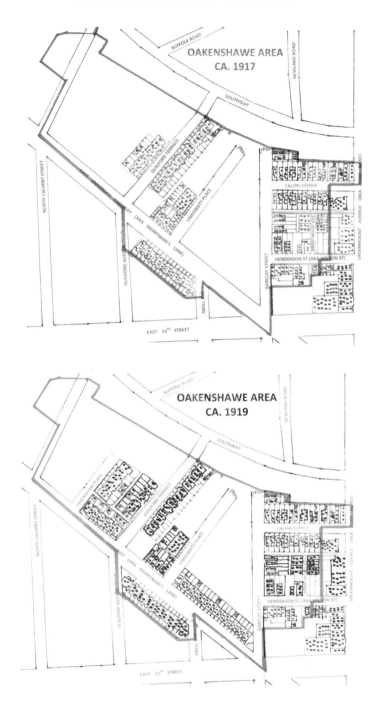

This page and opposite: The Oakenshawe Historic District indicating buildings existing in 1917, 1919, 1922 and 1926. *Author's modification of the Historic District Map.*

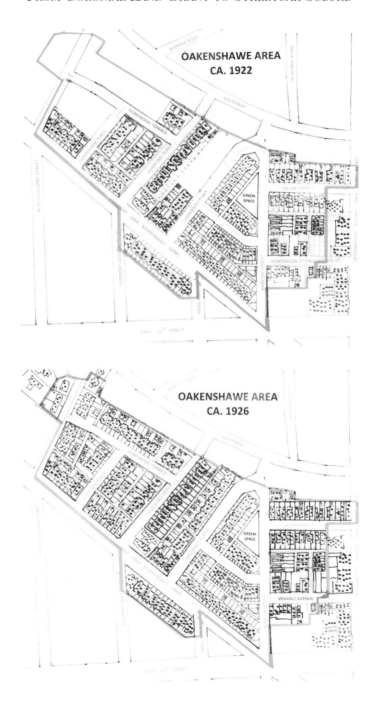

THE MUELLER BUILDING COMPANIES

The Oakenshawe development was originally conceived by Philip C. Mueller (1856–1914). He formed the Philip C. Mueller Building Company to build homes on land he acquired from the trust estate of Sallie Wilson known as Okenshaw. The estate was a portion of the much larger summer estate of James and Mary Wilson, left to their son Henry R. Wilson upon their deaths. Technically, the Okenshaw estate was left to Henry's wife and children, thus protecting it from potential creditors of any of the several businesses started or operated by Henry. Sallie preceded Henry in death, and he continued to occupy the estate until his death in 1908. On April 14, 1914, the estate was sold by their two surviving children for $57,000 to the Philip C. Mueller Building Company.[139]

After purchasing the property, Philip C. Mueller suddenly died on August 28 the same year. The Philip C. Mueller Building Company survived him as a corporate entity, and the Mueller Construction Company was later formed by his brothers, John L. (1858–1923), George A. (1864–1949) and Louis A. (1873–1945). George's son Matthew G. (1889–1975) also joined the company and later Louis's son, Maximillian A. Mueller, joined the firm. Louis became president and general manager of the Mueller Construction Company, John was vice president, George was secretary and Matthew was treasurer. Offices were located at 22 Gunther Building at Fayette and St. Paul Streets in Baltimore.

Two additional lots were acquired by the Mueller companies from William Patterson, a Wilson heir, for development in 1919. Portions of both these and the 1914 land purchases were sold by the Mueller companies to other owner-builders, including the Lutheran Church, James Keelty, the Guilford Building Company and George A. Cook.[140]

Oakenshawe houses were designed for the Philip C. Mueller Building Company in the Neoclassical Revival and Colonial Revival styles by Flournoy and Flournoy, Architects, a Washington, D.C., firm that opened an office in Baltimore in 1913. The Neoclassical and Colonial Revival houses incorporated elements of Georgian Revival, similar to Homewood House on the Johns Hopkins University campus,[141] as well as Arts and Crafts elements like small window repeats and clipped gables.[142] These designs, based on the fashionable daylight type recently employed by Edward L. Palmer Jr. for homes in Roland Park, are presumed to have been completed before the 1914 purchase of land for the Oakenshawe development. Daylight houses boasted natural daylight in every room, accomplished in middle

rooms by the use of transoms from roof skylights. It took two years for the Mueller brothers to reorganize and execute the building plans of Philip, and construction began on the Oakenshawe terraced townhouse groups in the fall of 1916.

At least seven architects designed homes built in Oakenshawe, including Flournoy and Flournoy, Frederick E. Beall, Stanislaus Russell, Matthew G. Mueller and William B. Gerwig. John Freund designed the Gothic Revival building at 300A East University Parkway, and at least one home on Barclay Street (3307) is attributed to J.S. Nussear Jr.[143]

Despite the number of independent architects that designed homes for the Oakenshawe development, a cohesive appearance exists within the community. The primary architectural styles represented in Oakenshawe are Neoclassical Revival, Colonial Revival and Dutch Colonial Revival, while Victorian Gothic and Italianate are represented by the older homes east of Barclay Street.

Philip C. Mueller was born in Bavaria and was a member of the famed building family. The Mueller patriarch in Baltimore, Matthias Mueller, moved the family to Baltimore in the mid-nineteenth century. The family of Matthias Mueller consisted of the parents, eight sons and two daughters. They created a building empire in Baltimore, having established building supply companies, real estate offices and building companies and managed home and loan associations. They capitalized on the ground rent system in Baltimore, offering to sell a lot to one person, build a house on it for a second person using a Mueller-owned building company and materials obtained from a Mueller-owned supply house and then finance all of the purchases through one of the home and loan organizations managed by the family. They are largely responsible for the construction of the historic Brewer's Hill neighborhood in east Baltimore. The Philip C. Mueller Building Company was formed by the oldest son to build in the affluent northern suburbs of Baltimore. The original offices at 500 North Milton Street later moved to 22 Gunther Building.

Philip C. Mueller was a devout Catholic and state deputy for Maryland of the Grand Knights Council, Baltimore Chapter #205. He died in Baltimore on August 28, 1914, at the age of sixty-eight.[144] His brothers John, George and Louis Mueller were builders and maintained the Northeastern General Supply Company on Patterson Park Avenue. After Philip's death, the brothers formed the Mueller Construction Company and maintained both companies as builders in Oakenshawe as well as other projects in Baltimore. Two younger Muellers were also principals in the new firm: George's son, Matthew G. Mueller, and Max A. Mueller, son of Louis. Matthew once

resided at 29 Quick Avenue in Gardenville, according to census records; this was probably the family home. The last will and testament of Philip C. Mueller, "late of Baltimore County," is registered at WJP Liber 17 folio 453. His bequests include $5,500 to Catholic organizations in the city.

A notice in the 1916 *American Contractor* stated that the Philip C. Mueller Building Company was building eighteen two-and-a-half-story Colonial-style brick dwellings with tile baths in Guilford Park for $70,000. The architects of record for the construction were Flournoy and Flournoy at 1417 John Street. This confirms that the Philip C. Mueller Building Company continued after the death of its founder in addition to the newly formed Mueller Construction Company. The Mueller Construction Company continued to employ Flournoy and Flournoy as architects, as stated in the *Roland Park Magazine* in 1931, for many of the homes it built in Baltimore. Its designs included a pair of semidetached homes built on the corner of Calvert Street and Southway in April 1927.[145] The Mueller Construction Company also constructed buildings in Roland Park (402 Woodlawn Road), Homeland (204 Enfield Road) and Guilford (3808–3810 Juniper Road). A 1917 advertisement in the Baltimore City Directory for Oakenshawe homes describes them with the following amenities:

These houses are located in the most beautiful and exclusive section of Baltimore. They are of charming appearance, and designed with regard to comfort and convenience as well. No two houses are alike, all porches are separate, and they were planned with a view toward securing privacy and individuality. The construction of these homes makes it now possible to purchase at a relatively low figure, on liberal terms, a beautiful home in a beautiful section of town. These houses are constructed of natural brick, with touches of white beam trimmings and slate roofs. The porches have floors of Welsh tiles, laid in white cement, bordered by lawns. Low, terraced front. Description of Houses, There are nine rooms and two baths. The trimmings are white and mahogany throughout. Decorations and lighting are of the best quality and are tastefully selected. On the first floor is a large reception room and stairway, with a coat closet, a living room with open fireplace and chute to empty ashes directly into basement receptacle. The dining-room has a built in closet. Hardwood floors. The kitchen has a generous-sized white enameled one-piece sink and drain board, a white enameled gas range, a white enameled kitchen cabinet and a pantry and broom closet. The basement contains one of the best systems of hot water heat, A Rudd instantaneous water heater and servant's toilet. The second

floor contains three bedrooms with ample closet space, a bath, with built-in tub and shower, pedestal washstand, medicine cabinet, tiled floor and wainscoting. The third floor contains two bedrooms and a bath. Only by actual inspection of these homes will their location, beauty and comfort be realized. HOW TO GET THERE Take Boulevard or St. Paul street car, marked "Guilford" or "Roland Park". Get off at St. Paul street and University Parkway (main entrance to Guilford). Walk through Guilford on Chancery road, to Southway, to Guilford Terrace. Or walk east on University Parkway (formerly Merryman Lane) to Guilford Terrace.

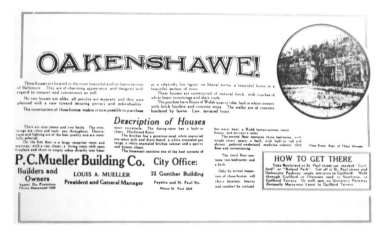

Top: A 1917 Mueller Construction Company advertisement for sale of houses in the Oakenshawe subdivision. *From the* 1917 Baltimore City Directory, *courtesy Baltimore City Archives.*

Bottom: A Mueller Construction Company advertisement for houses in Oakenshawe in 1921 listing John Leo Mueller as vice president. *From* Polk's Baltimore City Directory 1921, *courtesy Enoch Pratt Free Library.*

A 1923 advertisement for the Mueller Construction Company in *Polk's Baltimore City Directory* refers to Oakenshawe and gives a local phone number of Homewood 4945 and the Gunther Building address with phone Plaza 2236.[146]

Louis A. Mueller (1873–1945) was the youngest of the four brothers. Louis was president and general manager of the Mueller Construction Company. Prior to the Oakenshawe development, he was a principal in Northeastern Supply Company on Patterson Park Avenue. He was also a principal in another building supply firm, Bauer & Company. After his brother's death in 1914, he continued the Philip C. Mueller Building Company and later formed the Mueller Construction Company with his brothers. He married Eleanor "Ella" K. Mueller, and they lived at 809 North Patterson Park Avenue as late as 1917. In 1918, Louis and Ella moved into the newly completed home at 3408 Guilford Terrace, and they lived there until 1920, when they moved to 226 East University Parkway. In 1922, they moved to 200 East University Parkway, where they lived out their lives. Like his brother Philip, Louis was a member of the Grand Knight's Council (Baltimore Chapter #205) and president of the council. He is listed as a builder in the 1910 census, married to Eleanor, with two children, Charlotte K. and Maximillian. In 1940, he is listed as president of a construction company.

John Leo Mueller Sr. (1858–1923), the oldest surviving brother, was also a principal in the Northeastern Supply Company and lived on Maple Avenue in Overlea. His wife was Mary C. Mueller. He continued to live in Overlea until 1921, when he and his family moved to 314 East University Parkway. He is listed as vice president of the Mueller Construction Company in a 1921 advertisement for Oakenshawe but not in a 1923 ad for the company; he resigned from the construction company in 1922 due to poor health and died the following year. His widow continued to reside at 314 East University Parkway after his death. John's brother Maximillian V. Mueller lived next door at 312 East University Parkway. John's son, John Leo Mueller Jr., became involved with the Northeastern Supply Company as its treasurer after Louis formed the Mueller Construction Company. John L. Mueller Jr. lived at 639 North Patterson Park Avenue until 1922, when he moved to 352 East University Parkway in Oakenshawe.

George A. Mueller (1864–1949) was secretary of the Mueller Construction Company from its beginning. His wife was Elizabeth A. Mueller, and they lived at 29 Quick Avenue in Gardenville, near Belair Road. He is listed in the census as a builder. They had a large family, with at least four sons and

Right: George Adam Mueller, secretary of the Mueller Construction Company. *Courtesy of Amanda Gutberlet.*

Below: A Mueller Construction Company advertisement for houses in Oakenshawe in 1923 no longer lists John Leo Mueller as vice president; he retired the previous year. *From the 1923 Baltimore City Directory, courtesy Enoch Pratt Free Library.*

four daughters, including Matthew G. Mueller and Philip C. Mueller (the younger), born in 1897.

Matthew G. Mueller (1889–1975) lived at the 29 Quick Avenue address of his father, George, after he married Mary L. Agnes Tierney in 1912. They had two children, Lois, Sister of Mercy (1914–2014), and Agness (1916–1978). He became treasurer of the Mueller Construction Company when it was formed in 1918 and was previously associated with the Philip C. Mueller Building Company. His World War I draft card, issued in 1917, describes him as a carpenter employed by the Philip C. Mueller Building Company, tall, slender, with blue eyes and a full head of brown hair; he would have been twenty-eight at the time. He was educated at the Maryland Institute,

became a member of the Maryland Association of Engineers, practiced architecture and building and built nearly one thousand homes in Baltimore before his retirement in 1965.[147] Like his uncles Philip and Louis, he was a member of the Knights of Columbus and the Alhambra Association.[148] He lived at 352 East University Parkway until 1921, when his cousin John Leo Mueller Jr. moved there. Matthew then purchased and moved his family to 3409 University Place; he later moved his family to Davis Granit, Maryland, and sold the house at 3409 University Place.

Maximillian V. Mueller (1875–1944), a son of Louis A. Mueller, married Mary and was a partner in the grocery supply firm Philip C. Mueller & Company; prior to 1916 he lived at 1931 East Baltimore Street. The company was formed by his cousin Philip, a son of George A. Mueller, at 2100 Canton

This page: John Leo Mueller (*left*) and Max V. Mueller (*right*) next to the home of Max Mueller, 312 East University Parkway, while standing on University Place, ca. 1922. *Both, courtesy of Bruce Mueller.*

Street. The company is variously described as dealing in groceries, cereals and rice at 2122–2126 Cambridge Street. In 1916, he lived at 2222 East Lombard Street, and he later lived at 2304 Mount Royal Terrace. In 1923, he is listed as president of the King Electric Washing Machine Company and living at 312 East University Parkway, next door to Mary C. Mueller, the widow of John Leo Mueller, at 314 East University Parkway. Philip C. Mueller Jr. is listed as vice president of the King Electric Washing Machine Company in 1928.

Maximillian A. Mueller was born in 1902. He was a student in 1920 living with his parents, Louis A. and Ella Mueller, at 226 University Parkway. In 1923, he joined the Mueller Construction Company and lived with his parents at 200 University Parkway, where they moved in 1922. In 1926, he is listed as vice president of the Mueller Construction Company, living at 3401 North Calvert Street and married to Theresa B. Mueller.

OTHER BUILDERS

The original purchase of the Okenshaw estate by the Philip C. Mueller Building Company in 1914 consisted of the western portion of the current neighborhood.[149] The 1919 purchases by the Mueller Construction Company included a purchase on August 16 from the Realty Improvement Company. This was the southern portion of the original lot acquired by James Wilson on September 3, 1802,[150] including a lot from the Lutheran Church Extension Society of Baltimore[151] and an adjacent lot along East University Parkway.[152] A second lot included in the same purchase lay at the corner of Merryman's Lane (East University Parkway) and Barclay Street "to the land formerly owned by A.S. Abell" (i.e., to Southway) and to the land conveyed from William C. Wilson to Mary Wilson Patterson on July 3, 1873.[153] These were "the same two lots of ground deeded September 13, 1916, conveyed by John Dunn and wife to the Realty Improvement Company."[154] An earlier purchase by the Mueller Construction Company, on August 12, 1919, conveyed property from the Realty Improvement Company. This lot included property west of the other Realty Improvement Company purchases, between Barclay Street and University Place.[155] Some smaller lots from these Mueller purchases were sold to other builders, and these builders constructed row houses similar in style to adjacent Mueller-built houses.

R.C. Boone built the Gothic-style Baltimore City Jail at 801 Van Buren Street and East Madison Street. He also built the Fifth Regiment Armory, the Maryvale School, St. Mary's Industrial School (now Cardinal Gibbons) and other buildings around Baltimore.[156] He is listed in the application for Oakenshawe's National Register of Historic Places Designation without any specific attribution.[157]

George A. Cook, of Ilchester Avenue, was a Baltimore builder. He was heavily involved in building the Peabody Heights neighborhood to the south of Oakenshawe and frequently employed Jacob F. Gerwig to design his buildings. He employed William B. Gerwig to build houses on Birkwood Place.

James F. Keelty was born in Ireland. He came to Baltimore and founded a home building company in 1904; it still exists as Keelty Builders. He built many row houses in Baltimore. One of his first large projects was Edmondson Village. In 1924, he purchased an eighty-six-acre dairy farm north of the city where he planned to build a community; this was much derided at the time. It became Rodgers Forge, built over a twenty-year period and finished by his sons due to the increasingly poor health of their father. The first houses in Rodgers Forge were sold in 1934. His son James S. Keelty Jr. was instrumental in bringing the St. Louis Browns to Baltimore in 1953, christening them the Baltimore Orioles, and was president of the Orioles from 1955 to 1959.[158] Keelty employed W.T. Childs as his builder in Oakenshawe. Childs acquired the properties where he built 300–310 East University Parkway and 3400–3410½ University Place in two purchases.[159] The first property was acquired from John Dunn on December 23, 1916. Dunn had acquired the lot from William Patterson via Julian S. Carter, who purchased the lot on April 5, 1916,[160] and transferred ownership to Dunn on September 13, 1916.[161] A second property, also along East University Parkway, was acquired by Childs from the Realty Improvement Company. The same deed states that the Realty Improvement Company would build a street named University Place "as prepared to be laid out by Realty Improvement Company, 60 foot wide at right angle to University Parkway, recently widened." A W.T. Childs was comptroller of Maryland in the early 1900s. Whether he is the same person as the builder in Oakenshawe is unknown.[162] Keelty and Cook employed Frederick Edgar Beall to design the houses built on East University Parkway and University Place.

The Guilford Building Company was responsible for a group of houses built in 1917 on East University Parkway (303–331) as well as apartment buildings at 301 East University Parkway (built in 1919) and 300A East

University Parkway (built in 1920).[163] The Guilford Building Company also constructed a building at Thirty-Fourth Street and Guilford Avenue and apartment buildings at the northwest corner of Charles Street Avenue and Wyndhurst Road and the southeast corner of Madison Avenue and Biddle Street in Baltimore. The company is listed from 1917 to 1921 in the tax rolls and probably existed much earlier and longer than that.

The Architects

A wide range of architects designed houses in Oakenshawe. Some were highly educated in design and engineering; others first gained skill as laborers and carpenters, then moved into the design side of the industry with no formal education. Some designed large, expensive, high-end buildings for clients like universities, public schools and churches, and others designed smaller, residential, two- or three-story homes and row houses. Some worked out of a small office for one or more local builders, while others worked from branch offices of larger concerns. Some only built a few housing units for select clients, and others built hundreds of housing units across the city and beyond. Many were born and raised in Baltimore; some came to Baltimore later in life. Some stayed in Baltimore after retirement, and others left the city. The list below contains known architects who designed housing units for Oakenshawe. Some have abundant information available describing their lives and careers, while others are lesser known, and descriptions of their lives and careers have faded into obscurity.

Parke Poindexter Flournoy Jr. (1873–1951) and his brother Benjamin Courtland Flournoy (1876–1939) were born and raised in Bethesda, Maryland, and educated at the Hampden-Sydney School in Virginia, alma mater of their father, Parke Poindexter Flournoy Sr., AM, DD, LittD (1839–1935), a well-known and widely read Presbyterian minister, writer and lecturer. There were eight children in the family, all born in either Rockville or Bethesda. In 1920, the parents moved to Georgetown.

Parke P. Flournoy Jr. was an 1892 graduate of Hampden-Sydney. He was employed as an architect early in his career by federal agencies in Washington, D.C., including the Agriculture and Treasury Departments. He was a member of Phi Gamma Delta and the Delta Deuteron Chapter at Hampden-Sydney. He was a senior member of Flournoy and Flournoy, Architects, at 1517 N Street, NW, in Washington, D.C.; he started the firm

with his brothers Benjamin and Addison.[164] He moved to 1417 John Street in Baltimore in 1913 and started a branch of the firm there. He lived in Baltimore the rest of his life. The Baltimore offices of the company were variously at the John Street address, 306 St. Paul Street (1921–1928) or 334 St. Paul Street (1929). Flournoy and Flournoy were the unofficial architects for Washington and Lee University in Virginia, designing several of the buildings on campus, including the Doremus Gymnasium, dining hall, Newcomb Hall, library and chemistry building, among others. They also designed buildings for the University of Maryland in College Park, the Glenmont School and the Samuel Taylor Coleridge School in Baltimore. In addition to the Oakenshawe neighborhood, their projects included 204 Enfield Road (Homewood); a pair of houses on McCulloh Street and the duplex at Calvert Street and Southway for the Roland Park Company in 1927; houses on Springlake Way, including 4805 (1927 and 1929), Taplow Road (1927) and Paddington Road (1928) in Homewood and 205 Paddington Way (1929). Parke Flournoy Jr. died in Baltimore at the age of seventy-eight.[165]

Benjamin C. Flournoy, like his father and brother, attended Hampden-Sydney, lived for a while in Washington, D.C., and then went to Washington and Lee University in 1893, graduating in 1897. He was a member of Phi Gamma Delta and was initiated into the Zeta Dueteron Chapter at Washington and Lee his first year.[166] He was a rodman for the Baltimore & Ohio Railroad and helped survey the Harpers Ferry Tunnel. He taught for two years and studied architecture at George Washington University in Washington, D.C., then called Columbia College. He was a draftsman for the bridge department of the New York Central Railroad and designed the renowned U.S. Post Office building at Jackson Heights, Flushing, Queens. He resigned after one year and accepted a position in the Office of the Supervising Architect of the United States. In 1905, he won the $500 Brickbuilder Prize for his design in a fireproof house competition. His building

Benjamin Courtland Flournoy, founding partner in Flournoy and Flournoy, Architects, of Washington, D.C. *Sketched from his obituary by Joanna Barnum, author's collection.*

designs for the federal government ranged from $40,000 to $1 million. When he left government employ, he spent several years traveling through Europe studying building design. When he returned to Washington around 1907, he and his brothers organized Flournoy and Flournoy, Architects, and specialized in college buildings. The firm won a competition in 1913 for the dormitories it designed for the Maryland Agricultural College. The firm designed the Church of the Pilgrims, Second South Presbyterian, at 2201 P Street, NW, in Washington in 1929 and the Lexington Baptist Church at 1517 H Street in Chevy Chase, Maryland. Flournoy and Flournoy's Baltimore office designed Oakenshawe houses on Guilford Terrace (3409–3443 and 3408–3424), Oakenshaw Place (3401–3415 and 3400–3414), East University Parkway (200–216, 218–234 and 312–354), University Place (3412–3438) and Calvert Street (3413–3421, 3412–3416, 3501–3511 and the duplex at 3523 with 201 Southway).

Stanislaus Russell (1876–1958) designed the houses at 303–331 East University Parkway and the apartment building at 301 East University Parkway. His office was located at 11 East Lexington Street in Baltimore. He was born in Orlean, Fauquier County, Virginia, and educated at Hume, Virginia. His parents were Thomas Alfred Russell and Emma J. Payne. He was a devout Catholic and married Harriet Lewis Triplett. She was also born in Orlean. They had two sons before she died in 1932. After the death of his first wife, he married Lily Morton (1885–1965), who had two daughters by a previous marriage. He came to Baltimore shortly after graduating from Drexel University in 1903 and lived at 3210 Howard Park Avenue. He worked for his father as a builder before college and after college worked in Philadelphia at the T.P. Chandler architectural firm for a short time before starting his own firm in Baltimore in 1905. Russell designed "hundreds of Baltimore City buildings."[167] He died after a long illness at the age of eighty-two.[168] His son Thomas Triplett Russell went to Miami, Florida, in the 1930s and also became an influential architect.

Frederick Edgar Beall (1885–1946) designed the Dutch Colonial Revival group of townhouses at 300–310 East University Parkway and the two-story row houses at 3400–3410½ University Place. He was born in Baltimore and lived there all his life. His parents were William Francis Beall and Mary Katherine Wehr. He was a self-employed architect with an office at 334 St. Paul Street, later working out of 3065 St. Paul Street and 1335 Gilmor Street, and retired in 1942, when he registered for World War II. He designed homes throughout Baltimore, including on Franklin, Mulberry

Apartment building at 301 East University Parkway constructed in 1920 by the Guilford Building Company, designed by Stanislaus Russell, architect. *From the National Register of Historic Places registration form for Oakenshawe.*

and Dennison Streets, Gwynns Avenue and Canterbury Road. He married Mary Elizabeth Linnbaum (1882–1957), and they had a son. They were a religious family and lived at 4508 Wakefield Road. He is buried at Most Holy Redeemer Cemetery in Baltimore.

John Freund Jr., sometimes considered a little-known Baltimore architect, worked in Baltimore from 1905 to 1930. He had an office at 1307 St. Paul Street. He is best known for designing the Riviera Apartment Building at 901 Druid Hill Park Drive in Reservoir Hill for $500,000 in 1914.[169] It was his most ambitious structure and combined Beaux-Arts and Renaissance Revival styles, popular at the time. When completed, the six-story brick and cast stone building was called "the handsomest and most costly"[170] residence in the city. From 1915 to 1960, the Riviera was one of the most prominent addresses in the city. Mostly Jewish families lived there.[171] Freund created many smaller apartment houses and residences in Reservoir Hill as well as business buildings throughout town. His last project was Berman's Theater at 1 South High Street.[172] He designed the apartment building at 300A East University Parkway.

William B. Gerwig designed houses for George A. Cook on Birkwood Place (300–320, 301–321 and 323–329). Gerwig was the architect of thirty-two two-story dwellings near Poplar Grove Street in Baltimore in 1915. He was also the architect for twenty-five two-story houses in the northern section of Guilford Avenue between Twenty-Eighth and Twenty-Ninth Streets for George A. Cook as late as 1944. It is likely that Jacob F. Gerwig was a relative, but their relationship is unclear—the Baltimore branch of the Gerwig family is large and complex. Jacob F. Gerwig was a carpenter turned architect with no formal training in design[173] whose firm was at 210

East Lexington Street. He was a favorite architect of George A. Cook for his buildings in Peabody Heights, now Charles Village, between 1905 and 1919. Jacob F. Gerwig began designs in the 1890s for two- and three-story swell-front row houses at Auchentoroly Terrace in Druid Hill Park and later designed over forty two- and three-story row house units for the Peabody Heights Company. In 1911 alone, he worked on over twenty projects for as many builders, never repeating a design.

James S. Nussear Jr. possibly worked at the architectural firm of Dixon, Balbimie & Dixon and designed houses in Roland Park. He had an office at 324 North Charles Street in 1920. He is thought to have designed the "non-contributing structure"[174] at 3307 Barclay Street and may have designed other structures in the Oakenshawe area.

Matthew G. Mueller (1889–1975) designed the townhouses at 3401–3407 and 3409–3435 University Place and at 228–234 and 200–226 Homewood Terrace. He was born and educated in Baltimore, where he attended the Maryland Institute. He worked for the Philip C. Mueller Building Company while his uncle Philip C. Mueller was living. He became treasurer of the Mueller Construction Company when it was formed in 1916.

OAKENSHAWE TODAY

T oday, Oakenshawe is a neighborhood in north Baltimore much sought after for its attractive, well-built homes, lovely landscaping, convenient location, friendly neighbors and low crime rate. Like Guilford to its north and west, it is primarily a residential neighborhood. Oakenshawe is bordered on the east and south by Waverly and Charles Village/Abell, which contain both residential and commercial areas. The nonresidential buildings in Oakenshawe include a beauty salon at 354 University Parkway and auto repair shop at 3304–3313 Barclay Street, several private auto service buildings on Brentwood Avenue and the structure at 430 Calvin Street (also known as 3410 Greenmount Avenue) that contains a shoe shop, holistic products shop and hair-braiding salon.

Oakenshawe consists of 328 structures, including 246 dwellings (mostly terraced townhomes and single-family dwellings or duplexes), 2 apartment buildings and 80 ancillary structures (mostly freestanding garages). Three structures were originally designed as divided apartments: 300A East University Parkway, 301 East University Parkway and 3438 University Place. The University Place structure has since been converted to a single-family dwelling.

Oakenshawe was built between 1916 and 1926 on land acquired between 1914 and 1919 for the purpose of building a subdivision. A portion of the neighborhood east of Barclay Street was once a part of Waverly, including the residential properties on Barclay Street and Calvin and Venable Avenues. The properties west of Greenmount Avenue, not included in the

Map of the Oakenshawe neighborhood and its surroundings. *From* North Baltimore from Estate to Development.

Waverly business district, were annexed to Oakenshawe sometime in the mid-twentieth century.

The commercial and public properties along York Road (Greenmount Avenue) still reside within the Waverly Business District, along with the Waverly branch of the Enoch Pratt Free Library, at the corner of Thirty-Third Street and Barclay Street. The single-family homes and townhouses

Left: Interior unit of townhouse group C on Guilford Terrace, built by the Philip C. Mueller Building Company in 1916 and designed by Flournoy and Flournoy, Architects. *From the* Architectural Forum, *1918*.

Below: End unit of townhouse group A on Guilford Terrace, built by the Philip C. Mueller Building Company in 1916 and designed by Flournoy and Flournoy, Architects. *From the* Architectural Record, *1918*.

Top: The townhouse group on Guilford Terrace showing 3414 and 3416, built in the spring of 1917 by the Philip C. Mueller Building Company and designed by Flournoy and Flournoy, Architects. *From the National Register of Historic Places registration form for Oakenshawe.*

Bottom: The apartment building at 300A East University Parkway and the end of the Dutch Colonial group at 300–312 East University Parkway, built in 1917 by James Keelty and W.T. Childs using designs of Frederick W. Beall, architect. *From the National Register of Historic Places registration form for Oakenshawe.*

on Venable Avenue reside in Oakenshawe, but a group of three townhouses east of Brentwood Avenue is not included in the Oakenshawe Historic District because its date of construction falls outside the historic time period. A single property in Oakenshawe exists at 430 Calvin Avenue on Greenmount Avenue.

A group of houses on Wilson Street (now Venable Avenue) east of Barclay Street was built prior to 1877, but the houses currently standing on Venable Avenue were probably constructed later, between 1890 and 1910. Houses on Calvin Avenue were built in 1887 and 1888. The Wilson family developed land along the York Turnpike Road as far west as Barclay Street long before large planned housing developments came to the area. Most of the Wilson land east of Greenmount Avenue and north of Southway was sold by the family prior to 1871.

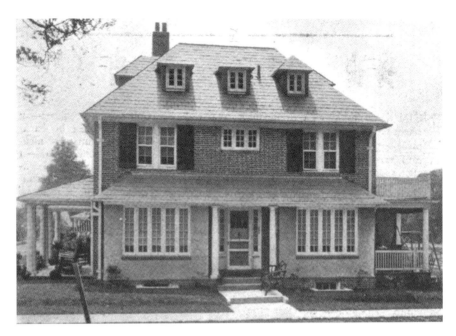

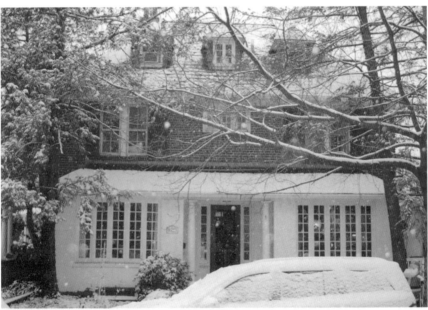

This page: End unit of group E on Guilford Terrace, built in the spring of 1917 by the Philip C. Mueller Building Company, designed by Flournoy and Flournoy, Architects, from 1918 and 2017. *From the* Architectural Record, *1918 (1918 photograph), and author's collection (2017 photograph).*

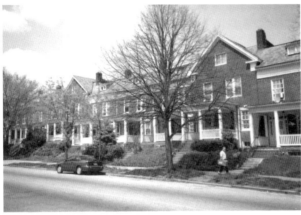

Top: Row house group at 216–228 East University Parkway, built in 1919 by the Mueller Construction Company and designed by Flournoy and Flournoy, Architects. *From the National Register of Historic Places registration form for Oakenshawe.*

Middle: Row house group at 312–354 East University Parkway, built in 1919 by the Mueller Construction Company and designed by Flournoy and Flournoy, Architects. *From the National Register of Historic Places registration form for Oakenshawe.*

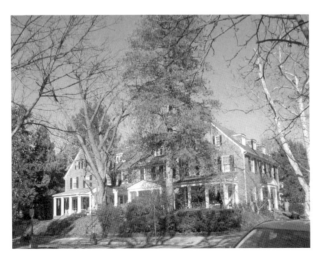

Bottom: The group of townhouses at 228–234 Homewood Terrace, built by the Mueller Construction Company in 1921, designed by Matthew G. Mueller. *Author's collection.*

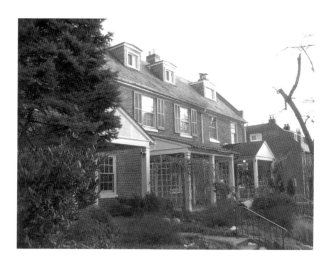

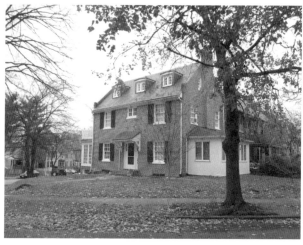

Top: End of the group of houses at 3409–3413 University Place, built by the Mueller Construction Company in 1922, designed by Matthew G. Mueller. *Author's collection.*

Middle: End unit of the townhouse group at 3435 University Place, built by the Mueller Construction Company in 1922, designed by Matthew G. Mueller. *Author's collection.*

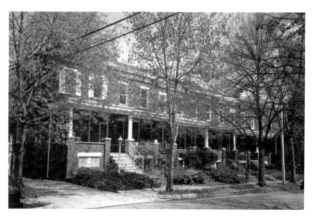

Bottom: A rowhouse group at 300–312 Birkwood Place, built in 1923 by George Cook, designed by William Gerwig. *From the National Register of Historic Places registration form for Oakenshawe.*

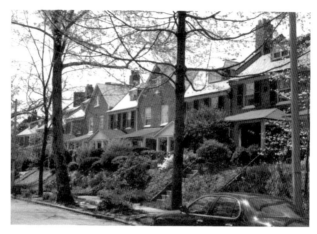

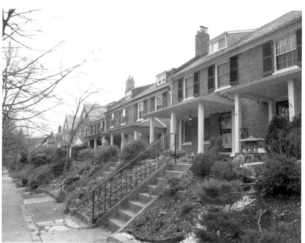

Top: The townhouse group at 3410–3422 University Place, built by the Mueller Construction Company in 1924, designed by Flournoy and Flournoy, Architects. *From the National Register of Historic Places registration form for Oakenshawe.*

Middle: The townhouse group at 3412–3438 University Place, built by the Mueller Construction Company in 1924, designed by Flournoy and Flournoy, Architects. *Author's collection.*

Bottom: The townhouse group at 3513–3517 North Calvert Street, built in 1926 by the Mueller Construction Company, designed by Flournoy and Flournoy, Architects. *From the National Register of Historic Places registration form for Oakenshawe.*

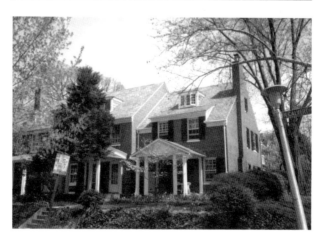

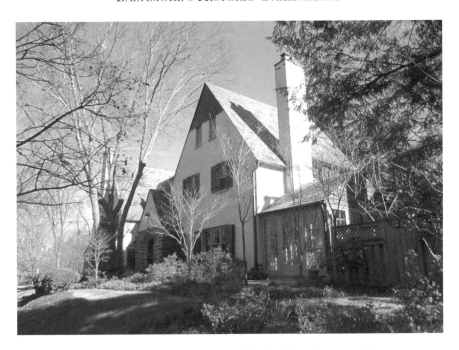

The Neoclassical Revival duplex at the corner of North Calvert Street and Southway, viewed from North Calvert Street. Constructed by the Mueller Construction Company in 1926, designed by Flournoy and Flournoy, Architects. *Author's collection.*

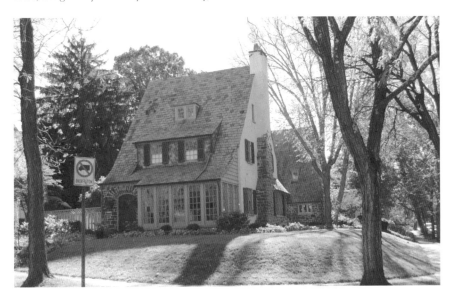

The Neoclassical Revival duplex at the corner of North Calvert Street and Southway, viewed from Southway. Constructed by the Mueller Construction Company, designed by Flournoy and Flournoy, Architects. *Author's collection.*

Oakenshawe hosts several annual neighborhood events, including the annual Terrace Party (held on Homewood Terrace, which is closed for the event), neighborhood yard sales, a pie social, a cookout, a Halloween parade for the children of the neighborhood and clean-up days in the summer and fall. A parking decal pickup day is held in late January, and an Oakenshawe house tour is held in the fall, although it is no longer an annual event.

The neighborhood boasts an eleven-thousand-square-foot greenspace bordered by Barclay Street and the alleys behind University Place and Birkwood Place. The space was never built upon but became a parking lot for Bell Atlantic when its building was located on the corner of Barclay Street and Thirty-Third Street, where the Enoch Pratt Free Library now stands. When the original library was built in 1975, the Oakenshawe neighborhood

Top: Duplexes on Venable Avenue, unknown builder and architect. Thought to have been constructed ca. 1900, probably replacing previous dwellings built in the 1870s. *From the National Register of Historic Places registration form for Oakenshawe.*

Bottom: A pair of Victorian Gothic dwellings at 3407 and 3409 Barclay Street, unknown builder and architect. Most houses on Barclay were built ca. 1900. *From the National Register of Historic Places registration form for Oakenshawe.*

covered the old parking lot with land fill and seeded it with grass; several trees were planted around the perimeter, giving the space a parklike atmosphere, and the Oakenshawe Greenspace, as it became known, has provided a place for outdoor activities for community children and adults alike for more than forty years. An effort to remove a small section of buried asphalt from the original parking lot was attempted several years ago but proved too costly and labor intensive to encompass the entire greenspace.

Until recently, the greenspace was maintained by neighborhood volunteers who constituted the Oakenshawe Greenspace, Inc., a nonprofit, non-stock corporation run by its members, who must be Oakenshawe residents (info@ oakenshawegreenspace.org). Members participated in semiannual cleanups; shared mowing and turf improvement duties; planted, cared for and pruned trees, shrubs and flowers; and kept the space clean. As of June 2018, through the efforts of members led by Laurie Feinberg, the Oakenshawe Greenspace is now owned and protected by Baltimore Greenspace, Inc. Founded in 2007, Baltimore Greenspace, Inc., is an environmental land trust, and the Oakenshawe Greenspace is the oldest of eleven sites preserved by the organization to date. Oakenshawe residents continue maintenance of the greenspace under the new ownership agreement.

The greenspace looking north. *Author's collection.*

The greenspace looking south. *Author's collection.*

The entire neighborhood is overseen by the Oakenshawe Improvement Association (OIA), which collects nominal annual dues, spearheads organization and participation in annual events and special occasions and maintains a neighborhood website. A news publication called the *Oakenshawe Log* was discontinued when the neighborhood joined the local online communication system NextDoor. A centennial celebration planned by the OIA in 2016 included several fun events that were well attended, an afternoon tea at the Clifton mansion with period dress reminiscent of 1916, historic tours of Oakenshawe and Charles Village, a house and garden tour, an ice cream social and historic lectures of the Oakenshawe area by local historians including the well-known Baltimore historian Jacques Kelly, who recalled visiting relatives in Oakenshawe as a young boy.

While numerous prominent people of note have lived in Oakenshawe, two of the more colorful residents were Richard and Shirley Reinhardt Byrd, who lived at 3438 University Place from 1976 until their deaths in 1992 and 2000, respectively. Shirley Byrd "rose from Miss Howard County to become one of the area's most prominent actresses," according to her obituary.

Left: Calvin Avenue house, unknown builder and architect. The first houses appeared on Calvin Avenue the year the street was built, 1887. *From the National Register of Historic Places registration form for Oakenshawe.*

Below: A pair of Victorian Gothic houses on Venable Avenue, unknown builder and architect. These houses are thought to have been built ca. 1900. *Author's collection.*

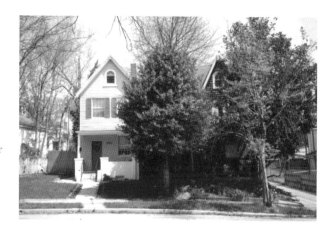

The Victorian Gothic house at 3503 Barclay Street, unknown builder and architect. Built ca. 1900. *From the National Register of Historic Places registration form for Oakenshawe.*

She appeared in over 150 productions and shared stage and film with such notable actors as Robert Redford, George C. Scott and Alan Alda. She had television roles in the daytime operas *One Life to Live* and *Texas* and acted in Baltimore productions at Center Stage, the Four Corner Cabaret Theater and Vagabond Players. She also played in Ocean City at F. Scott Black's Dinner Theater and the Princess Royale Theater. She worked on the New York stage and toured with such notable actors as Forrest Tucker, Broderick Crawford, Carrie Nye and Alexis Smith. After her husband's death in 1992, she opened a gift shop and art gallery in Sandwich, Massachusetts, near Cape Cod, where she displayed her own paintings, jewelry and crafts while maintaining her Oakenshawe house in Baltimore.[175] Richard Byrd earned a law degree from the University of Baltimore and became a successful Baltimore attorney. His first law job was as assistant state's attorney in the Baltimore County state's attorney's office. He was later assistant Baltimore County solicitor and had a private practice before working as an assistant state's attorney in Baltimore City. He worked in the Baltimore County public defender's office prior to his death. He fused careers in law, theater, radio and city politics. He had a passion for theater and produced over fifty Baltimore-area shows and appeared in over one hundred productions, often with his wife. He hosted the *Richard Byrd Show* in the 1980s on WBAL, where he was also the radio station's director of promotion and public relations. He was president of the Second Sunday Series, sponsored by the Belvidere Arts Council, and his television writing earned him an Emmy nomination. He served a term in 1953 on the Baltimore City Council under Mayor Thomas D'Alessandro Jr.; at the time, he was the youngest person ever to serve on the council.[176] University Place was once known as "Lawyers Row" due to the number of attorneys who lived there, including Richard Byrd.

Appendix I
WILSON LAND TRANSACTIONS

JAMES WILSON LAND TRANSACTIONS, 1802–1850

YEAR	RECORD	SELLER	SIZE	COST
1802	WG 71 582	Edwards	10.25 acres	$3,000
1802	WG 74 20	Job Merryman	3.75 acres	£227
1809	WG 105 117	Eb Sm Thomas	7 acres	$1,585
1811	WG 114 437	Whitely	2.25 acres	$600
1814	WG 130 397	Tipton	3 acres	unknown
1819	WG 154 183	P&N Merryman	110.25 acres	$2,140
1823	WG 179 639 and WG 168 653	McCormick	7.5 acres	$7,000
1826*	WG 179 639	Union Bank	216.5 acres	$6,923
1834	TK 236 312	G. DeNicoll	2 parcels	$200
1837	TK 274 156	Pease	18.25 acres	$39.75
1840	TK 303 290	F & A Harrison	1.25+2.5 acres	transfer

YEAR	RECORD	SELLER	SIZE	COST
1845	AWB 350 382	Warfield	113 acres	$680
1846	AWB 39 195	Ward	142 acres	$9,000
1846	AWB 39 195	Ward	187.75 acres	$9,000
1846	AWB 39 197	Ward	50.5 acres	$2,750
1848	AWB 391 167	Allender	7.5 acres	$1,227
1850	AWB 294 219	Wm G Howard	111.5 acres	$13,000

Additional properties, not on this list, were acquired and disposed of by Jas. Wilson.

* Purchased by both James and Thomas Wilson

THOMAS WILSON LAND TRANSACTIONS, 1816–1838

YEAR	RECORD	SELLER	SIZE	COST
1816	WG 138 14	Maris	Gist's Inspection	
1820	WG 156 50	Jackson	14.75 acres	$7,000
1836	TK 258 209	Gibson	3.75 acres	$1,828
1838	TK 277 221	Collins	3.75 acres	$595
1838	TK 285 185	Deford	3.25 acres	$270

JAMES WILSON REMEMBERED

This item appeared after the death of James Wilson in February 1851 in *Hunt's Merchant's Magazine and Commercial Review* (vol. 24, page 516).

James Wilson, Esquire, the last surviving partner of the old house of William Wilson and Sons. In communication it may not be improper for us to give a brief history of the house of which he was so prominent a member. The war of our Independence had just closed, when Baltimore became one of the largest and most active markets, for various staples of our country, upon the Atlantic seaboard. At this time it was that the firm of William Wilson and Sons began to assume a prominence in the mercantile world; they occupied the counting room that continues to be occupied and used by their survivors, for the same purpose, to this day. It is in Baltimore-street, opposite the "Clipper" office—not a whit changed, except by age, since the year 1770. The subject of our obituary was born in this building, in 1775. He was learned to manage with his brothers Thomas and William, Jr. the trade and fortune that his father founded, and it continued under their superintendence after death had removed the head of the house; and now the grandsons of William Wilson still conduct the immense business that he originated. James Wilson desired to be a leading man of no sect or party—what when a leading name for philanthropic object was wanting, the signature of "Wm. Wilson and Sons" was never applied for in vain. In his daily life, he observed a strict rule of unobtrusiveness, and his greatest acts of benevolence were only known by those who blessed him in silent

gratitude for their relief. As a business man his integrity, punctuality, and fairness were unexampled, at the family altar his devotion was unfeignedly earnest, and at the hearth his affection was true and ingenuous. Men like him the world can hardly spare—it can spare its heroes of military or political renown, their places are soon filled; but when a good man dies, a good man in the strictest sense of the term, it may long seek among its millions in vain for one worthy to be his successor.

Appendix III

James Wilson's Last Will and Testament

I, James Wilson of the City and county of Baltimore in the State of Maryland, do make and publish this my Last will and testament in manner and form following, hereby [not legible] *which I may heretofore at any time have made.*

First, I bequeath the sum of Three hundred and Sixty thousand Dollars as follows; To Each of my children namely, David S. Wilson, Jane S. Brown, Eliza M.K. Wilson, William C. Wilson, Mary Louisa Patterson, Anne Rebecca Harrison, Thomas J. Wilson, Henry R. Wilson and Melville Wilson, I give and bequeath the sum of Forty Thousand Dollars. Whatever sums may be charged to my children in my private Leger as advanced to them are to be deducted from the amount of their respective Legacies: and the payment of said Legacies or any of them may be made in whole or in part by a transfer of Stocks or other Securities in my possession at the time of my decease, at their market price or value at the time when such transfer shall be made. The said Legacies are to be paid at the end of twelve months from my decease unless my Executor shall consider it to be for the advantage of my Estate to postpone the payment thereof, in which case interest on said legacies or in such parts thereof as may not be paid, shall be paid Semi annually to said legatees, computing the interest from the end of said twelve months, but the whole of said Legacies shall be paid as soon after the expiration of said twelve months as may be practicable consistently with the interest of my estate. (James Wilson)

2. Second, It is my will and desire that each of my said children including my daughters whether single or married, shall have power by Last Will and Testament or instrument of writing in the Nature of a last will and testament, whether the same shall be made in my life time or after my decease, and although such child may die before me to dispose of absolutely or in any manner he or she may think proper, All the property, real, personal or mixed, bequeathed or devised immediately or by way of remainder to or in trust for him or her by this my Will, or which may come or pass to him or her under or by virtue of any clauses or provisions of this my Will, and such property shall pass and be distributed in all respects according to the Will or instrument in the nature of a will of such child. None of my said daughters are to have the power of disposing of the property left in trust for them respectively except by will aforesaid, but my sons are not only to have the power of disposing, by will as aforesaid of the property left to them respectively, but may dispose thereof in any manner as they become entitled thereto; it being my intention to leave their portions to them respectively, absolutely and free of all restriction. And it is further my Will and desire,… in case any of my daughters shall die after having executed the power of disposition hereinbefore given to them and having a [testament?] paper for that purpose in force, that the trust by my will created shall be [closed] to such daughter and the property derived or bequeathed for her, and that said property shall be paid delivered and transferred to her [illegible] or legatees as the case may be. (James Wilson)*

3. Third, The said legacies of Forty thousand Dollars to each of my daughters are to be held on trust by the Trustee hereinafter named (When I have also appointed my Executor) for the exclusive use and benefit of my daughters respectively during their natural lives, so that my Trustees pay to or present [suffer?] *my daughters whether married or single to recover the interest, dividends, and income of their respective legacies* [as] *of the Stocks,* [estate?], *or property in which the same may be invested, to interest that the same may be for them respective sole and separate use and may not be subject to the debts, control or engagements of any present or future husband or husbands of my said daughters or any of them, and from and after the death of any of my daughters there as to the legacy of any of them so dying and also dying intestate thereof, In Trust for her or their respective issue who may be living at the time of her death, of any such issue to* [late?] *per stirpes. If any of such issue shall there be an infant or infants, then the Share or Shares of such infant shall remain and continue in trust*

until he, she or they shall respectively arrive at age, that is to say, until the son or sons shall arrive at the age of Twenty one years, and the daughter or daughters shall arrive at the age of Eighteen years, at which time their respective shares shall be payable and the Trust shall cease and close as to them respectively.

If any of my children shall die before me intestate as to their said legacies of Forty thousand Dollars, and leaving issue living at the time of my death, then as to the legacy or legacies of the child or children so dying, In Trust for his her or their respective issue living at the time of my death per Stirpes, The share or shares of such issue as may be an infant or infants to remain and continue on and to be Subject to the same trusts as are above declared as to the infant issue of my deceased daughters above mentioned.

If any of my children shall die before me without issue living at the time of my death & intestate as to their respective legacies of forty thousand dollars, then as to the legacy or legacies of the child or children so dying, In Trust for the use of his her or their brothers and sisters who may be living at the time of my death and the issue then living of any brother or sister who may then be deceased, the Shares of the brothers to be paid or transferred to them and the Shares of the Sisters to be held in the same manner upon the same trusts, and with the same limitations in all respects as are hereinbefore or hereinafter provided as to the legacies of Forty thousand Dollars above bequested to them, and the issue of any deceased brother or Sister to take per stirpes the Share or Shares to which its or their parent would if living be entitled, the Share or Shares of such issue as may be an infant or infants, to remain and continue upon and be subject to the same trust as are above declared as to the infant issue of my deceased daughters as above mentioned.

If any of my daughters shall die after me without issue living at the time of their respective deaths and intestate as to her or their respective legacies of forty thousand Dollars, then as to the legacy of any daughter so dying, In Trust for the use of her brothers & sisters if any who may be living at the time of her death, and the issue then living of any brother or sister who may then be deceased, the shares of the brothers to be paid or transferred to them, and the Shares of the Sisters to be held in the same manner, upon the same trusts and with the same limitations in all respects as are herebefore provided as to the legacies of Forty thousand dollars, above bequeathed to them, and the issue of any deceased brother or sister to take per Stirpes the Share or shares to which its or their parent would if living be entitled, the Share or Shares of such issue as may be an infant or infants to remain and continue upon and be subject to the same trusts as are above

declared as to the infant issue of my deceased daughters as above mentioned.
(James Wilson)

4. Fourth. Whereas I have purchased from John W. Ward and others a
farm in Baltimore County near Govanstown, which was conveyed to me
in three Deeds dated in the year 1846 and duly recorded, which farm I
purchased for my Sons William C. Wilson and Melville Wilson, and
whereas they have not yet agreed upon the manner in which it is to be
divided between them, so that I can execute deed to them for their respective
portions. Now in case I should die before the execution of such deeds, I
give & devise the said farm to my trustees hereinafter named, in Trust for
my said two Sons William C. Wilson and Melville Wilson their heirs
and assignees as tenants in common, and upon further trust that as soon
as the said William C. Wilson and Melville Wilson shall agree upon
the division of said farm between them, my said trustees shall convey to
each of them the legal estate in and to the portions which shall be allotted
to them respectively, in such wise that they and their heirs may hold and
enjoy both the legal and equitable estate therein forever in severalty, But it is
my intention that my said Sons William C. Wilson and Melville Wilson
shall be charged with their respective portions of the cost of said farm,
and with the amount paid for the Stock and improvements, or otherwise
paid or advanced, for or to them respectively in respect of said farm; the
amount of which charges shall be deducted from their respective legacies of
Forty thousand dollars, as in the case of changes made against any of my
children in my private leger agreeably to a foregoing provision of my Will.
(James Wilson)

5. Fifth. Whereas I have purchased from Alexander C. Magruder, Trustee,
a lot of Ground near the first turnpike gate on the York turnpike road in
Baltimore County, and have fitted up therein a chapel for the purposes of
public Worship, and of a Sabbath school, I give and devise to said Trustees
the said Chapel and the Land on which it stands, and so much of the said
Lot whereupon it stands as may be necessary for the convenient occupation
of the said chapel and the right of way from said chapel, to said turnpike,
read even a road which shall be laid out and over my land, which road
shall be laid out and the boundaries of the chapel let defined by my Trustees
within twelve months after my decease, to be held by them forever in trust
that they will permit the said chapel and chapel lot with its appurtenances
to be used and occupied for the purposes aforesaid by the members of any

Evangelical denomination of Christians which my said trustees may from time to time approve & for so long a period as they may think proper.

It is my intention to apply to the next legislature of Maryland for an act of incorporation of certain Trustees for the purpose of more effectively carrying out the objects of the trust, In case I should die before such an act can be obtained, I direct my said trustees to apply for such an act and after it shall be obtained by them to convey said chapel, chapel lot and its appurtenances (to be defined by them as aforesaid) to the corporation which shall be created by such an act, to be held by it in trust similar to those above mentioned, that is to say, to be held by said corporation forever in trust that it will permit said chapel, chapel lot and its appurtenances to be used and occupied for the purposes aforesaid by the members of any Evangelical denomination of Christians of which the Trustees appointed by or under said Act may from time to time approve and for as long a period as they may think proper. (James Wilson)

6. Sixth. Whereas Elizabeth Carmichael & Lucretia Carr have lived in my family many years and have rendered faithful services during that time, I leave to my said Trustees One thousand Dollars of City Six per cent Stock, one half the interest which may be received thereon to be paid to each during his natural life, Whenever either shall die one half of said City Stock shall fall into the residue of my personal Estate and on the death of the other the remaining half shall fall into said residue. (James Wilson)

7. Seventh. In a former will made by me now cancelled I left to my late son James the sum of twenty five thousand Dollars. This amount I direct shall be lent to my Son David S. Wilson if he shall survive me, to be paid to him within one year after my decease and to be lent to him for the time of five years from the time of said payment to him without interest & without requiring any security for the same, and after the expiration of that time, then said sum of Twenty five thousand dollars is to be divided in the same manner and proportions as I have heretofore directed as to said sum of Three hundred & Sixty thousand Dollars above bequeathed by me, and is to be transferred to of held in the same trusts for the same persons who according to my will, shall at the end of said five years, be entitled to said sum of Three hundred and Sixty thousand Dollars.

If my Son David should survive me but should die before the end of said five years, then the said sum of Twenty five thousand dollars is to be divided in the same manner and proportions as I have hereinbefore directed

as to the said sum of three hundred and Sixty thousand dollars, and is to be transferred to or held in the same trusts in trust for the same persons who according to my will shall on the death of said David be entitled to said sum of Three hundred and Sixty thousand Dollars. But the Executors of administrators of my said Son David, in the event of his dying before the end of said five years, shall have one year after his death to pay said sum of Twenty five thousand Dollars and during said year shall not be chargeable with interest therein, unless said year should extend beyond said five years, in which case interest shall be chargeable therein at the end of said five years.

If my said Son David should not survive me then the said sum of Twenty five thousand Dollars shall be divided in the same manner and proportions and shall be payable at the same time or times as I have hereintofore directed as to said sum of Three hundred and Sixty thousand Dollars, and is to be transferred to or held in the same trusts for the same persons who according to my will shall on my death be entitled to said sum of three hundred and Sixty thousand Dollars.

My said children are to have the power to bequeath their respective portion of said sum of Twenty five thousand Dollars in the same way in all respects & as fully as they are by virtue of the second clause of my will authorized to dispose of by will or testamentary paper in the nature of a will any portion of the property left by me. (James Wilson)

8. Eighth. Whereas there have been various trusts reposed in me all of which I believe are noted in my private leger, I direct that all said trusts be strictly complied with by my Trustees and be carried out by them. (James Wilson)

9. Ninth. All the undivided interest which I may have in any property real of leasehold with any person or persons may be sold by the person or persons interested with me who may survive me and the proceeds of my portion shall be paid into and constitute a part of the residue of my personal estate. (James Wilson)

10. Tenth. It is my will and desire that the Stock Standing in the name of my wife Mary Wilson on the Books of Banks, road Companies or the Corporations, shall be regarded as her property, and not taken into the account of my Estate for any purpose whatever, but shall be disposed of by her as her own property and entirely at her own will and pleasure, I bequeath to her absolutely all my leasehold furniture in both my town

and Country residences, my plate and my carriages and horses & all my personal property which at my death may be at or in my Country seat or in my residence in town. (James Wilson)

11. Eleven. All the residue of my real and leasehold estate Standing in my own name, and all the residue of my personal estate I desire and bequeath to my said Trustees, In Trust that they permit my said wife occupy and reside on such portion or portions of my real and leasehold estate as she may select, and that they pay over the income and interest arising from the entire residue of my real leasehold and personal estate to my said wife as it arises, And my will and desire is and I hereby direct that if my personal estate shall be so much diminished by losses in business or otherwise that the income of the residue hereby bequeathed together with the rents of the residue of my real and leasehold estate hereby devised and bequeathed (exclusive of those portions of my real and leasehold estate which my said wife may occupy for her own residences) shall not yield to my said wife an income of Ten thousand Dollars per annum, my said Trustees shall be authorized and empowered and it shall be their duty to pay to my said wife (provided she shall desire or require it) annually out of the principal of said residue of my personal property such sum of money as will with the increase of the residue of my personal property, and the rents of said residue of my real and leasehold estate, excluding those portions thereof which she may occupy for her own residences, yield a clear income of Ten Thousand Dollars a year. (James Wilson)

12. Twelfth. After the decease of my said wife I direct that each specific piece of real and leasehold estate of which I may die possessed, except such portions as I have hereinbefore otherwise devised, as well as each specific piece of real and leasehold Estate which may be acquired by my said Trustees after my death and before the division hereinafter directed, shall be valued by those persons selected by the Orphans Court for Baltimore County, and shall be divided by said persons into parts with a view to an equal division thereof among all my children who shall be living at the death of my said wife and the issue then living of any of them who may then be deceased, the issue of a deceased child to take per Stirpes the Share or portion to which its or their parent would if living be entitled, such division to be made by permitting the eldest child to take first choice at the valuation, and the next oldest the second choice and so on in rotation according to age, and if any of my children shall be deceased, leaving issue under the age

of Twenty one years, my said Trustees shall chose for such issue, although there may be other issue of such child over said age—and such issue of a deceased child shall stand in the place of its or their parent in respect to the order of choice.

And if after all my children and the issue of any deceased child shall have had a choice as aforesaid, any of my said property shall remain unchosen then the eldest child shall again have the first choice of said unchosen property and the next eldest the second choice & so on in rotation according to age. Should the portion or portions selected by or for any child or issue of any deceased child exceed the portion of my real and leasehold estate to which such child or issue would be entitled on an equal division thereof as aforesaid among all my children who shall be living at the death of my said Wife and the issue then living of my deceased child then such excess is to be accounted for by such child or issue with my trustees, and when paid shall fall into the residue of my personal estate, and I hereby direct that until such excess shall be fully paid with interest from the time of choice the amount of such excess with Interest shall constitute and remain a charge on the portion on account of which it may be payable, and if the same shall not be fully paid within one year after such choice, or secured to the satisfaction of my Trustee provided they shall consent to postpone the payment thereof beyond said year, payment may be enforced by my Trustees by sale of such portion or any part thereof.

Should the portion or portions selected by or for any child or issue of any deceased child fall short of the portions of my real and leasehold Estate to which such child or issue would be entitled on an equal division aforesaid, then such deficiency, with interest from the time of choice shall be paid to or for said child or issue by my Trustees out of the residue of my personal Estate in money or in whole or in part in Stocks or in other securities at their market price at the time of payment.

Should any portion or portions be rejected by all my children and the issue of any deceased child or children, then the same shall be sold by my Trustees and the proceeds thereof shall fall into the residue of my personal Estate and the child or children or the issue of a deceased child or children so rejecting shall receive in money or in whole or in part in Stocks or other securities at their market price out of said residue, an equivalent in value to the proportion of real and leasehold estate to which he she or they would respectively be entitled on an equal division thereof as aforesaid according to the valuation made as aforesaid by persons appointed by the Orphan's

Court, and allowing interest thereon from the time appointed by my Trustees, (hereinafter provided) for making choice.

And if said persons after having valued my real and leasehold estate aforesaid shall not find it advantageous to divide the sum into as many portions as shall equal the number of my children who shall be living at the time of the death of my said wife (the issue then living of any deceased child to count for and stand in the place of such child) then they are to divide it into as many portions as they may deem expedient, and my said Trustees shall make up and supply out of the residue of my personal Estate (which I hereby charge for that purpose) in money, or in whole or in part in Stocks or other securities at their then and market price the deficient portion or portions the value of a portion to be the same to which a child would be entitled on an equal division of any said real and leasehold Estate according to the value ascertained as aforesaid among all my children who shall be living at the time of the death of my wife and the issue then living of any deceased child (such issue to stand in the place of its parent) The division is then to be made as herein before directed, except only that the portion or portions so made up from the residue of my personal estate are to stand in the place of said deficient portion or portions of real and leasehold property.

Such parts of any said real and leasehold estate as may be chosen by my said sons or by or for the adult issue of a deceased child, I desire may be conveyed to them respectively and their heirs, executors and administrators absolutely by my trustees, but should the same exceed their portions, the excess with interest from the time of choice is to be paid to my trustees before any conveyance shall be made to them. Such parts of said property as may be chosen by my daughters respectively, or the money or property received instead thereof as above provided in case of their not choosing or not receiving any part of my said real and leasehold estate, are to be held by my said Trustees and I do devise the same to them in Trust for the sole and separate use of my said daughters respectively in the same manner upon the same trusts and with the same limitations over in all respects as hereinbefore provided as to the legacy of Forty thousand Dollars bequeathed in trust for my daughters. Such parts of said real and leasehold property as may be chosen for the infant issue of any of my children who may be deceased at the time of the death of my said wife, or the money or property received instead thereof in case no such choice shall be made, are to be held in trust by my said Trustees until such issue shall respectively arrive of age, that is to say, until such son or sons shall

157

arrive at the age of twenty one years, and the daughter or daughters shall arrive at the age of Eighteen years, at which time the trust as to them respectively shall cease.

In case any of my children should under the testamentary power herein before conferred on them devise or bequeath their portion or portions in my said real and leasehold estate and die before the death of my said wife, then I direct that such devise or legatee shall count for and stand in the place of such child respectively, in respect to said division.

After the valuation above directed shall be made, it shall be returned to the Orphan's Court and my Trustees shall appoint a time within sixty days after such return, when those entitled to a choice as aforesaid may meet on such notice as my Trustees may think proper to give, and at such place as my Trustees may select for the purpose of making choice as above provided, and if those entitled shall fail to make choice in their proper turn, either in person or otherwise at such time, they shall be held to have refused so to do. (James Wilson)

13. Thirteenth. It is my will and desire that at the death of my said wife, the residue of my personal property bequeathed in trust for her as aforesaid or so much thereof as may have been paid over and exhausted or disposed of under the foregoing provisions of my will, shall be divided among such of my children and their issue and in such proportions as my wife may think proper to appoint by her will, and in case of her omitting to make any such appointment, I give and bequeath the same to be equally divided among my children who shall be living at the time of her death, and the issue then living of any of them who may be deceased, the issue of any deceased child to take per Stirpes, the share or portion to which its or their parent would if living be entitled. If any of such issue shall then be an infant or infants then his her or their share or shares shall remain and continue in trust until he she or they shall respectively arrive of age, that is to say, until the son or sons shall arrive at the age of Twenty one years and the daughter or daughters shall arrive at the age of Eighteen years, at which time their respective Shares shall be payable and the trust shall cease and close as to them respectively. The portions of my daughters to rest in my trustees and to be held by them in trust for my said daughters respectively upon the same trusts with the same limitations over and in all respects in the same manner, as is provided with regard to the legacies of forty Thousand dollars, hereinbefore bequeathed and directed to be held in trust for each of my said daughters.

In case my said wife should not exercise the testamentary power herein given, all my children shall have power to bequeath their respective portions of said residue of my personal property in the same way in all respects, and as fully, as they are, by virtue of the second clause of my will, authorized to dispose of by will or testamentary paper in the nature of a will any portion of the property left by me. (James Wilson)

14. Fourteenth. If my said wife should die before me the residue of my real and leasehold estate devised in trust for her for life is to be valued and divided and held in all respects in the manner hereinbefore provided, except that such division is to take effect in all respects from the period of my death, and not from the period of her death as above provided.

And if my said wife should die before me the residue of my personal estate is also to be divided and held in all respects in the manner herein before provided in the case of her surviving me and dying intestate, except that such division is to take effect in all respects from the period of my death, and not from the period of her death as above provided. (James Wilson)

15 Fifteenth. It is my will and desire that in every case where under any of the provisions of my will, my Trustees shall hold property, real leasehold or personal for the issue of any of my children and where such issue shall consist of more than one, if anyone or more of such issue shall die without issue and intestate before the share of such issue so dying shall be payable then the Share or shares of the issue so dying shall pass and belong to his her or their brothers and sisters who shall then be living, and the issue then living of any deceased brother or sister such issue to take per Stirpes the share to which its parent would if living be entitled, and if any said brother or sister shall then be under age, that is to say, if the son or sons be under the age of twenty one years and the daughter or daughters under the age of eighteen years then my Trustees shall continue to hold said property for such issue or said brothers and sisters, until they shall respectively arrive at such age. (James Wilson)

16. Sixteenth. It is my intention that my trustees shall be considered, as [residue?] legatees, and that they shall have power to assent to the taking out of letter testamentary by my Executors upon their giving bond to pay debts and legacies under the provisions of the Act of the General Assembly of Maryland commonly called the Testamentary Act, passed at November Session 1798, Chapter 101 sub Chapter 14 Section 6, So far as the same may be in force at the time of my death. (James Wilson)

17. Seventeenth. I appoint my son David S. Wilson, my son in law Robert P. Brown and my son Thomas J. Wilson, and the Survivors and Survivor of them, and the Executors and Administrators of the Survivor, my Trustees, and devise & bequeath to them as such and the survivors and survivor of them and the Executors & Administrators of the survivor, All the property real, leasehold and personal which in my will I have directed to be held in trust under any of the clauses or provisions thereof and I hereby authorize and empower said Trustees and the survivors and survivor of them, and the Executors & Administrators of the Survivor, to sell, lease, exchange and dispose of and convey from time to time in their discretion, All the property real, leasehold and personal which may come into their possession or pass to them as Trustees under any of the clauses or provisions of my Will, without the authority of an application to any court or tribunal and the proceeds to invest & reinvest from time to time, upon the same trusts, in such property as they may deem best for the interest of those concerned, so as to Keep up & maintain the property entrusted to them without loss or diminution All investments of funds by my said Trustees in real or leasehold property or in stocks or other property, are to be made in their own names as Trustees.

But it is my wish and I so entrust my Trustees that during the life of my said wife, as to the property left to her for life, they shall so make investments thereof as not materially to alter the amounts now invested or being in real & leasehold property, or in personal property, other than leasehold. That is to say, if they shall during the life of my said wife dispose of any of my said [rent?] or leasehold left to her for life I desire then to invest the proceeds in either real or leasehold property as they may think advisable leaving it however in their discretion as to any [or considerable?] balance of such proceeds which may remain in their hands and which it may not be convenient or desirable to invest in real or leasehold property, to invest the same in any other property, and as to that portion of my estate which is not now invested in either real or leasehold property, and which is bequeathed to her for life, I desire that during her life it shall not be invested in either real or leasehold property, leaving it however in the discretion of my Trustees to employ a small portion of that part of my estate, if they think it desirable so to do, in order to complete any purchase of real or leasehold property which they may deem it expedient to make. (James Wilson)

18. Eighteenth. I appoint the same persons, to wit, David S. Wilson, Robert P. Brown & Thomas J. Wilson, the Executors of this my will, with full power for the purpose of Settling my estate to sell and dispose of

all the leasehold and personal estate which I may leave, as well that directed to be held in trust, or the rest, without the authority of or application to the Orphan Court for Baltimore County or any other tribunal. (James Wilson)

19. Nineteenth. Whereas any of my Executors or Trustees shall die, or if any shall refuse to act, or resign, then I appoint my son Henry R. Wilson (if he should then be living) in place of the one first dying, resigning or refusing to act, in the same manner, and with the same powers, and in all respects as if he had been named one of the original Trustees or Executors. (James Wilson)

20. Twentieth. It is the meaning of the fourteenth clause of my will and I so provide, that in case my wife should die before me, instead of the residue of my property real, leasehold and personal being divided among my children who shall be living at the death of my wife, and the issue of any deceased child (as is provided by the twelfth & thirteenth clauses of my will) the same shall pass to & be divided among my children who may be living at the time of my death and the issue then living of any deceased child, such issue to take a child's share. (James Wilson)

21. Twenty first. Before the execution of this will, the following corrections and alterations have been made therein, in the third clause the words "infant" and "hereinafter" are interlined, in the tenth clause the words "horses and all my," are written over an erasure, and the words "my country Seat, or in my residence in town" are interlined at the end of the clause, in the twelfth clause the words "then living" are twice interlined and the words "or by or for the adult issue of a deceased child" are also interlined, in the thirteenth clause, the word "dollars" is interlined and the words "all my" are written over an erasure, and in the seventeenth clause the words "and convey" are interlined.

In Testimony Whereof I have hereunto set my hand and affixed my seal on the twenty second day of January, in the year of our Lord One Thousand eight hundred and forty eight, and have also subscribed my name at the foot of each of the foregoing pages of my will.

James Wilson (with stamp)

Signed sealed published and declared by James Wilson the above named testator as and for his last will & testament in the presence of us who at

his request, in his presence and in the presence of each other have hereunto subscribed our names as witness thereto

C.C. Jamison
J.W. McCulloh
J. Thomas Smith

Memorandum

Whereinas after the forgoing will was prepared but before it was executed, a corporation has been established under and by virtue of an act of the General Assembly of Maryland passed at December Session 1846 Chapter 320 by the name of Trustees of Huntingdon Chapel, the Articles whereof have been duly recorded among the records of Baltimore County, and it has therefore become unnecessary to make application to the legislature of Maryland for the act of incorporation which is contemplated in the 5th Clause of my said will, Now I hereby revoke the direction given in said clause that an application shall be made for an act of incorporation and direct that the Trustees appointed in my said will to convey the chapel, chapel Lot, and Appurtenances mentioned in said clause to said Corporation to be held by it under the provisions of the articles of Association in creating said Corporation. It is my intention to make a conveyance of said property to said Corporation in my life time, and the direction is to be carried out by my Trustees only in case I should die before fulfilling intention. This memorandum or writing which is executed at the same time as my said will, is to be taken and held as a part thereof. In Testimony whereof I hereunto set my hand & seal this twenty second day of January Eighteen hundred forty eight.

James Wilson (seal)

Signed Sealed published and declared by James Wilson the above named testator as and for an addition to his last will & testament in the presence of us, who at his request, in his presence and in the presence of each other have hereunto subscribed our names as Witness thereto

C.C. Jamison
J.W. McCulloh
J. Thomas Smith

Baltimore County [L.?] On this 20th day of February 1851 came Cornelius C. Jamison, James L. McColloh and John Thomas Smith the three Subscribing Witnesses to the aforegoing last Will and Testament of James Wilson, late of said County deceased and Cornelius C. Jamison and John Thomas Smith made Oath in the holy Evangely of almighty God, and James W. McColloh solemnly declared and affirmed that they did see the Testator Sign and seal the will that they heard him publish, pronounce and declare the same to be his last Will and Testament that at the time of his so doing he was to the best of their apprehensions of sound and disposing mind memory and understanding, and that they subscribed their names as witness to this will in his presence at his request and in the presence of each other.

Sworn and affirmed to the open Court

Test: D.M. Perine Register of Wills for Baltimore County

Whereas I James Wilson of the City of Baltimore in the State of Maryland have made and duly executed my last Will and testament in writing, bearing date the twenty second day of January in the year One Thousand Eight hundred and forty eight, which said last Will and testament I do hereby ratify and confirm except so far as the same is hereinafter altered and being desirous to alter some parts thereof and make some additions thereto do therefore hereby make this Codicil, which I will and direct shall be taken as a part of my said will and testament, in manner and form following that is to say:

Whereas by the Eleventh clause of my said Will, all the residue of my real and leasehold estate Standing in my own name and all the residue of my personal estate, are left to Trustees by my said Will appointed, for purposes therein Stated, and the income arising therefrom is thereby directed to be paid over to my wife during her life time. I now direct that out of such portion of said residue as under my said will my said Trustees are authorized to invest in personal property, a sum not exceeding in value two tenths of the whole remnant of the residues above mentioned, shall be taken by my said Trustees and that one of said tenths or so much thereof as my son Thomas J. Wilson shall desire, shall be loaned to my said son Thomas J. if he shall desire it and that the other of said tenths, or so much thereof as my son Henry R. Wilson shall desire, shall be loaned to my said son Henry R. if he shall desire it, said loan to be made to aid my said Sons

respectively in carrying on business and my said Sons are respectively to pay to my said Trustees, interest on said loans, Semi annually, at the rate of six per centum per annum, said interest to be paid over by my said Trustees to my said wife as a portion of her income, in the same manner as if the principal so loaned, were invested in Stocks or other securities.

For the purpose of ascertaining the amount to be loaned to each of my said Sons as above, the various portions of my real and leasehold estate, combined in said residue thereof shall be appraised by my said Trustees at what they may deem their fair market value, and the personal Estate, contained in said residue thereof so far as it does not come into the hands of my said Trustees in Cash, shall be valued in the same manner.

The above shall be considered in every respect as loans on interest to my said Sons, and shall be repaid by them respectively, to my Trustees on the death of my said wife, or if either or both/other of my said sons should die in the life time of my said wife said loan shall cease as to the son so dying and shall be repaid to my said Trustees as a debt due by the Son so dying, in the same manner in which a debt due by such son to any other person, would by law be payable on the death of such a son.

And for the purpose of further protecting my estate from loss, and securing the repayment of said loans by my said Sons respectively, I direct that if my said wife shall exercise the power conferred on her in my said will by the thirteenth section thereof, and shall leave any portion of my personal property which by said clause she has the power of bequeathing to my said sons Thomas J or Henry R or either of them, the amount so bequeathed by my said wife to my said sons or either of them, or so much thereof as may be necessary, shall be paid to my said Trustees in liquidation, so far as the same shall avail for that purpose of whatever my said sons shall owe on account to said loans to them respectively that is to say whatever shall be left by my said wife to my said son Thomas J. shall be applied to the payment of whatever he may owe on account of said loan and whatever shall be left by my said wife to my said son Henry R. shall be applied to the payment of whatever he may owe on account of said loan.

And if my said wife shall not execute the power of bequeathing the residue of my personal estate which is conferred on her by the thirteenth clause of my said will, I direct that the respective shares which in the event of her failing to execute said power will by virtue of said clause, pass to said Thomas J. or Henry R. or other respective issue or legatee, shall in the first place be charged with and applied by my said Trustees to the payment of whatever my said Sons may respectively owe on account of said loans.

And for the purpose of still further protecting my estate from loss and securing the repayment of said loan I direct that the portion of my real and leasehold estate or the money or other property in lieu thereof, which either of my said sons, Thomas J. or Henry R., may have or receive by virtue of the provisions contained in the twelfth clause of my said will shall also be held and retained by my said Trustees as a security for, and shall be charged with whatever may be due by either of my said Sons on account of said loan to him, and may be sold by my said Trustees for the purpose of paying said loan. And if either of my said Sons should be deceased at the time of the death of my said wife, leaving any portion of the said loan to him unpaid, then the share of my real and leasehold Estate or the money or other property in lieu thereof which may be chosen or received by virtue of the provisions contained in said twelfth clause, for the issue, devises or legatees of such deceased son, shall be retained and held by my said Trustees as a security for whatever may be due by such son on account of said loan to him, and may be sold by my said Trustees for the purpose of paying said loan.

In case any of my Executors in my said will named and appointed shall at the period of my death be absent from the United States and shall not return thereto within thirty days from my decease, I hereby appoint my son Henry R. Wilson, Executor in the place of the one who shall be so absent, and shall not return within said time.

In Testimony whereof I have hereto set my hand and affixed my Seal this Ninth day of May in the year One thousand eight hundred and forty eight James Wilson (seal)

Signed Sealed published and declared by James Wilson the above named testator as and for a codicil to his last will and testament, in the presence of us at his request, in his presence & in the presence of each other, have subscribed our names as witnesses thereto. Two erasures having first been made on this page, one in the tenth, and the other in the fifteenth line thereof.

C. C. Jamison
J. W. McCulloh
J. Thos. Smith

Baltimore County On the 20th day of February 1851 came Cecelius C. Jamison, James W. McCulloh and John Thomas Smith, the three Subscribing Witnesses to the aforegoing Codicil to the last Will and testament of James Wilson, late of said County deceased and Cecelius C.

Jamison and John Thomas Smith made Oath in the Holy Evangely of almighty God, and James W. McCulloh Solemnly declared and affirmed that they did see the Testator sign and Seal this Codicil, that they heard him publish, pronounce & declare the same to be a Codicil to his last Will and testament, that at the time of his so doing he was to the best of their apprehensions of sound and disposing mind, memory & understanding, and that they subscribed their names as witnesses to this Codicil, in his presence, at his request and in the presence of each other.

Sworn and affirmed to the open Court

Test: D.W. Perine Register of Wills for Baltimore County

In Testimony that the aforegoing is a true Copy taken from the original filed and remaining in the Office of the Registrar of Wills for Baltimore County I hereunto subscribe my name and affix the Seal of my Office this Fourth day of March in the year of our Lord one thousand eight hundred and fifty one

Test: D.W. Perine Register of Wills for Baltimore County

MARY SHIELDS WILSON'S
LAST WILL AND TESTAMENT

I Mary Wilson of the City of Baltimore in the State of Maryland, do make and publish this my last will and testament as follows.

My carriages, Carriage horses and hames, plate and French dinner Set and the furniture and all the other personal property which at my death may be in both my town and country residences, I give and bequeath to my daughter Eliza M. Wilson, absolutely.

My Gay Street fee simple property including the portion thereof under lease to William C. Conine, which I acquired by inheritance from my father, which I conveyed for a particular purpose to certain of my children and which has, by deed of the first of February A.D. Eighteen hundred and Sixty Eight from William C. Wilson and other duly recorded, been reconveyed to me, I will and devise Shall be Sold by my Executors herein after named, as Soon as a price can be obtained for the Same and out of the net proceeds of the Sale, I bequeath to my Son Thomas J. Wilson the sum of Five Thousand Dollars, to be paid to him by my Executors. And out of said proceeds of said Gay Street property, I bequeath a like sum of Five thousand dollars to my Executors herein after named, as Trusts, in Trust, for my daughter in law, Sallie Lloyd Wilson, for her separate use for life, free from the control of her present and future husband, and from all liability for their debts and contracts, and with power to her to bequeath the Same at her death to her husband, Henry R. Wilson, by any instrument in the Nature of a will, And in default of such bequest, I bequeath the Same to be equally divided among her children by my said son, who may be living

at her death, and the descendants of any deceased child of my Said Son and daughter in law, Such descendants to take per stirpes only the Share, or part to which its, or their parent or parents, would, if living, be entitled.

And out of Said proceeds of Said Gay Street property, I further bequeath the Sum of Three thousand dollars to my daughter Anne R. Harrison, absolutely.

I do further give and bequeath out of the said proceeds, the Sum of three thousand Dollars to each of my five children hereinafter named to wit, David S. Wilson, Jane S. Brown, William C. Wilson, Elizabeth M. Wilson and Mary L. Patterson, absolutely.

The remainder of said proceeds together with all stocks and personal property belonging to me and not herein bequeathed already, I give and bequest to my said daughter Eliza M. Wilson absolutely.

And whereas by the [illegible?] *clause of the will of my late husband James Wilson, being date the twenty Second day of January A.D. Eighteen hundred and forty Eight, duly proven and of record in the Office of the Registrar of Wills for Baltimore City, I am empowered to divide the residue of his personal property, held in Trust for me, under Said will, at the time of my death among Such of our children and their issue, and in such proportion, as I may think proper. I do now, in the execution of such power, will and bequeath, as follows, that is to Say, The Trustee, who shall hold Said residue of personal estate, at the time of my death, Shall as Soon as practicable thereafter appraise and value the Same and every part thereof and Shall then set apart two twelfths parts thereof in value, provided each of Said twelfth parts Shall equal the sum of value of twelve thousand Dollars, but if not, there they Shall set apart two parts of Shares of the value of twelve thousand dollars each, and one of said twelfth parts, or shares, So to be Set apart they shall pay, or transfer to my son Thomas J. Wilson, but this bequest, in favor of my Said Son and all the other bequests herein contained, in favor of other children, and made in the execution of the power I am exercising are made with reference and Subject to the provisions of the Codicil my Said husbands will dated the ninth day of May A.D. Eighteen hundred and forty eight, likewise duly proven and recorded by which Such requests are charged with the payment of any loans, which may have been made such children respectively and which may remain unpaid at my death to the Estate of my Said husband. The other twelfth part, or Share above directed to be set apart, I further will and bequeath Shall be held by Said Trustees, until Such time as Henry M. Wilson the eldest child of my Son Henry R. Wilson Shall attain, if he*

die before Said period, would have attained, the age of twenty one Years, In trust for the children, which Said Henry R. Wilson and his wife Sallie L. Wilson now have, or may hereafter have during said period the income thereof to be applied in the meantime by said Trustees to the Maintenance and education of Said children Equally.

And I further will and direct, that at the time when, Said Eldest child attains, or if he die before Said period, when he would have attained the age of twenty one, Said twelfth part, or Share Shall be equally divided by said Trustees among the children, which my said Son Henry R. Wilson and his wife, Sallie L. Wilson, may have, living at said period, the Shares of the Sons to be paid to them on their respectively arriving at the age of twenty one years.

The shares of the daughters of Said Henry R. and Sallie L. Wilson Shall be held by Said Trustees, In Trust for the Separate use of Said daughters respectively, free from the control of any husbands they may have, and free from all liability for their contracts or debts.

And at the death of such daughters respectively, then I bequeath their respective Shares to their issue, living at their respective deaths. Equally for stirpes, and in default of such issue, with power to Such daughters respectively to devise and bequeath their respective Shares, by any instrument in the nature of a last will, and if such daughters Shall die intestate and without issue living at their respective deaths, then as to the Share of Such daughters so dying I devise and bequeath the Same to her of their surviving brothers and sisters and the issue of any deceased brother or sister per stirpes.

And I hereby authorize said Trustees and their successors to invest the Said Shares of any Said Grand children, the children of my Said Son Henry R. and his Said wife, in Such Safe and productive Securities and property as they may think most advisable and to change the investment thereof as often as they may think best, and upon the death, resignation or incapacitation of any Said Trustees I hereby authorize and direct the Surviving and continuing Trustees to fill Such vacancies as they may occur, So that the number of three Trustees Shall be kept up, until this Trust Shall be fully closed.

After Setting apart the two twelfth parts or Shares, as above provided I further will and bequeath that the Said Trustees Shall divide the remainder of the residue of the personal property of my said husband, held in Trust by them, into nine equal parts, and one of Said parts they shall pay or transfer to each of my Sons, David S. Wilson, William C. Wilson and Thomas J. Wilson, respectively, one Ninth part they Shall pay or transfer

to the legatees named in the will of my deceased Son Melville Wilson, duly proven and of record in the Office of the Registrar of Wills for Baltimore City, and which will was executed in pursuance of a power given him under my said husbands will.

One other part they Shall retain in trust for each of my daughters Jane S. Brown, Eliza M. Wilson, Mary Louise Patterson and Anne Rebecca Harrison, respectively, to be held, upon the Same trusts, conditions, provisions, and powers, as are declared in the Second and Third clauses of my said husbands Will in reference to a legacy of Forty Thousand dollars in Said clauses, bequeathed in Trust for each of them.

In regard to the remaining ninth part, I bequeath as follows, I hereby direct to the Said Trustees to ascertain the amount due by my son Henry R. Wilson to his father's Trust Estate for loans and advances of real and personal Estate, and after deducting therefrom the value of the real Estate coming to my Said Son under his father's will which they shall likewise appraise and ascertain, I then give and bequeath out of Said remaining Ninth part of the residue of the personal Estate, So much thereof, as will Equal and liquidate the balance, which may be due my Said Son Henry, to his father's estate, for such loans and advances, and which portion of said ninth part of the residue of the personal Estate, now bequeathed by me, in accordance with the codicil to my husbands will aforesaid.

I hereby charge with the balance due by my Said Son Henry, for such loans and advances, after crediting the value of his one ninth of the real estate, as aforesaid, and so that the Said balance may be thus fully paid and discharged.

After thus paying this balance if there should be any Surplus remaining of Said ninth part, I bequeath said Surplus, to and for the children, which my Son Henry R. Wilson and his Said wife now have or may hereafter have living at the time when their Said Eldest Son Shall attain, or if he die before Said period, when he would have attained, the age of twenty one years, to be then divided by Said Trustees, equally, among Said children, the Share of the Sons to be paid to them, as they respectively arrive at the age of twenty one absolutely, and the Shares of the daughters, to be held by Said Trustees, in Trust for them respectively upon the Same Trusts, and Subject to the Same conditions, powers, provisions limitations, in all respects, as are above provided, in reference to the Shares of Said children, respectively, of any Said Son and his said wife of a twelfth part or Share of the residue of the personal Estate of my husband, hereinbefore directed to be set apart for the benefit of my said grandchildren. If Said remaining ninth part should

not be Sufficient in value, to meet and pay the balance due by my Said son Henry for loans and advances, I then charge the Shares or ninth parts, already bequeathed to my three Sons, and four daughters In Trust, and to the legatees of my son Melville with an equal amount to make good Such deficiency and so that the amount due by Said Son for loans and advances, may be fully met and Satisfied.

And I also provide that if Said ninth part of Said residue of the personal Estate hereinbefore bequeathed to and for any children aforesaid respectively, Should not be Sufficient to pay and Satisfy the amount for which any of them are now charged, for loans, or advances, after crediting the value of the real estate to which they may be entitled I then Still further charge the portions of personal Estate herein given to and for all my remaining children (including my Son Melville as aforesaid) with a Sufficient amount to make good Such deficiencies, and to be chargeable upon the portions of such remaining children, Equally. And I also give to my Sons David S, William C, and Thomas J and to my daughters Jane S, Eliza M, Mary Louisa and Anne Rebecca the power, by any instruments, in the nature of a last will, and whether the Same Shall be made in my life time, or after my decease, and although Such child may die before me, to dispose of, absolutely, or in any manner any of Said children may think proper, the Ninth part of the residue of personal property, herein before bequeathed to them, or in Trust for them, respectively, but Such testamentary provision, on the part of any of my Said children Shall only affect and dispose of, the Surplus of such ninth part, given to Said child, respectively, after first paying or Securing to my husband's estate any liability of Such child, for loans and advances, as already herein before declared and shall likewise be Subject to the charge to make good the deficiencies of any other legatees of the ninth part of the residue of the personal estate herein before bequeathed to such legatees respectively.

I do hereby constellate and appoint—David S. Wilson, Thomas J. Wilson and Henry R. Wilson and the Survivors of them, the executors of this my Will and I hereby authorize them to defer the Sale of the Gay Street property, until they Shall be able to obtain what they may deem its Full value, and in the meantime, they Shall rent Said property, and the net rent apply for the benefit of the Same persons, and in the Same proportions, as I have above provided, in reference to the proceeds of Sale of Said Gay Street property.

And revoking all wills by me heretofore made I declare this to be my last and only will.

In witness whereof I have hereto Subscribed my name and affix my Seal on this tenth day of February A.D. Eighteen hundred and Sixty Eight.

Mary Wilson

Signed, Sealed, published and declared by Mary Wilson the within named Testatrix, as and for her last will and Testament, in the presence of us, who at her request, in her presence and in the presence of each other, have hereunto Subscribed our names as witness thereto

Arthur Geo. Brown
Rufus W. Applegarth
John W. Simpson

Baltimore City 88, on the 29th day of April 1869 Came Arthur Geo. Brown and John W. Simpson, two of the Subscribing witnesses to the aforegoing last Will and Testament of Mary Wilson late of Said City deceased, and Made Oath on the Holy Evangely of Almighty God that they did See the Testatrix Sign and Seal this Will: that they heard her publish pronounce and declare the Same to be her last Will and Testament, that at the time of her so doing She was to the best of their apprehensions, of sound and disposing mind memory and understanding; and that they together with Rupert W. Applegarth the other Subscribing Witness thereto Subscribed their names as witnesses to this Will in her presence, at her request, and in the presence of each other.

Sworn to in Open Court

Test: J. Harman Brown
Register of wills for Baltimore City

Baltimore City 88: On the 6th day of May 1869 Came Rufus W. Applegarth, one of the Subscribing witnesses to the aforegoing last Will and Testament of Mary Wilson late of Said City deceased, and Made Oath on the Holy Evangely of Almighty God, that he did See the Testatrix sign and Seal this Will; that he heard her publish, pronounce and declare the Same to be her last Will and Testament; that at the time of her so doing she was, to the best of his apprehension, of Sound and Disposing mind, memory and understanding; and that he together with Arthur Geo.

Brown and John W. Simpson, the other two Subscribing Witnesses thereto Subscribed their names as witnesses to this Will in her presence at her request, and in the presence of each other

Sworn to in Open Court

Test: J. Herman Brown, Register of Wills for Baltimore City

Whereas, Since the execution of my will bearing date the 13th day of February A.D. 1868, the Trustees, under the will of my late husband, have with my consent, made a further advance, out of the Trust Estate in their hands, for the benefit of my Son Henry R. Wilson, amounting to upwards of Seventy one hundred dollars, and it is just, that Should, by a Codicil, charge Said advance upon the portion which I have under the powers conferred upon me by the 13th clause of my Said husband's will, give to the children of my Said Son Henry R. Wilson and his wife, Sallie L. Wilson, I do now therefore will and direct; that the Trustees of my Said husband's estate, who shall hold the residue of the personal estate, bequeathed under Said 13th clause at the time of my death; before they Shall pay or transfer any part of the personal estate, so held by them, to or for the use of the children of my said Son Henry, in accordance with the provisions of my will out of the twelfth part of sum of $12,000 Set apart for their benefit or part of the ninth part of the remainder of Said personal estate; shall first repay or Secure to my husband's estate, the full amount of the additional advances, made by Said trustees for the benefit of my Said son Henry as aforesaid, or so much thereof as may remain unpaid by him.

All the other provisions in my Said will and especially those in favor of the children of my Said Son Henry, except as the Same may be affected by this Codicil thereto I hereby ratify and confirm.

In witness whereof I hereunto Set my hand and Seal this fourteenth day of May in the Year one thousand Eight hundred and Sixty Eight.

Mary Wilson

Signed, Sealed, published and declared, as and for a codicil to the Will of the Said Mary Wilson, dated the 13th of February 1868, by the Said Mary Wilson, above named, in the presence of us, who at her bequest in her presence and in the presence of each other have signed our names as witnesses thereto.

Appendix IV

Arthur Geo. Brown
John W. Simpson
Frederick J. Brown

Baltimore city 88: On the 28ᵗʰ day of April 1869 Came Thomas J. Wilson and made Oath on the Holy Evangely of almighty God, that he doth not know of any Will or Codicil of Mary Wilson late of Said City, deceased, other than the above instrument of writing and that he took the Same from the Safe Deposit Company where it was deposited by Deponent after securing it from the Testatrix who gave it to him at the time of its execution that the Testatrix departs this life on the 17ᵗʰ day of April 1869.

Sworn in Open Court

Test: J. Harman Brown Register of Wills for Baltimore City

Baltimore City [SS. or W.?] On the 29ᵗʰ day of April 1869 Came Arthur George Brown and John W. Simpson two of the Subscribing witnesses to the aforegoing Codicil to the last Will and Testament of Mary Wilson late of said City deceased, and made Oath on the Holy Evangely of almighty God, that they did see the Testatrix sign and Seal this Codicil And they heard her publish, pronounce and declare the Same to be according to her last Will and Testament, that at the time of her so doing she was to the best of their apprehensions of sound and disposing mind memory and understanding and that they together with Frederick J. Brown the other Subscribing Witness thereto Subscribed their names as witness to this Codicil in her presence, at her request, and in the presence of each other

Sworn to in Open Court

Test: J. Harman Brown Register of Wills for Balto City

Baltimore City [SS or W.?]: On the 29ᵗʰ day of April 1869 Came Arthur George Brown and made Oath on the Holy Evangely of Almighty God, that Frederick J. Brown, one of the Subscribing witnesses to the aforegoing Codicil to the Last Will and Testament of Mary Wilson late of said City deceased, is his Brother and is well acquainted with his hand writing and verily believes that the Signature of "Frederick J. Brown" as a Witness to

the aforegoing Codicil to the Last will and Testament of the Said Mary Wilson, is the genuine Signature of the said Frederick J. Brown.

Sworn to in Open Court:

Test: J. Harman Brown Register of Wills for Baltimore City

In Baltimore City Orphan's Court

The Court after having carefully examined the above last Will & Testament of Mary Wilson late of Baltimore City deceased together with the Codicil thereunto attached and also the evidence adduced as to its validity Proven and [Decsas?] this Sixth day of May 1869 that the Same be admitted in this Court as the true and genuine last Will and Testament and Codicil of the Said Mary Wilson deceased

W. Waldesston
Thos. Bond
Bolivar D. Danels

In Testimony that the aforegoing is a true Copy taken from Wills Liber J.H.B. No. 35 folio 290 etc being one of the Records in the Office of the Registrar of Wills for Baltimore City.

I hereunto Subscribe my name and affix the Seal of my Office this Eleventh day of October in the Year of Our Lord Eighteen hundred and Sixty-Nine.

Test: J. Harman Brown Registrar of Wills for Baltimore City

Appendix V

DAVID SHIELDS WILSON'S OBITUARY

This obituary is posted on the Radcliffe Family Tree at Ancestry.com and appeared in the *Baltimore Sun* on June 4, 1882, under the heading "Death of Mr. David S. Wilson: A Sketch of His Life."

Mr. David S. Wilson, aged about 80 years, died at 5:30 yesterday afternoon at his country residence, Kernewood, on the York road, at Cold Spring Lane. He had been ill for about a week with malarial fever, death resulting from a general breaking down of the system.

Mr. Wilson was a member of the old commercial and shipping house of Wm. Wilson & Sons. He studied for the bar with Justice Perviance but preferred commercial pursuits, and entered the firm in 1824, becoming its head on the death of his father, James Wilson. The shipping business of the firm, which once covered the globe, was broken up by the war. For the last twenty years Mr. Wilson has been retired from active business. An unique circumstance in regard to this house is that when Mr. Wilson entered it he occupied the same counting room in which his grandfather, the founder of the house, had done business, and he himself subsequently had a son in that same counting room.

Mr. Wilson has been a prominent figure in the social as well as the business life of Baltimore. When a young man he took much interest in military affairs, and was an officer of the First Baltimore Hussars. After the bank riots of 1835, when the City Horse Guard was organized to sustain the authority in the enforcement of the laws, he was elected an

officer. For over thirty years Mr. Wilson has been a director of the Bank of Baltimore, in which he had a hereditary interest. The presidency, which his grandfather held for 17 years, was several times offered to him. He was the oldest director of the Baltimore Fire Insurance Company, and was one of the original trustees of the Peabody Institute, having been an intimate friend of its founder. Mr. Wilson was a fine type of the old Maryland gentleman. His manner was characterized by great urbanity and he entered with great zest into social enjoyments. He entertained a great deal at his town house, and had numerous friends, both throughout this country and Europe. He was very fond of travel, and frequently visited Europe. Only two years ago he returned from an extended tour, and that summer had gone as far as to engage his passage, when a temporary illness caused him to change his plans. During the summer he visited Cape May, Newport and Saratoga enjoying himself among his friends as he was wont. Notwithstanding his advanced years he retained the vivacity of manner and love of companionship. He was very self-reliant, and did not hesitate to start alone on the most extended tours. He used to inngainly [sic] remark: "I can take care of myself, and if I take a valet I have to take care of him to [sic]." Mr. Wilson's wife was the granddaughter of Daniel Bowly, one of the town commissioners before the incorporation of the City. He survived her many years. He leaves three children—Jas G. and Wm. B. Wilson, of Wilson, Colston & Co, and a single daughter.

Mr. Wilson was a cousin of Mr. W. Corcoran, of Washington, whose name, William Wilson, is taken from that of the founder of the Baltimore house. Mr. Wilson leaves a very large estate both in real estate and personal property. The funeral will take place at 3 P.M. Saturday from Emmanuel P.E. Church, of which he was an attendant many years.

Notes

Acknowledgements

1. Mosca, "Oakenshawe House Tour."
2. Wagner, "Oakenshawe National Register."
3. Remington, *Society Visiting List*.

Introduction

4. Hayward and Belfoure, *The Baltimore Rowhouse*.
5. Scharf, *Chronicles of Baltimore*.
6. Wilson, unpublished notes.
7. WG Liber 71 folio 582 and WG Liber 74 folio 20; ; see appendixes.
8. Hall et al., *Baltimore*.
9. George Radcliffe, personal communication.
10. WG Liber 23 folio 298.
11. TK Liber 244 folio 375.
12. Swinnerton, "Sixty-Three."
13. Maryland Historical Society, Harris Collection, PP14.
14. waverlyimprovement.com.
15. Maryland Historical Society, Subject Vertical File Photograph Collection Baltimore City, Subject H Finding AID, Houses, note on reverse of photo "Roseland ca. 1920" in a folder with eight photos of "Roseland."
16. See Appendixes III and IV.

17. Wilson, unpublished notes.
18. www.pages.drexel.edu/~bgh24/index.html.
19. Ibid.
20. Schiszik, "City Designates 33rd Street."
21. Marye, "Place Names Part 2."
22. Marye, "Place Names Part 3."

Chapter 1

23. Marye, "Place Names Part 2," Ref: Maryland 1688 Patent Records for Land Liber 22 folio 438 and 440; Marye, "Place Names Part 3," Ref: LOM PRL Liber C No. 3 folio 531.
24. Wilson, unpublished notes.
25. RM Liber HS folio 479.
26. WG Liber 53 folio 675.
27. Bevan, "Perry Hall."
28. Marye, "Place Names Part 2," Ref: Patent 3 Mar 1760, Baltimore County RGS Liber 14 folio 295; BC and GS Liber 15 folio 219.
29. WG Liber JJ folio 4.
30. Marye, "Place Names Part 2," Lots 59, 76 and 77.
31. Marye, "Place Names Part 2."
32. WG Liber 74 folio 20.
33. Papenfuse et al., *Archives of Maryland*.
34. Bevan, "Perry Hall."
35. Culver, "Merryman Family."
36. *JHU Gazette*; Arthur and Kelly, *Homewood House*.
37. *Genealogy and Biography*.
38. Beirne, *The Amiable Baltimoreans*.
39. WG Liber 74 folio 20.

Chapter 2

40. Ibid.
41. WG Liber 60 folio 349.
42. WG Liber 65 folio 442.
43. WG Liber 65 folio 444.
44. WG Liber 71 folio 528.

45. Scharf, *Chronicles of Baltimore*.

46. Footner, *Tidewater Triumph*.

47. *Critic*.

48. McGrain, "A Brief History."

49. Martin, "Street-Hadfield Duel"; Hall et al., *Baltimore*.

50. Marye, "Place Names Part 3," "Place Names Part 4."

51. *Biographical Memoranda*.

52. Scharf, *History of Baltimore City*.

53. Ibid.

54. WG Liber 74 folio 20.

55. WG Liber 105 folio 117.

56. McGrain, *Charles Street*.

57. Thomas, "Poe in Philadelphia."

58. Thomas, *Reminiscences*.

59. May 13, 1822, thirty-six acres from Sheridine's Discovery, Ridgley's Whim and Garrison Meadows, Maryland State Archives S 1190-5028 #4881, Baltimore County Land Records.

60. Paul, "A Baltimore Estate."

61. Thomas, "Poe in Philadelphia."

62. Thomas, *Reminiscences*.

63. Paul, "A Baltimore Estate."

64. Thomas, *Reminiscences*.

65. WG Liber 114 folio 437.

66. WG Liber 114 folio 439.

67. WG Liber 154 folio 183.

68. Waverlyimprovement.org; Wilson, unpublished notes.

69. Alexander and Williams, *Charles Village*.

70. Hobbs, "A Place to Live."

71. Hobbs, "Unusual Care"; Hobbs, "The Cathedral That Wasn't."

72. Hobbs, "Reasonably in Accordance."

73. Hobbs, "All the Conveniences."

74. Ibid.

75. Baltimore City land transaction SCL Liber 4033 folio 593.

76. Ibid.

Chapter 3

77. Scharf, *Chronicles of Baltimore*.

78. Levering, *Levering Family*.

79. Ibid.

80. Ibid.

81. Records of Upper West Conocoheague Presbyterian Church.

82. Scharf, *History of Baltimore City*.

83. Scharf, *Chronicles of Baltimore*.

84. Johnston, "Stansbury Family."

85. WG Liber 79 folio 349.

86. WG Liber 123 folio 298.

87. Scharf, *History of Baltimore City*.

88. Parts of Bryan's Chance, Ridgley's Whim and Sheridine's Discovery, AWB Liber 382 folio 64.

89. Parts of Bryan's Chance and Ridgely's Whim, AWB Liber 405 folio 37.

90. AWB Liber 385 folio 551.

91. GHC Liber 35 folio 146.

92. Marye, "Place Names Part 4."

93. *Papers Related to Foreign Affairs*.

94. *Herd Registry*.

95. *Merchant's Bank v. Williams*.

96. www.stoneleigh21212.net/history.

97. Ibid.

98. TK Liber 244 folio 375, AWB Liber 446 folio 148; Wilson, unpublished notes.

99. Swinnerton, "Sixty-Three."

100. Ibid.

101. "The Bellman's Bookshelf," *Bellman*, November 8, 1913; "Miss Patterson's Success," *New York Times*, June 14, 1914.

102. *Billboard*.

103. *Scrap Book*.

104. "Conturbia-Patterson Wedding Announcement," *New York Times*, June 14, 1914.

105. "Marriage of Miss Anna St. Clair Patterson," *Richmond Evening News*, June 2, 1899.

106. Sleicher, "People Talked About."

107. "Mrs. Griswold Was Addicted to Drug Habit," *Washington Times*, October 7, 1921.

108. "Town and Country," *Town and Country*, 1921.

109. Hobson, *Recollections of a Happy Life*.

110. Ibid.

111. Didier, "The Social Athens of America."

112. Cutler, *Greyhounds of the Sea*.

113. *Baltimore Petroleum Company Records*; Smythe, *Obsolete American Securities*.

114. *Baltimore Underwriter*.

115. Wilson, *The Life Story of Franklin Wilson*.

116. Ibid.

117. Maryland Historical Society, MS833, Box 3, Folder 1826–1868, Wilson Papers, Legal Papers of Rev. Franklin Wilson.

118. Persig, "Hayes Family."

119. Kollen, *Lexington*.

120. 1946 list of paintings in the Maryland Historical Society Collection: #128 23.11.1, John McKim Jr. (1766–1842); #129.23.11.2, Mrs. John McKim Jr. (Margaret Telfair) (1770–1836); #198.23.11.3, Mrs. Benjamin Franklin Timothy (Anne Telfair); "Portrait Collection."

121. "Maryland Historical Society Gets Portraits by Rembrant Peale," *Baltimore Sun*, January 20, 1924.

122. Maryland Historical Society, MS833, Box 3, Folder 1826–1868, Wilson Papers, Legal Papers of Rev. Franklin Wilson.

123. Wilson, *The Life Story of Franklin Wilson*.

124. Didier, "The Social Athens of America."

125. Getty, "Bloomfield Manor's History."

126. Maryland State Archives #C 168-466 C109.

127. *Baltimore City Superior Court*.

128. Levering, *Levering Family*.

129. Scharf, *History of Baltimore City*.

130. Levering, *Levering Family*.

Chapter 4

131. *American Contractor*, 1916.

132. Hamlin, "The American Country House."

133. Whitmore, "Methods of Economy."

134. *Roland Park Company Magazine*.

135. *Guilford Bldg. Co. v. Goldsborough*.

136. waverlyimprovement.org.

137. Wagner, "Oakenshawe National Register."

138. Ibid.

139. SCL Liber 2891 folio 305.

140. Wagner, "Oakenshawe National Register."

141. Rassmussen, "Restoration of Homewood."

142. Mosca, "Oakenshawe House Tour."

143. Wagner, "Oakenshawe National Register."

144. *Engineering and Contracting Magazine.*

145. "Gardens, Homes and People."

146. *Polk's Baltimore City Directory.*

147. "Obituary: Matthew Mueller," *Capital,* December 16, 1975.

148. Ibid.

149. SCL Liber 2891 folio 305.

150. WG Liber 71 folio 689.

151. SC Liber 2276 folio 4610.

152. SC Liber 3099 folio 504.

153. BC Liber 9 No. 80 folio 780.

154. SCL Liber 3075 folio 249.

155. SCL Liber 33495 folio 477.

156. Michael Tunney, personal communication.

157. Wagner, "Oakenshawe National Register."

158. Kelly, "Obituary of James S. Keelty Jr."

159. SCL Liber 3099 folio 50.

160. SCL Liber 3039 folio 500.

161. SCL Liber 3075 folio 249.

162. *American City.*

163. *Guilford Bldg. Co. v. Goldsborough.*

164. *American Contractor,* 1916.

165. *Hampden-Sydney Record of the Alumni Association.*

166. Ibid.

167. *American Contractor,* 1916.

168. "Architect Russell Dies," *Baltimore Sun,* September 28, 1958.

169. Gunts, "Riviera's Luster to Be Restored."

170. Ibid.

171. Ibid.

172. Terrill, *Reservoir Hill.*

173. Hayward and Belfoure, *The Baltimore Rowhouse.*

174. Wagner, "Oakenshawe National Register."

Chapter 5

175. Libit, "Shirley Reinhardt Byrd."

176. Mirabella, "Richard D. Byrd."

BIBLIOGRAPHY

Alexander, Gregory, and Paul K. Williams. *A Brief History of Charles Village.* Charleston, SC: The History Press, 2009.

Ambrose, Kathleen C. *Remington: The History of a Baltimore Neighborhood.* Charleston, SC: The History Press, 2013.

American City 15, no. 2 (August 1916): 221.

American Contractor 37, no. 2 (January 8, 1916): 41, 42.

———— 41 (1920).

Arthur, Catherine Rogers, and Cindy Kelly. *Homewood House.* Baltimore: Johns Hopkins University Press, 2004.

Baltimore American. March 1, 1913.

Baltimore City Superior Court, Chancery Papers, 1851–1870. Maryland State Archives 168.

Baltimore Petroleum Company Records, 1881. Johns Hopkins University, Milton S. Eisenhower Library, manuscript 210.

Baltimore Sun. "Architect Russell Dies." September 28, 1958.

————. January 28, 1915.

————. "Maryland Historical Society Gets Portraits by Rembrandt Peale: Paintings of McKim Family Are Presented by William Power Wilson of Boston, a Descendant." January 20, 1924.

Baltimore Underwriter: A Weekly Journal Devoted to the Interests of Insurance in All Its Branches 16, no. 3 (July–December 1876): 28.

Beirne, Francis F. *The Amiable Baltimoreans.* Baltimore: Johns Hopkins University Press, 1951.

"The Bellman's Bookshelf." *Bellman* 15 (November 8, 1913): 596.

Bevan, Edith Rossier. "Perry Hall: Country Seat of the Gough and Carroll Families." *Maryland Historical Magazine* 45 (1950): 33–46.

Billboard. "The Final Curtain: Death Notice of Marjorie Sherwood." March 20, 1948, 48.

Biographical Memoranda Respecting All Who Ever Were Members of the Class of 1832 in Yale College. New Haven, CT: privately printed, 1880.

Blum, Gayle Neville. *Baltimore County*. Charleston, SC: Arcadia Publishing, 2009.

Bowditch, Edith Unger, and Anne Draddy. *Druid Hill Park: The Heart of Historic Baltimore*. Charleston, SC: The History Press, 2008.

Capital [Annapolis]. "Obituary: Matthew Mueller." December 16, 1975.

Critic: A Weekly Review of Literature and the Arts. "Van Bibber. " March 10, 1894, 170.

Culver, Francis B. "Frisby Family." *Maryland Historical Magazine* 31 (1936): 337–53.

———. "Merryman Family." *Maryland Historical Magazine* 10 (1915): 176–299.

Cutler, Carl C. *Greyhounds of the Sea, The Story of the American Clipper Ship*. Annapolis: U.S. Naval Institute, 1930.

Didier, Eugene L. "The Social Athens of America. " *Harper's New Monthly Magazine* 65, no. 385 (June 1882): 20–36.

Engineering and Contracting Magazine. "Philip C. Mueller Death." September 2, 1914, 37.

Footner, Geoffrey M. *Tidewater Triumph: The Development and Worldwide Success of the Chesapeake Bay Pilot Schooner*. Annapolis: U.S. Naval Institute Press, 1998.

"Gardens, Homes and People." *Roland Park Company Magazine* 2 no. 5 (1931): 2.

Genealogy and Biography of Leading Families of the City of Baltimore and Baltimore County, Maryland. New York: Chapman Publishing Company, 1897.

Getty, Joe. "Bloomfield Manor's History Presents Insight into South Carroll." Carroll's Yesteryears. *Carroll Times*, May 23, 1993.

Giroux, Ann G. *Guilford*. Charleston, SC: Arcadia Publishing, 2015.

Guilford Bldg. Co. v. Goldsborough. Court of Appeals of Maryland 116A. 913, 140 Md 159. 1922.

Gunts, Edward. "Riviera's Luster to Be Restored." *Baltimore Sun*, January 21, 1999.

Hall, Clayton Coleman, Ruthella Mary Bibbins, Matthew Page Andrews, S.Z. Ammen and John M. Powell. *Baltimore: Its History and Its People*. New York: Lewis Historical Publishing Company, 1912.

Hamlin, A.D.F. "The American Country House, Part II: The Working Man and His House." *Architectural Record* 44, no. 4 (October 1918): 302–25.

Hampden-Sydney Record of the Alumni Association 26, no. 3 (April 1952): 21.

Hayward, Mary Ellen, and Charles Belfoure. *The Baltimore Rowhouse*. Princeton, NJ: Princeton Architectural Press, 2001.

Hayward, Mary Ellen, and Frank R. Shivers Jr. *The Architecture of Baltimore: An Illustrated History*. Baltimore: Johns Hopkins University Press, 2004.

Henrietta D'Arcy and Thomas James Wilson v. Mary Netterville, Thomas Wilson and John D'Arcy. *Maryland Reports: Cases Adjudged in the Court of Appeals of Maryland 1851–1870* 20 (1864): 63–92.

Herd Registry of American Jersey Cattle Club 38 (August 1892).

Hobbs, Tom. "All the Conveniences and Amenities of Life: Construction Begins in Guilford." *Guilford News*, Fall 2012.

———. "The Cathedral That Wasn't." *Guilford News*, Fall 2013.

———. "A Place to Live in the City: Edward H. Bouton's Visionary Plan for the Roland Park–Guilford District." *Guilford News*, Fall 2011.

———. "Reasonably in Accordance with the Canons of Good Taste: Development of Houses in Guilford." *Guilford News*, Spring 2013.

———. "Unusual Care: Frederick Law Olmsted Jr. and the Plan for Guilford." *Guilford News*, Winter 2012.

Hobson, Elizabeth Christophers Kimball. *Recollections of a Happy Life*. New York: privately printed, 1914. Reprint, South Yarra, Victoria, Australia: Leopold Classic Library, 2015.

JHU Gazette. "Homewood House." July 9, 2012.

Johnston, Christopher. "Stansbury Family." *Maryland Historical Magazine* 9 (1914): 72–88.

Kelly, Jacques. "Obituary of James S. Keelty Jr." *Baltimore Sun*, August 27, 2003.

———. *Peabody Heights to Charles Village: The Historic Development of a Baltimore Community*. Baltimore: Equitable Trust Bank, 1976.

Kollen, Richard. *Lexington: From Liberty's Birthplace to Progressive Suburb*. Charleston, SC: Arcadia Publishing, 2004.

Levering, John. *Levering Family: History and Genealogy*. Indianapolis: Levering Historical Association, 1897.

Lewand, Karen. *North Baltimore from Estate to Development*. Randall D. Bierne, ed. Baltimore: Baltimore City Department of Planning and the University of Baltimore, 1988.

Libit, Howard. "Shirley Reinhardt Byrd, Prominent Actress of Stage, Television, Film Dies." *Baltimore Sun*, September 25, 2000.

"Marjorie Sherwood Notice." *Advance* 61 (1911): 20.

Martin, Luther, et al. "Street-Hadfield Duel." *Maryland Historical Magazine* 6 (1911), 84.

Marye, William B. "Baltimore City Place Names, Part 1: Mount Royal Forge, Mount Royal Mill, Spicers Run–Rutter's Run, Newington,

Lanvale–Rutter's Ford–Porcosin Run." *Maryland Historical Magazine* 54, no. 1 (March 1959):15–35.

———. "Baltimore City Place Names, Part 2: Huntington or Huntingdon, the Two Liliendales and Sumwalt's Run." *Maryland Historical Magazine* 54, no. 4 (December 1959): 353–64.

———. "Baltimore City Place Names, Part 3: Stony Run, Its Plantations, Farms, Country Seats and Mills." *Maryland Historical Magazine* 58, no. 3 (September 1963): 211–32.

———. "Baltimore City Place Names, Part 4: Stony Run, Its Plantations, Farms, Country Seats and Mills (Continued)." *Maryland Historical Magazine* 59, no. 1 (March 1964): 52–93.

McGrain, John. "A Brief History of Paradise Mill." *Tuscany-Canterbury Neighborhood Association Bulletin*, Spring 2013, 1–3.

———. *Charles Street: Baltimore's Artery of Elegance*. Bel Air, MD: Jack L. Shagena Publishing, 2013.

Merchant's Bank v. Williams, 110 Md. 337, 72 Atl 1114 Judge Berke. *Atlantic Reporter* 102 (1918): 995.

Mirabella, Lorraine. "Richard D. Byrd, Lawyer, Theater Producer, Writer, Attorney Dies." *Baltimore Sun*, January 12, 1992.

Mosca, Matthew. "Oakenshawe House Tour." 2003.

New York Times. "Conturbia-Patterson Wedding Announcement." What's Doing in Society. June 1, 1899.

———. "Miss Patterson's Success." June 14, 1914.

Papenfuse, Edward C., Alan F. Day, David W. Jordan and Gregory A. Stilverson. *Archives of Maryland: A Biographical Dictionary of the Old Legislature, 1635–1789*. Vol. 1: A–H. Baltimore: Johns Hopkins University Press, 1979.

Papers Related to Foreign Affairs. Vol. 1. Washington, D.C.: U.S. Department of State, 1867.

Paul, J. Gilman D'Arcy. "A Baltimore Estate: Guilford and Its Three Owners." *Maryland Historical Magazine* 51, no. 1 (March 1956): 14–26.

Peabody Heights Co. of Baltimore City v. Willson, 82 Md. 186. *Atlantic Reporter* 32 (1895): 1078.

Persig, Wendy. "Hayes Family: Judge, Writer, Tariff Commissioner, Civil War General, Editors." Old Berwick Historical Society. Last revised May 2012. http://www.oldberwick.org/index.php?option=com_content&view=article&id=127&Itemid=131.

Polk's Baltimore City Directory. 1923 ed. Baltimore: R.L. Polk & Company, 1922.

"Portrait Collection." *Maryland Historical Magazine* 41, no. 1 (1946): 30.

Rassmussen, Frederick N. "Restoration of Homewood Nearly Complete." *Baltimore Sun*, September 13, 2012.

Remington, C.P. *Society Visiting List of 1889 and 1890*. Baltimore: Thomas E. Lycett Company, 1889.

Richmond Evening News. "Marriage of Miss Anna St. Clair Patterson." June 2, 1899.

Scharf, John Thomas. *The Chronicles of Baltimore: Being a Complete History of Baltimore Town and Baltimore City from the Earliest Period to the Present Time*. Baltimore: Turnbull Bros., 1874.

———. *History of Baltimore City and County from the Earliest Period to the Present Day*. Philadelphia: Louis H. Everts, Publisher, 1881.

Schiszik, Lauren. "City Designates 33rd Street as Part of Olmstead Parkway." *Charles Villager*, Winter 2015, 1, 8.

The Scrap Book. Baltimore: Frank A. Munsey Company, 1908.

Sleicher, John Albert. "People Talked About." *Leslie's Weekly* 90, no. 2224 (1900): 223.

Smythe, R.M. *Obsolete American Securities and Corporations*. Vol. 2. New York: R.M. Smythe, 1911.

Swinnerton, Henry U. "Sixty-Three: Fortieth-Year Book of the Members of the Class of 1863." (not published) Princeton, NJ: Princeton University, 1904.

Tackett, John J. "Apple Core." May 1, 2012. tdclassisist.blogspot.com. es/2012/05/apple-core-baltimore.html.

Terrill, Kelly Dale. *Reservoir Hill*. Charleston, SC: Arcadia Publishing, 2013.

Thomas, Dwight R. "Poe in Philadelphia 1834–1844." PhD diss., University of Pennsylvania, 1978. Edgar Allan Poe Society of Baltimore, www.eapoe. org/papers/misc1921/pipdtdr4.htm.

Thomas, E.S. *Reminiscences of the Last Sixty-Five Years*. Hartford, CT: E.S. Thomas, 1840. Reprint, Charleston, SC: Bibliolife, 2009.

"Town and Country: Wills and Bequests." *Town and Country* 77–78 (1921): 18.

Wagner, Dean R. "National Register of Historic Places Registration Form for Oakenshawe." Washington, D.C.: U.S. Department of the Interior, National Park Service, 2002.

Washington Times. "Mrs. Griswold Was Addicted to Drug Habit: Contest Over $500,000 Estate Developed Testator Used Narcotics Freely." October 7, 1921.

Whitmore, Charles A. "Methods of Economy in Housing Construction." *Architectural Forum* 28, no. 4 (April 1918): 124–34.

Wilson, Franklin. *The Life Story of Franklin Wilson, as Told by Himself in His Journals*. Baltimore: Wharton & Barton Publishing Company, 1897.

Wilson, William Bowly. Unpublished notes, 1893. George Radcliffe collection.

ABOUT THE AUTHOR

Dennis Wilson has lived in Oakenshawe with his partner, John Farley, for the past twenty-four years. After earning degrees in biology (Northern Illinois University) and medicinal chemistry (University of Maryland, Baltimore), he worked in pharmaceutical and medical research as an immunologist and molecular biologist until he retired in 2017.

Prior to his retirement, the author developed an interest in the history of the Oakenshawe neighborhood and applied his scientific research skills to historical records related to Oakenshawe to generate this book. He is a member of the Maryland Historical Society, the Historical Society of Baltimore County, the Baltimore City Historical Society, Friends of Maryland's Olmsted Parks and Landscapes and Baltimore Heritage.

Visit us at
www.historypress.com
···